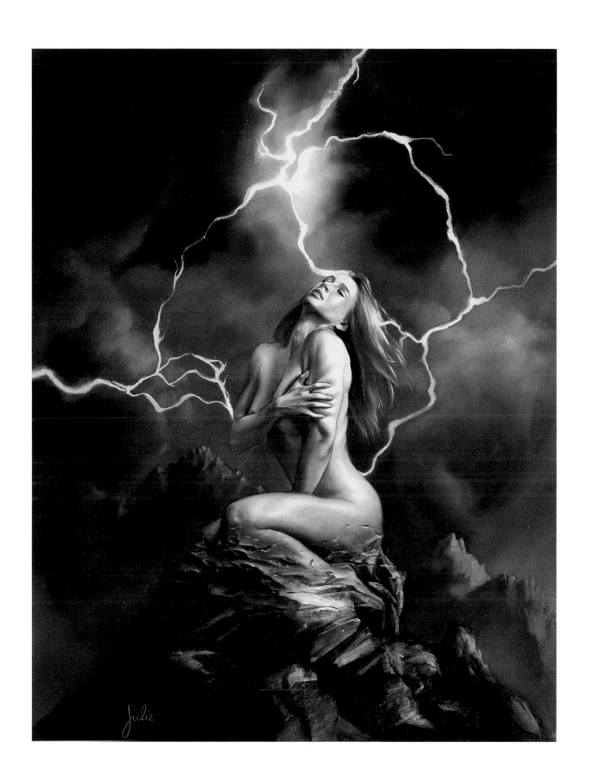

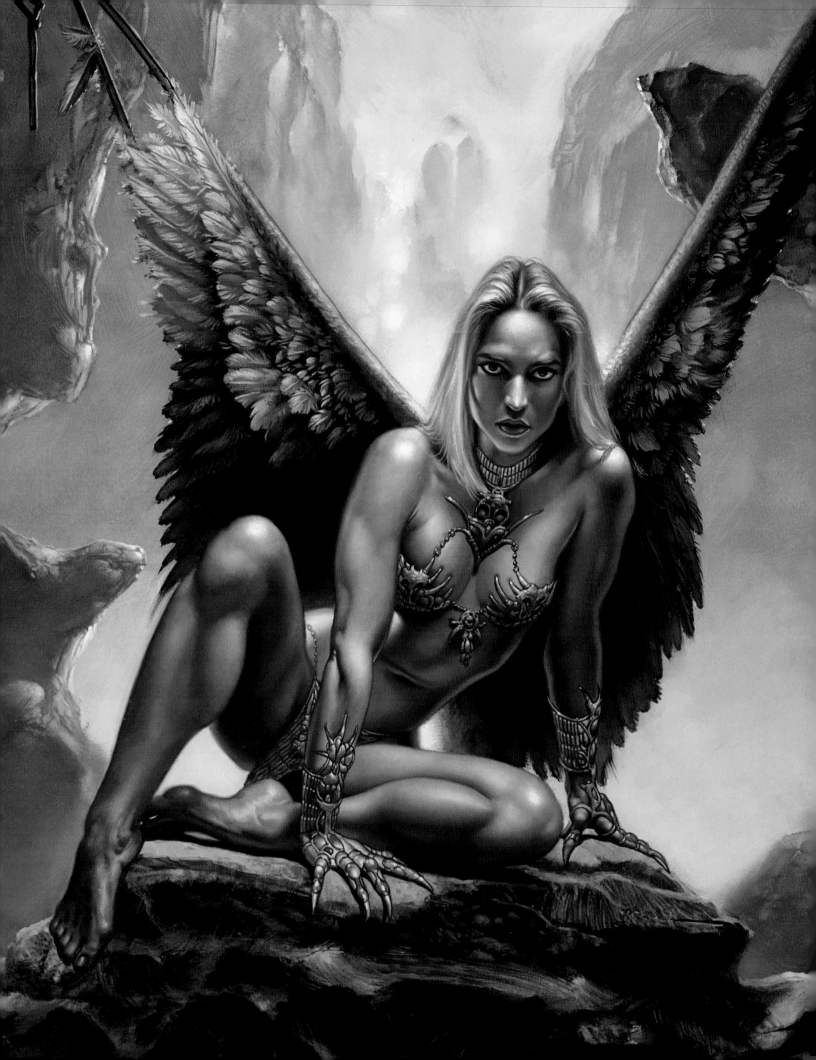

BORIS VALLEJO JULIE BELL

THE ULTIMATE COLLECTION

TEXT BY NIGEL SUCKLING

COLLINS|DESIGN

An Imprint of HarperCollins*Publishers*

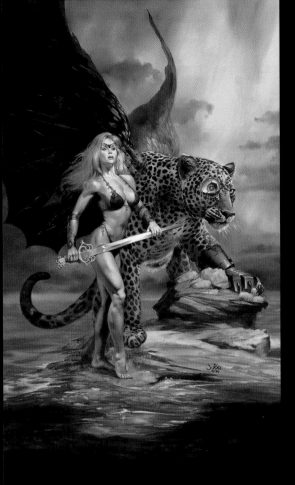

Above: 'The Arrival' 1999 Julie
Previous Page: 'The Broken Wings' 1999 Boris
Page 1: 'Ecstasy' 1990 Julie

HarperCollins books may be purchased for educational, business, or sales promotional use. For information, please write to: Special Markets Department, HarperCollins*Publishers*, 10 East 53rd Street, New York, NY 10022.

First published in Great Britain in 2005 by Collins & Brown
10 Southcombe Street
London
W14 0RA

First published in North America in 2005 by Collins Design
An Imprint of HarperCollins*Publishers*
10 East 53rd Street
New York, NY 10022
Tel: (212) 207-7000
Fax: (212) 207-7654
collinsdesign@harpercollins.com
www.harpercollins.com

Commissioning Editor: Chris Stone
Text: Nigel Suckling
Design: Philip Clucas MSIAD

Library of Congress Cataloging-in-Publication Data

Vallejo, Boris.
 Boris Vallejo and Julie Bell: The Ultimate Collection / Boris Vallejo,
Julie Bell.-- 1st ed.
 p. cm.
 Includes index.
 ISBN 0-06-088102-X (hardcover)
 1. Vallejo, Boris--Catalogs. 2. Bell, Julie--Catalogs. 3. Artist
couples--United States--Catalogs. 4. Fantasy in art--Catalogs. I.
Bell, Julie. II. Title.
 ND237.V14A4 2005
 758'.98130876'074--dc22

 2005017054

ISBN-10: 0-06-088102-X
ISBN-13: 978-0-06-088102-3

Reproduction by Classicscan Pte Ltd, Singapore
Printed and bound by Craft Print International Ltd, Singapore

9 8 7 6 5 4 3

Third printing, 2007

CONTENTS

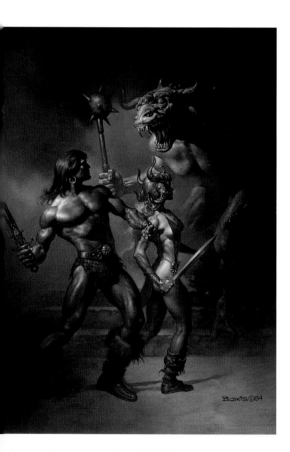

'AGAINST THE ODDS' 1984 BORIS

INTRODUCTION

In the 1970s, I found Boris' work to be inescapable if one had even a vague interest in science fiction or fantasy. His work was on many paperback covers of the time. He came at a time when there were some already outstanding fantasy artists – among them Greg and Tim Hildebrandt, Kelly Freas, Frank Frazetta and Jeff Jones. All had their unique and individual styles. In fact there seemed to be a new 'Golden Age' of fantasy and science fiction art. What amazed me about Boris was how the work seemed to be everywhere at once.

Growing up in the mid 1970s I remember his covers to Marvel magazines such as *The Savage Sword of Conan*, *Monsters Unleashed*, *Tales of the Zombie* and *Epic Illustrated* and the Warren magazine *Eerie*. I still in fact have his *Tarzan* calendar from 1977 which was a month-by-month feast for the eyes. How I miss those halcyon days before, it seemed, life got so serious.

It seemed to be a total, new look he had with stunningly rendered barbarian men and scantily clad Amazonian women. A sensuous oil painting style, if ever there was. His wispy and ethereal backgrounds were a delight, giving an inkling of places one might want to simply walk into the painting and explore, tempting us with unknown delights. What makes Boris such a great artist is his ability to DRAW. There are many artists who can slap paint around but it becomes meaningless if the draughtsmanship is not there. Boris is so secure in his drawing (at least as I see it) that his pencil work is as wonderful to see as his finished works.

And then there's Julie Bell . . . who started on one path and realized she was an artist in her own right. What I like about Julie's work is that she seems to be such an explorer. I remember reading that she became inspired by the sight of a 'just-opened, fresh box of pastels' and how their myriad colours seemed to call to her to simply start drawing and see what came forth. Her pastel work is simply amazing. I truly believe pastel to be such an underrated medium . . . it's nice to see it mastered so well, and to be so well thought of by other artists as well.

At first, one would see in her oil-painted work similarities to Boris' style and handling of that medium . . . but who better to be her teacher as well as life partner than Boris himself??? That said, I've seen Julie branch off yet again and create her own immediately recognizable style. Seeing her evolution ongoing, she now has a more 'earthy' and, I would even say, 'painterly' style than before. Her colour palette is also all her own. I particularly like her penchant for painting spaceships ('pointy rocketships' as they should be!) but then, she can paint just about anything and master it. She will never be 'in a rut' as some artists like to call it when they get pigeonholed for doing one thing.

Boris and Julie are life partners as well. They share the same interests – art , photography, bodybuilding and more. This, sharing a passion in a creative endeavour, I believe is the success of any such relationship, as I know because my own wife is herself an accomplished artist and writer. Life partnerships are a rare thing indeed, so I know exactly how Boris and Julie must think and feel. That's truly accomplishing a dream, so dig into this book and enjoy!!

Bob Eggleton

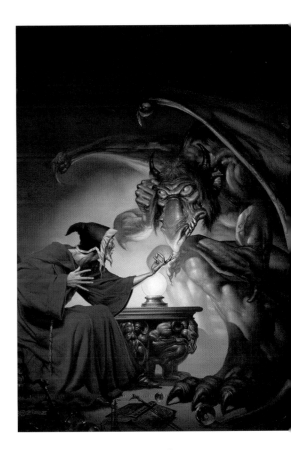

'DRAGON AND THE WIZARD' 1990 BORIS

EARLY PERIOD

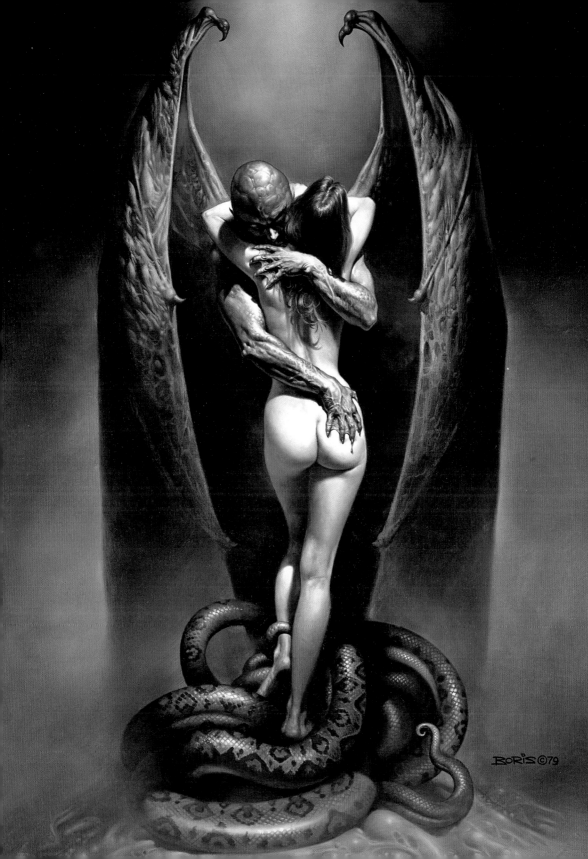

BORIS ©79

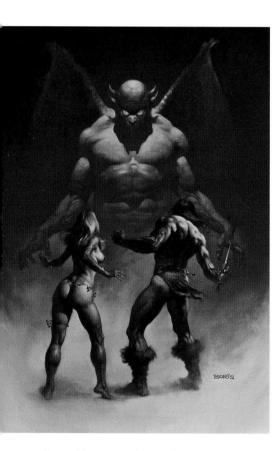

'IN THE UNDERWORLD' 1976 BORIS

PREVIOUS PAGE: 'VAMPIRE'S KISS' 1979 BORIS

EARLY PERIOD

This book is a 'cherry-picked' selection of pictures from other books Boris and Julie have published over the years – some two dozen in all, not counting different language editions, calendars and small portfolios. On pages 188–9 you can see a comprehensive selection of covers, though it's quite possible some are missing because, as Boris says: 'Being the way I am, I tend not to keep track of things like this.' Some of these books are themselves anthologies of work from various sources but many (*Enchantment*, *Ladies*, *Mirage* and *Fantasy Workshop* for example) have specific themes and their paintings were conceived as self-contained projects.

Not all the books shown are still in print but the majority are and the rest can mostly be tracked down on the internet, though collectors are notoriously reluctant to let them go. One of their published books, *Fantasia*, is a bit of an illusion though. The otherwise beautifully produced cover proclaims it to be a collection of Boris' digital art and the blurb elaborates on the back cover saying that his digital designs have been brought to life by Julie's marvellous brushwork. In fact the book is nothing of the kind, being simply a Spanish translation of their joint book *Fantasy Workshop*, an examination of their oil-painting techniques. They have experimented to an extent with digital art but remain unconvinced and certainly have no plans for publishing a book about it. So, apologies to Spanish readers of *Fantasia* who were misled . . .

Also, it is probably worth mentioning here that although most of these pictures have appeared in previous books, a few new ones have probably slipped through the net, and we also have a short chapter of previously unseen pictures at the end which cast fresh light on how some of Boris and Julie's most striking images have evolved.

The plan of this book may seem a bit confusing at first glance because Boris

became a published artist long before Julie, yet for most of this chapter you will find their pictures side by side. What we have done is take the early, middle and late periods of each artist's work and run them in parallel to avoid an unnatural separation.

Elsewhere Boris and Julie have discussed their art techniques in some detail, particularly in the books *Fantasy Workshop* and *Boris Vallejo's Fantasy Art Techniques*. They have also taught classes and are always happy to share with newcomers any technical tricks they have picked up in the course of their careers. But what we thought might be interesting in this book, to avoid repeating anything that's been said elsewhere, is to say a bit about the broader aspects of professional art rather than the practicalities – the attitudes needed to launch and sustain a professional career – and many of their insights are equally suited to other fields of creative work.

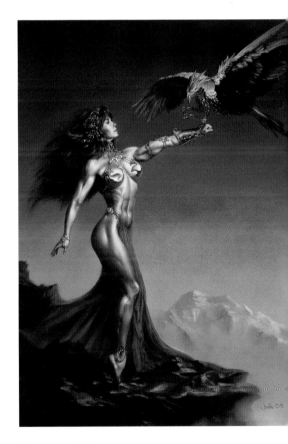

'ROBOBIRD' 1991 JULIE

Boris: One thing that is really exciting about beginning a career in the arts is the element of discovery – discovery of techniques and approaches to painting. You haven't really found confidence yet in what you do and how to do it, but that makes the whole process exciting.

Julie: Also the process of finding work, making pictures to get the interest of possible clients and finding areas that you can fit in to.

Boris: I remember as a young guy I used to work through the whole day, for hours and hours without stopping because I was so engrossed in what I was doing. When finished I would be really tired but I would prop the painting by the side of the bed, so it was the last thing I'd see when I went to sleep and the first thing in the morning. I didn't want to part with it because it was so exciting.

Julie: It still feels like that.

Boris: Aside from the excitement there was also the fear. There you have an empty canvas and you know that in a few days there has to be a full

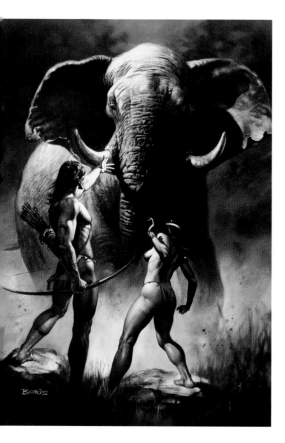

'JUNGLE MAN AND FRIENDS' 1976 BORIS

painting – it was fearsome to me. Twenty-five percent of the time I was thinking: 'What am I going to do with this mess?'

Julie: I still get that fear a lot, but having Boris beside me gives a lot of confidence. If I get stuck I feel that he can guide me. It never actually seems to happen but the feeling is there. A lot of working through that process is just pushing through the fear because confidence will come when you do it often enough.

Boris: In the early days it was always a surprise that paintings never turned out the way I visualized them at the start. You have to learn that paintings take on a life of their own.

Julie: You don't know that at the beginning and it's easy to get scared and just stop, which is a mistake. You have to realize that the picture will have its own life. It will never be quite what you think at the beginning.

Boris: When you don't have the confidence you can stop too soon and lose the thread of the picture.

Julie: Sometimes you almost have to 'work with your eyes' and eventually the picture will start to pull together and make sense. It really feels as though you have not to look at it too closely or for too long because panic can set in and you start to think 'this isn't working'.

At the beginning for me it was really exciting learning the business side of work – besides learning how to paint. It was an entirely new world. Sometimes I would get commissions that were really tough and beyond what I was really capable of, so it was like on-the-job training. It's exciting to be forced to do better than you can.

'CREATURES FROM THE EARTH CORE' 1971 BORIS

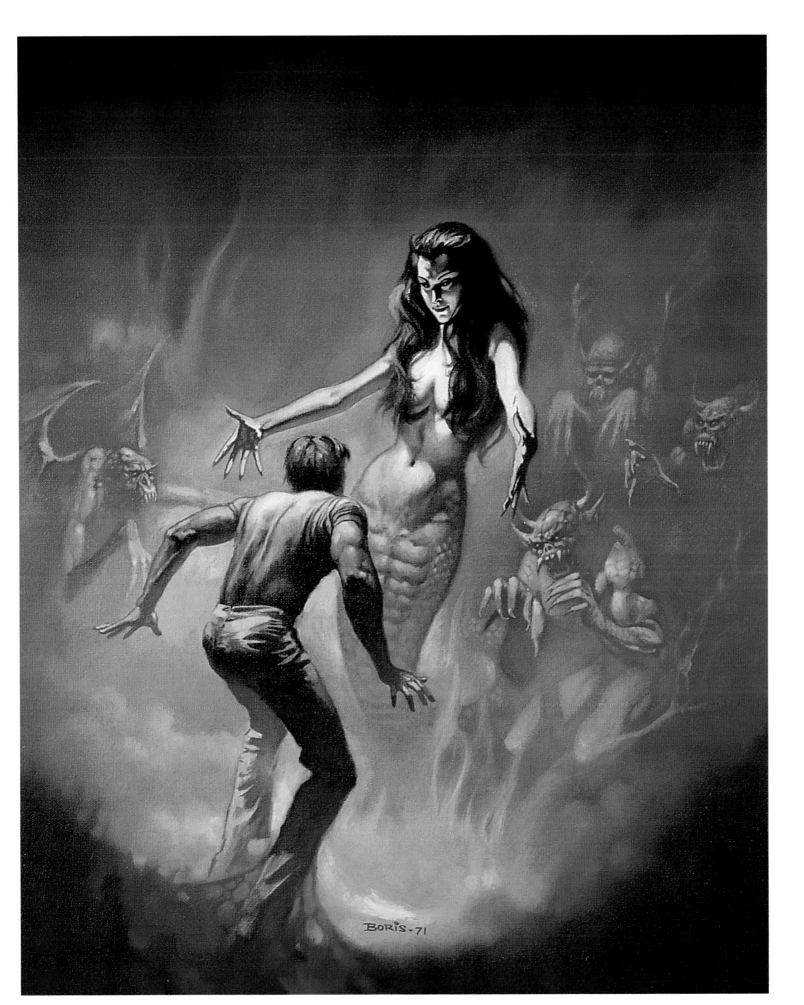

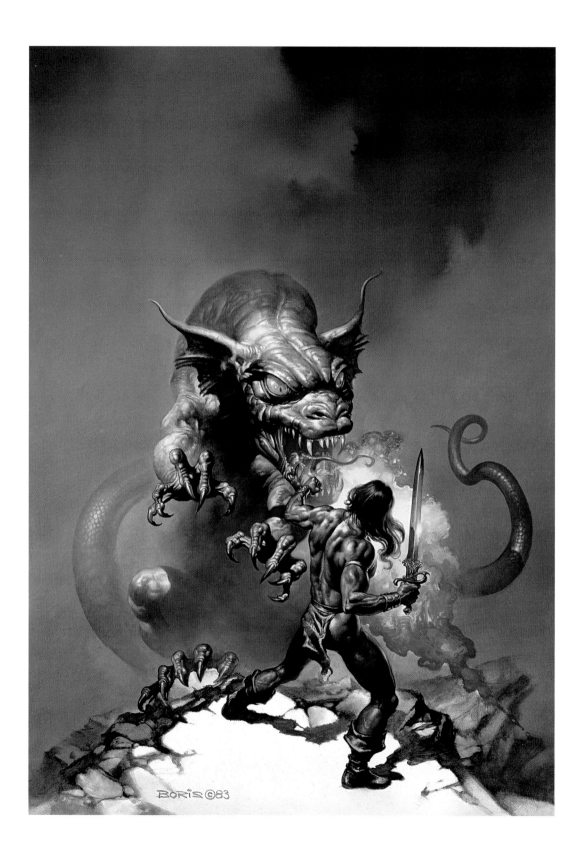

'DRAGON'S FIRE' 1983 BORIS

'JAVELIN' 1985 BORIS

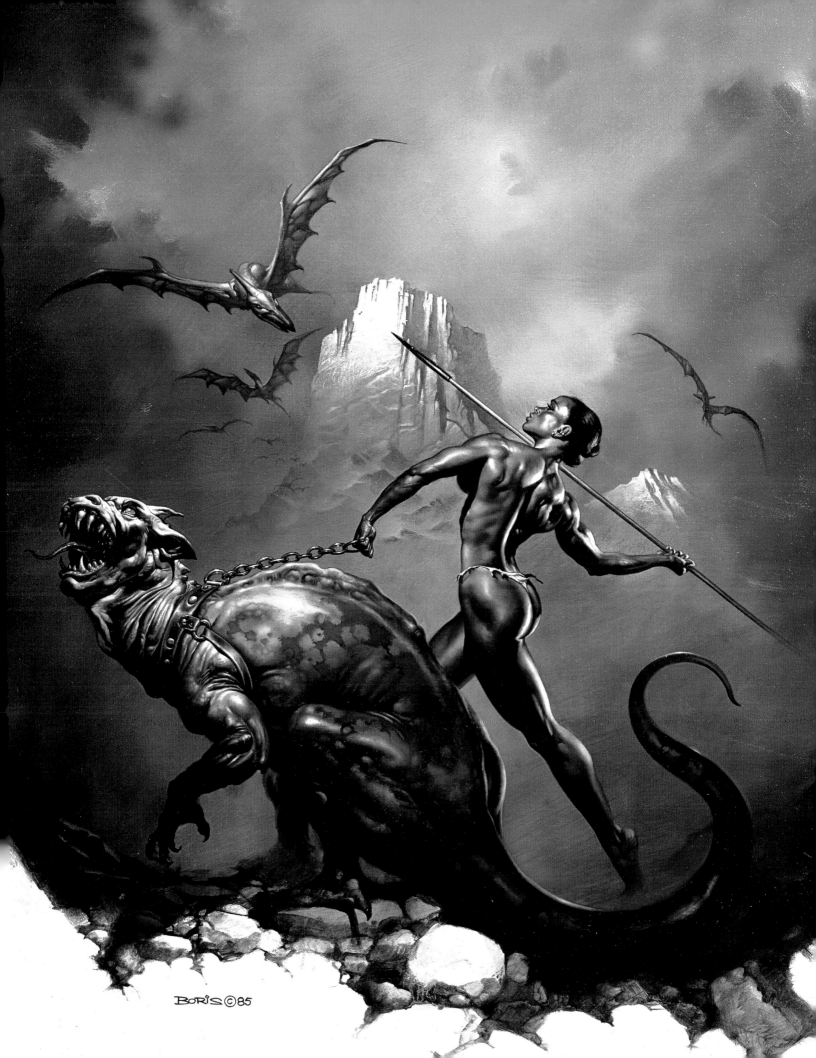

BORIS ©85

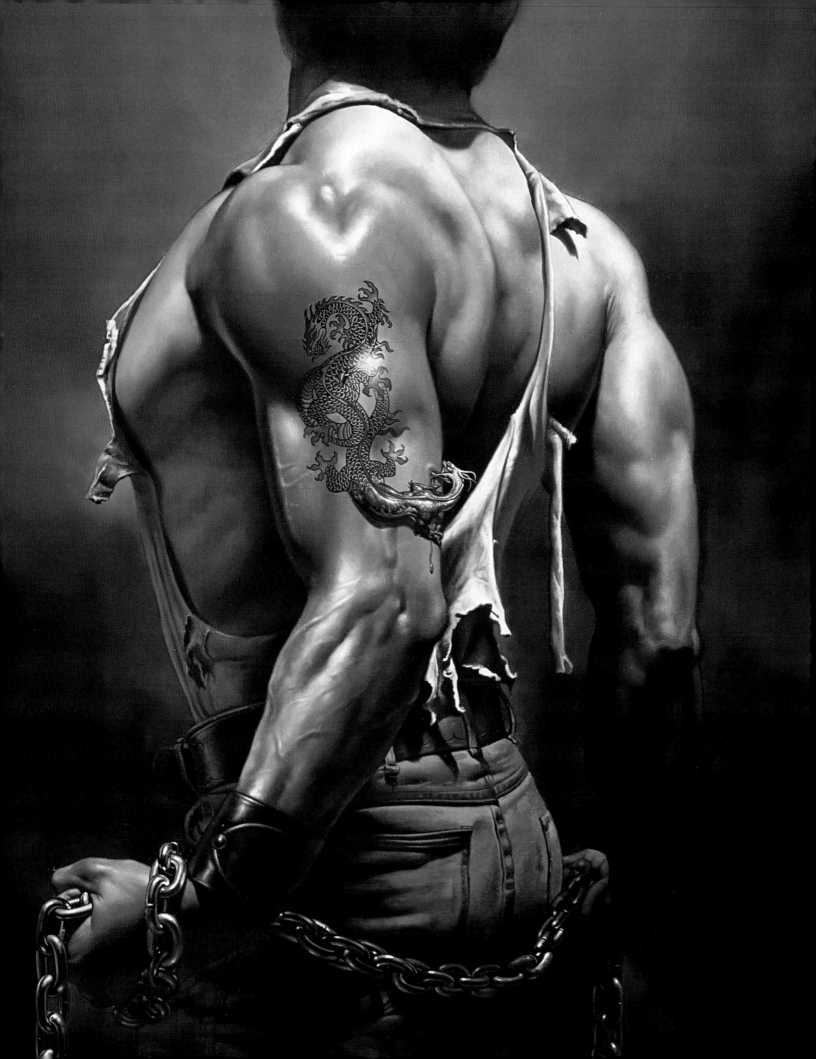

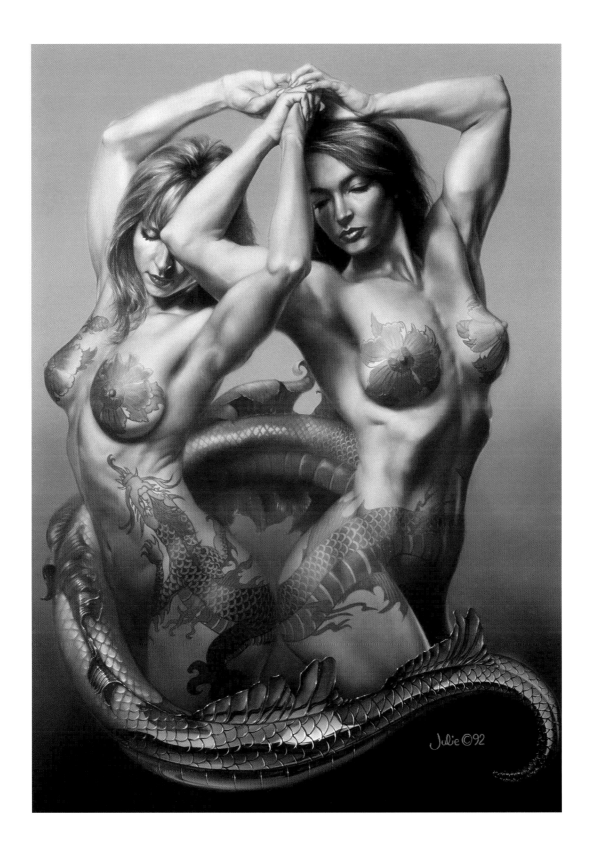

'TATTOO' 1981 BORIS

'DRAGON DANCE' 1992 JULIE

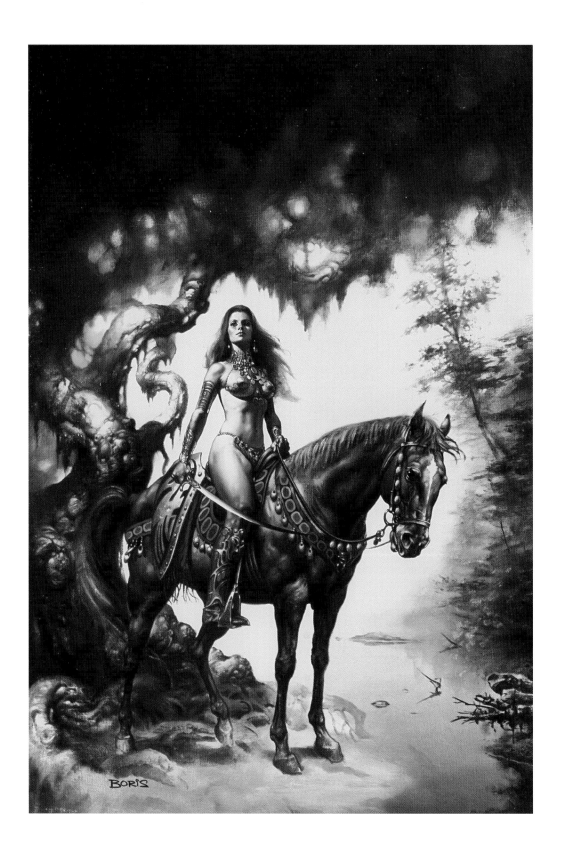

'DEMON IN THE MIRROR' 1975 BORIS

'UNICORN AND MAIDEN' 1979 BORIS

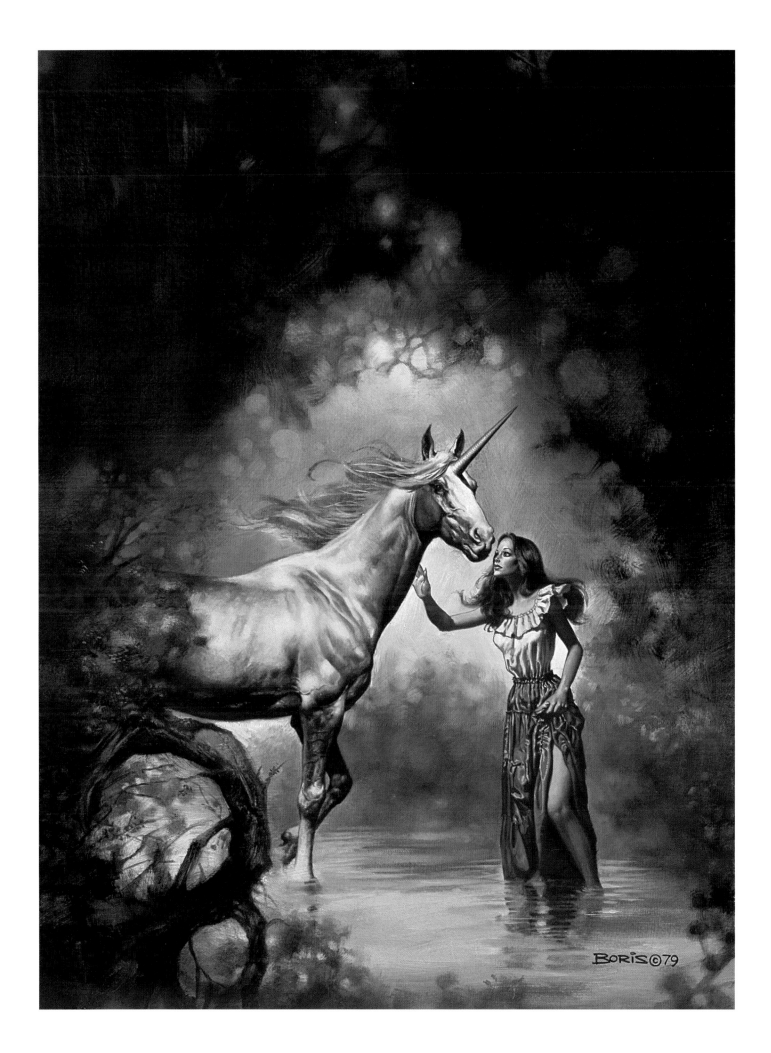

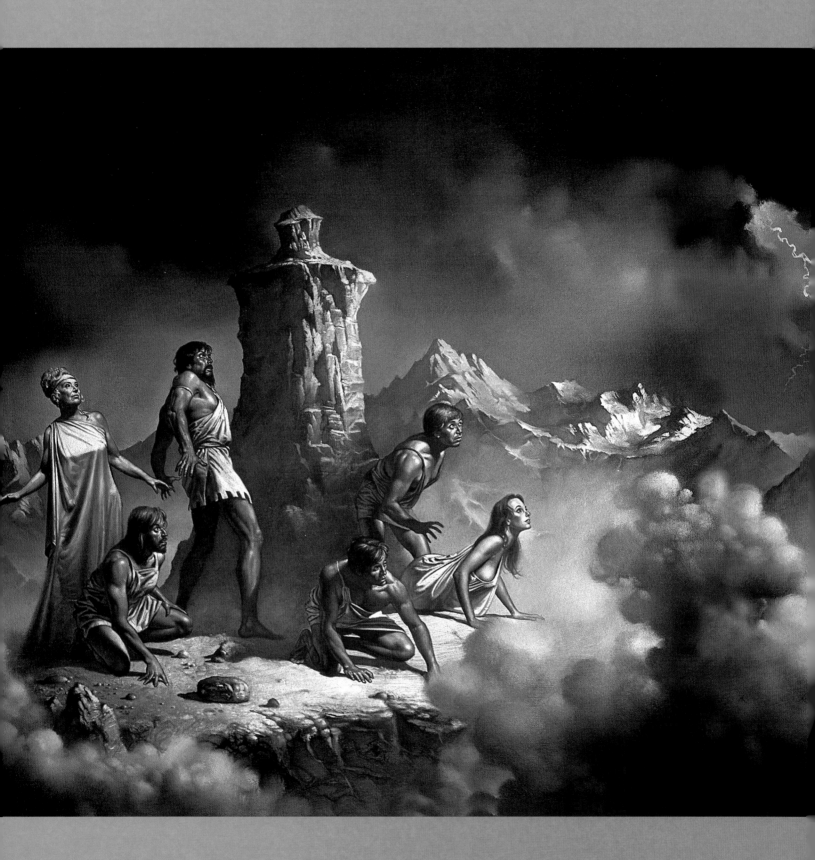

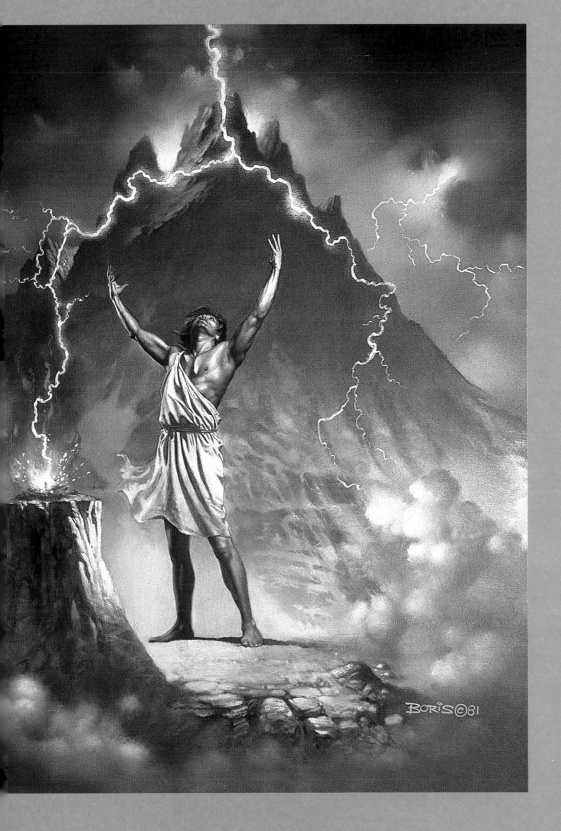

"I remember myself studying for hours the incredible technique of Boris' paintings when I was a teenager dreaming about becoming a fantasy artist. What a great inspiration were his books to me! Years later Julie's work also became well known for me due to its high quality. I must say that it's an honour for me to include a few words in this magnificent book of two fantasy art masters."

Ciruelo Cabral
www.dac-editions.com

'ELIJAH' 1981 BORIS

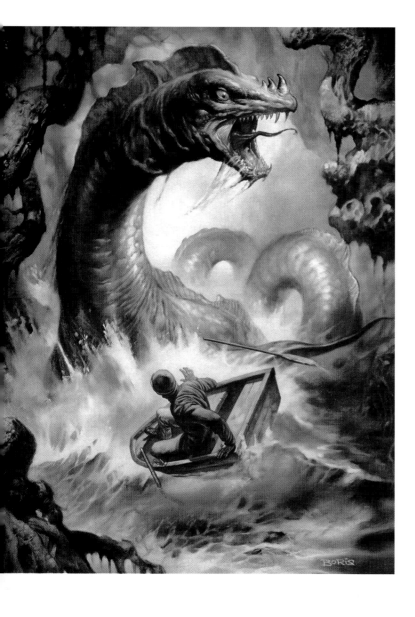

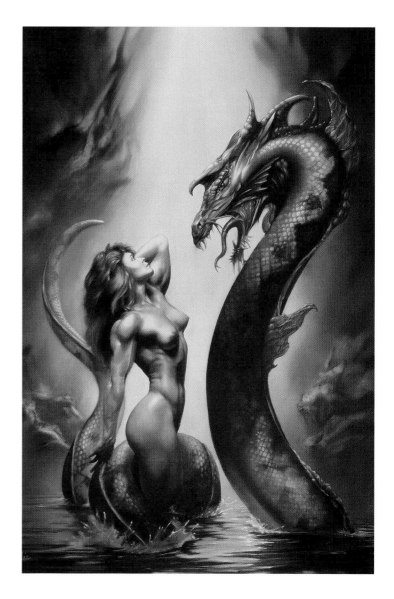

'THE LOCH NESS MONSTER' 1975 BORIS

'SERPENT SAGE' 1990 JULIE 'TO BECOME A MAN' 1991 JULIE

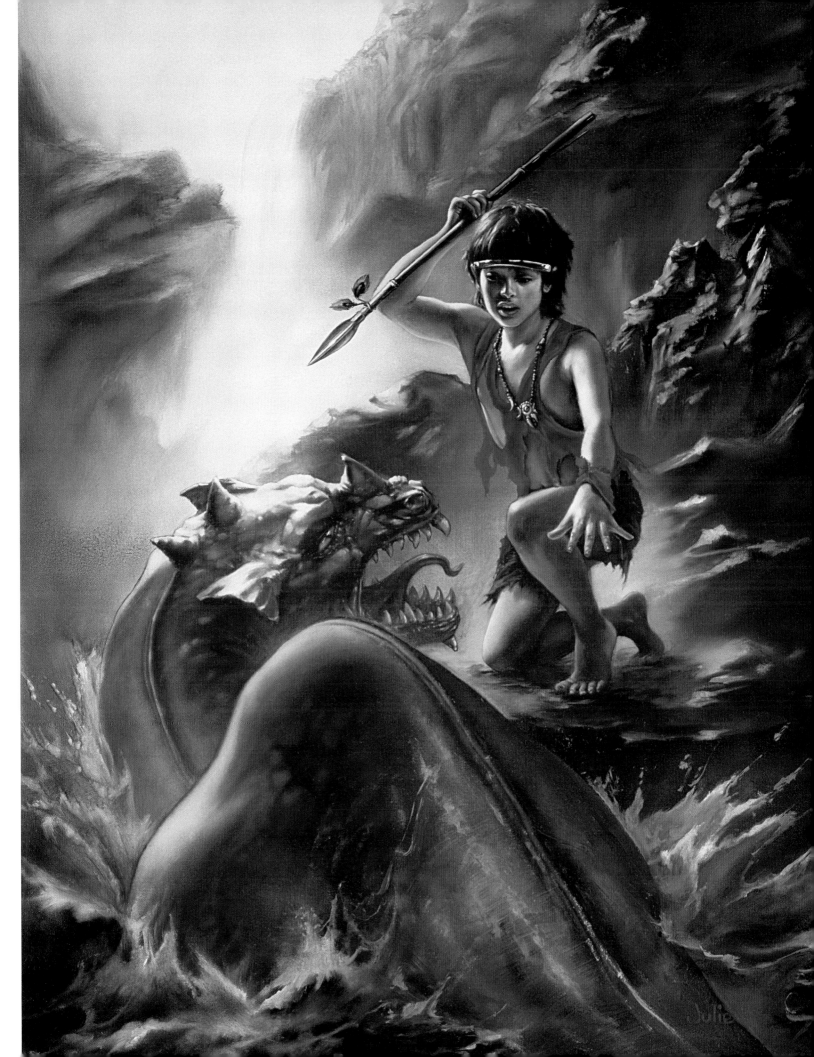

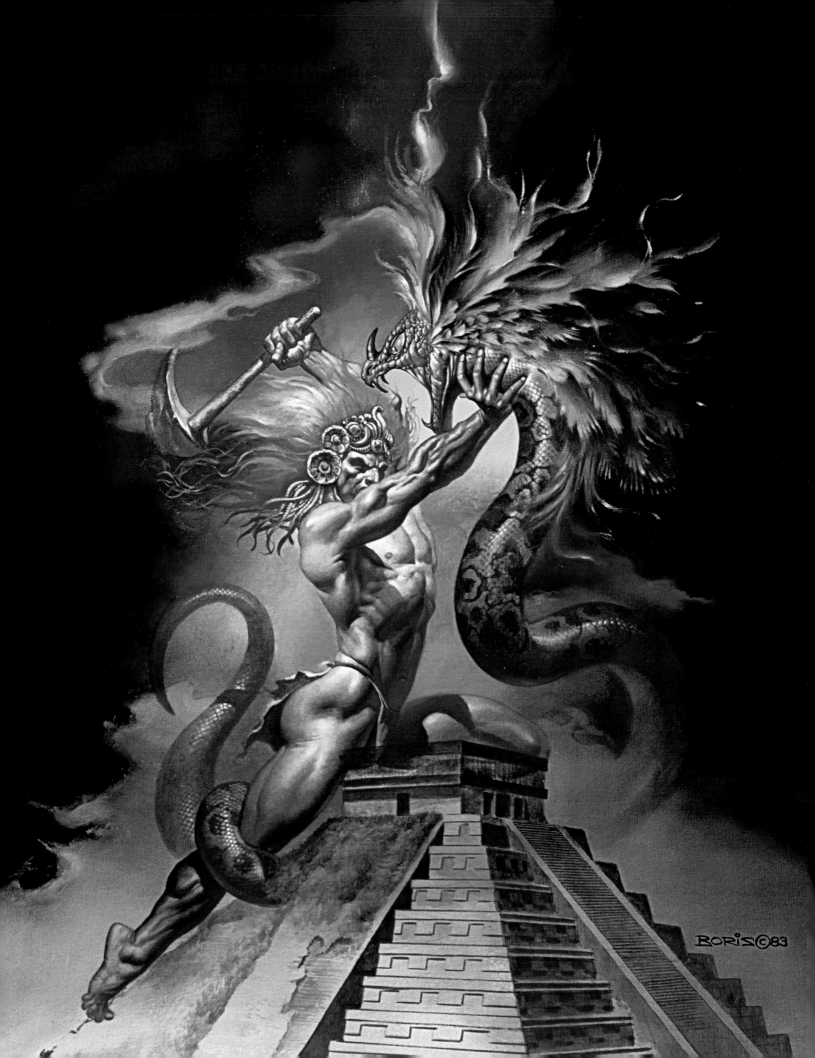

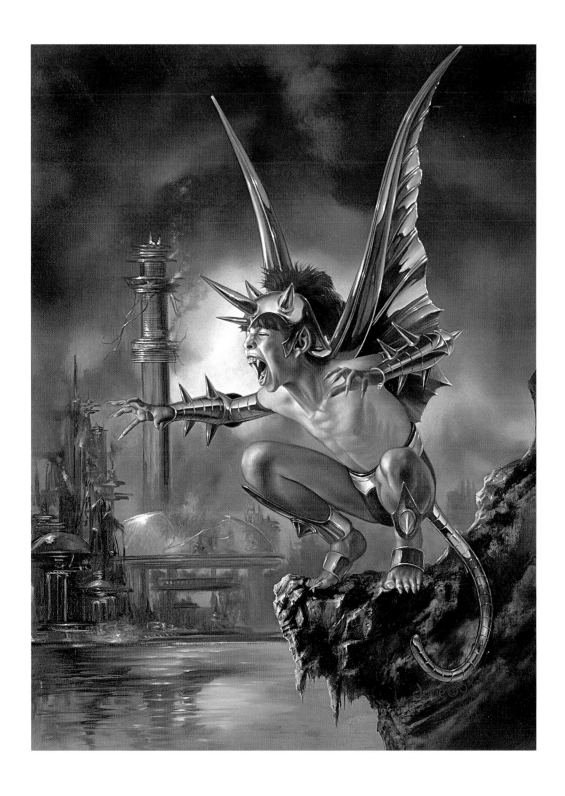

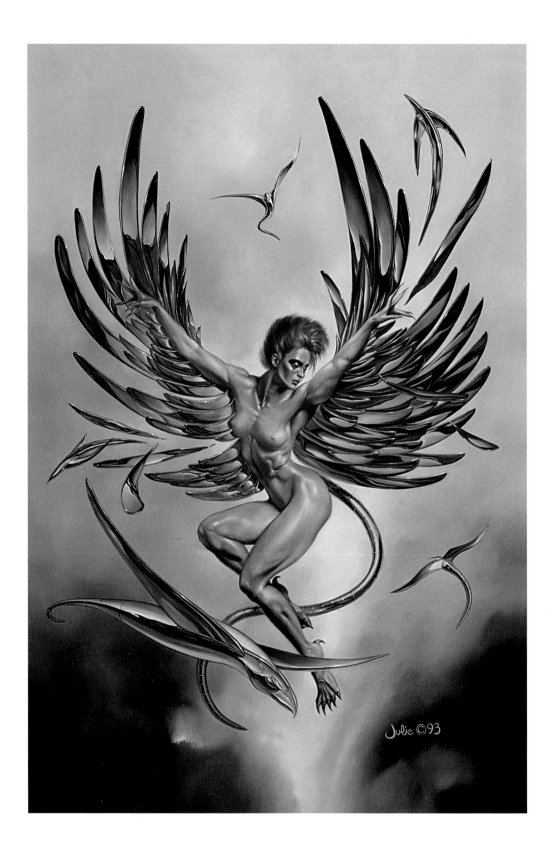

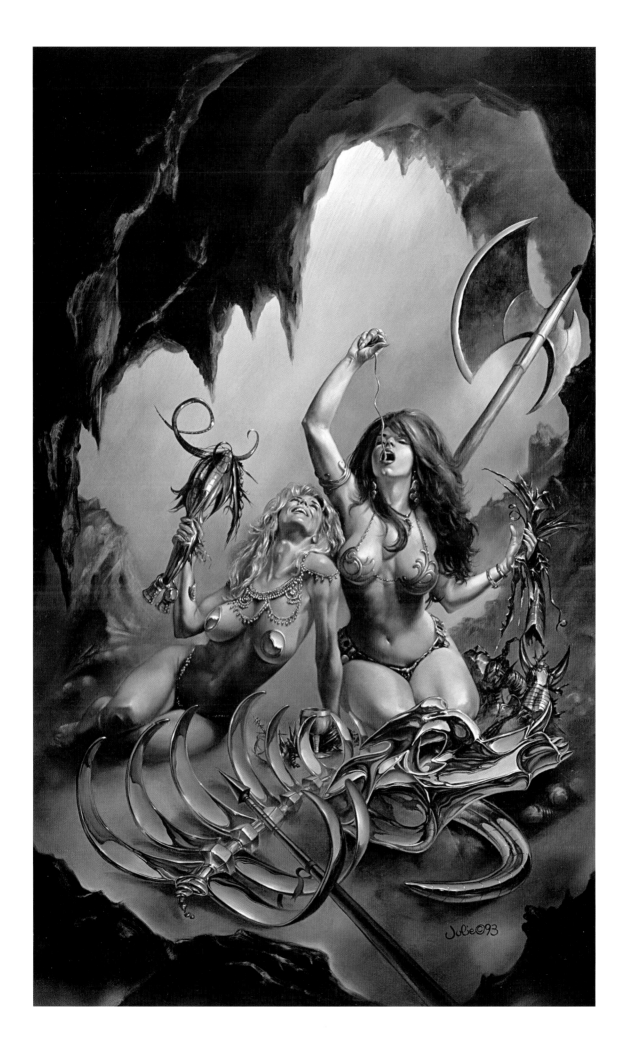

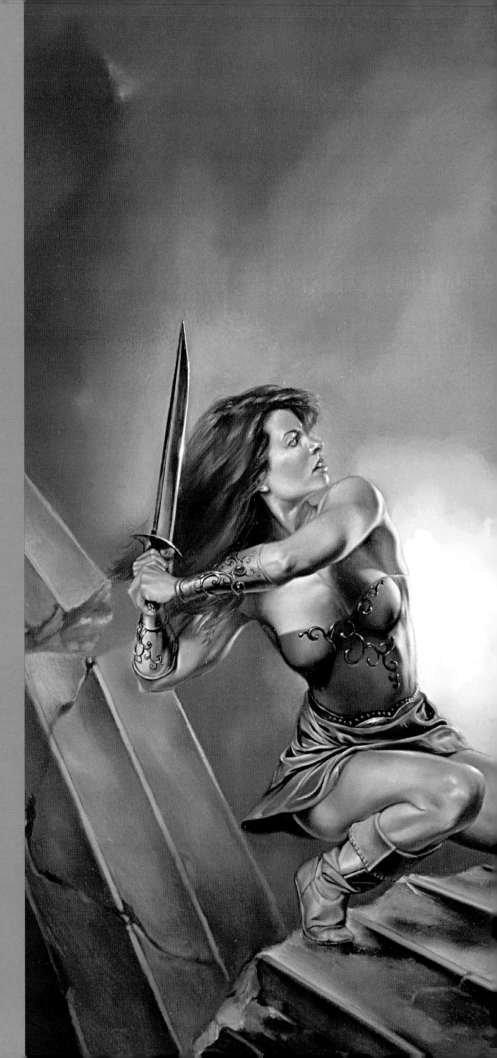

"Growing up as a young artist in the 80s, I was very influenced and inspired by the works of Boris Vallejo and Julie Bell that graced so many Heavy Metal covers. As a professional fantasy illustrator today, I continually look to the work of many great modern painters, for ideas and inspiration regarding colour, composition and technique."

Monte M. Moore – Two time winner – World Fantasy Art Show

www.mavarts.com

'FIREBALLS' 1992 JULIE

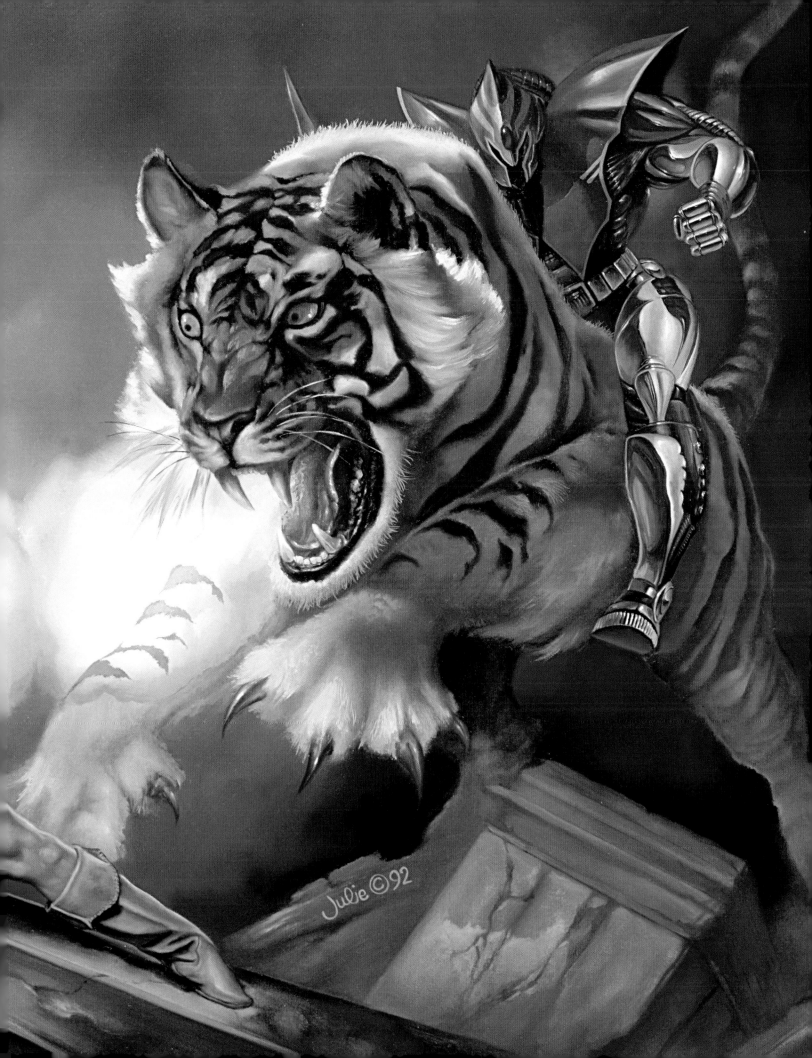

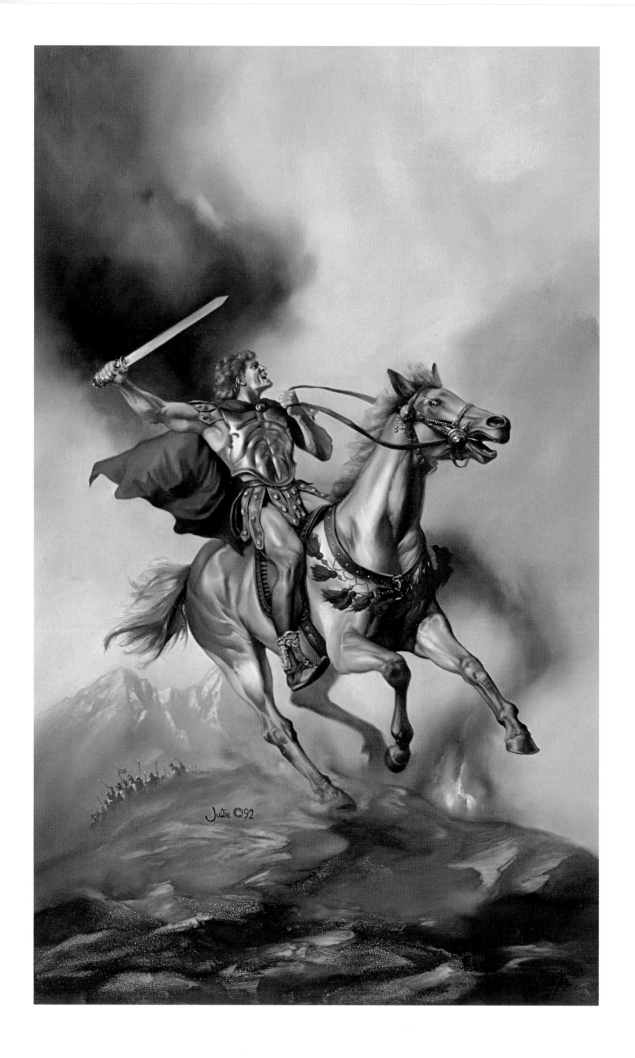

Julie ©92

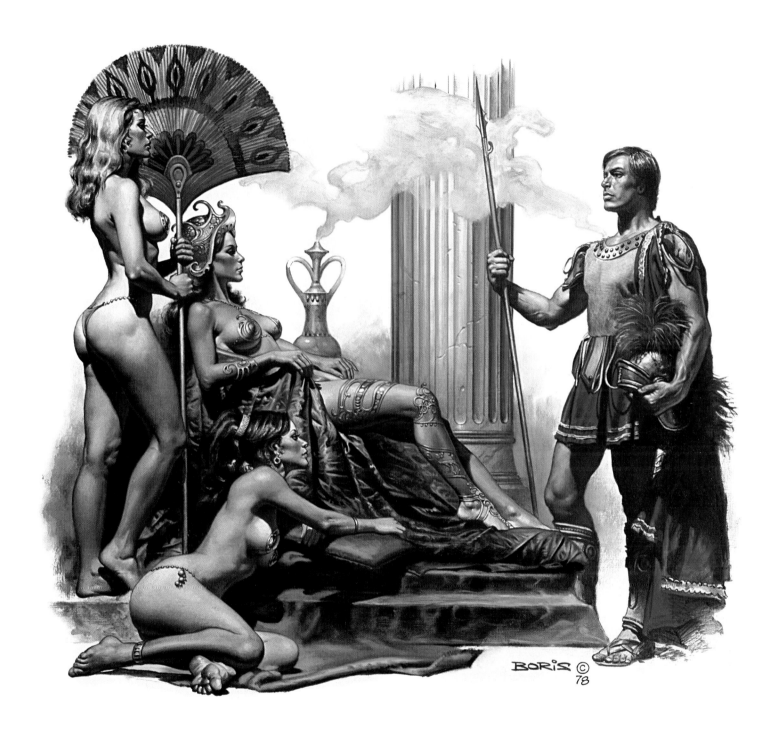

'BATTLE CRY' 1992 JULIE

'GRACUS THE CENTURION' 1978 BORIS

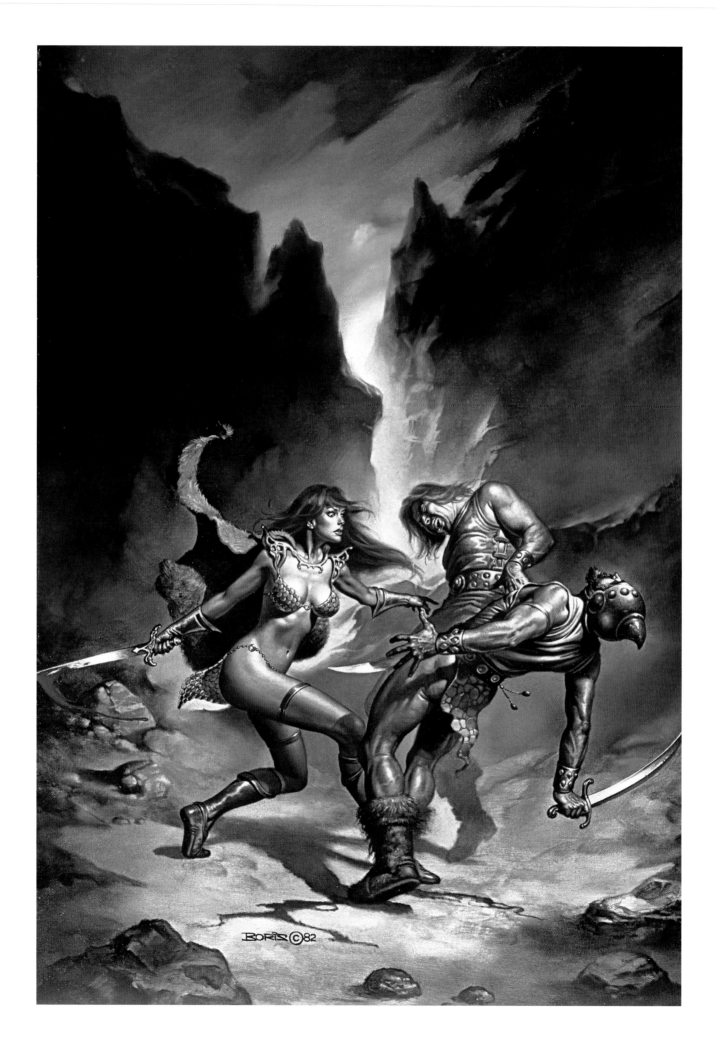

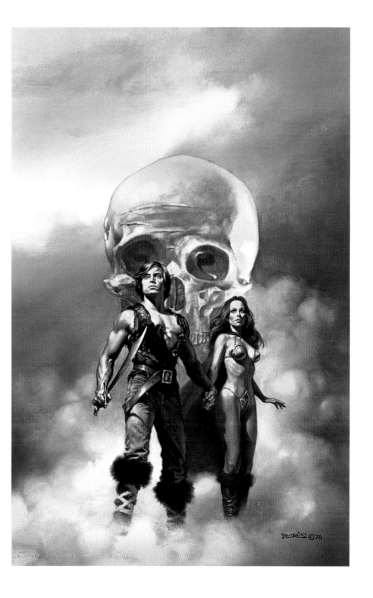

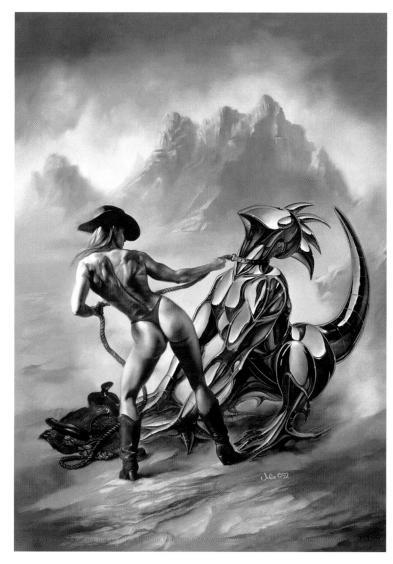

'SLASH' 1982 BORIS 'DEATH JOURNEY' 1978 BORIS 'SPACE COWGIRL' 1992 JULIE

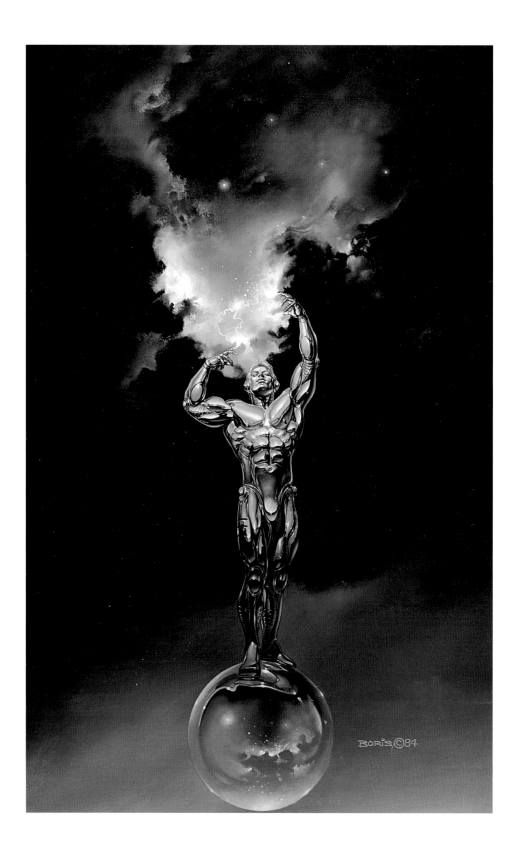

'CHROME ROBOT' 1984 BORIS

'GOLDEN LOVER' 1992 JULIE

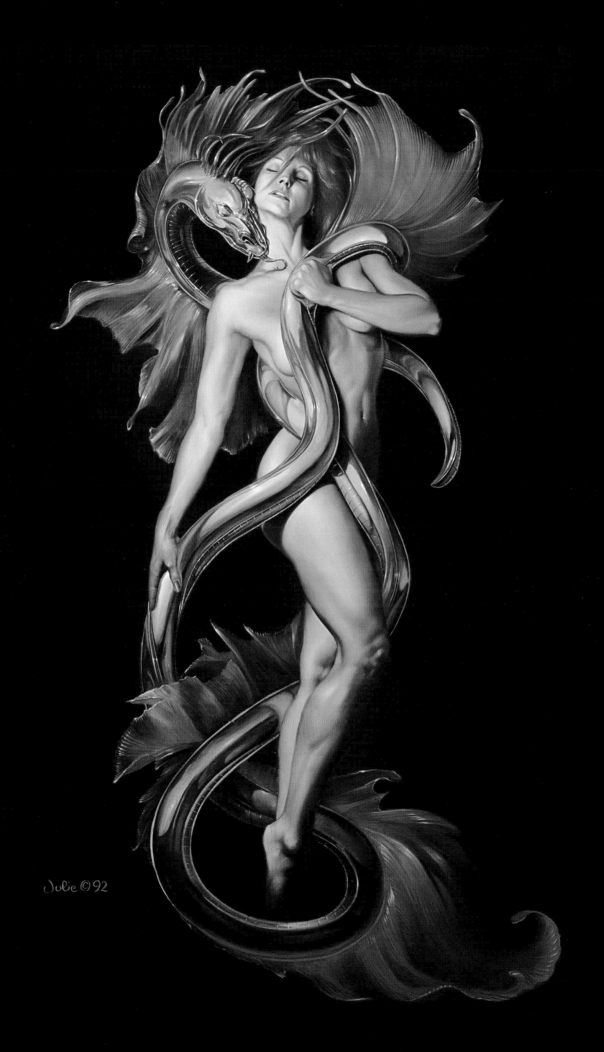

Julie ©92

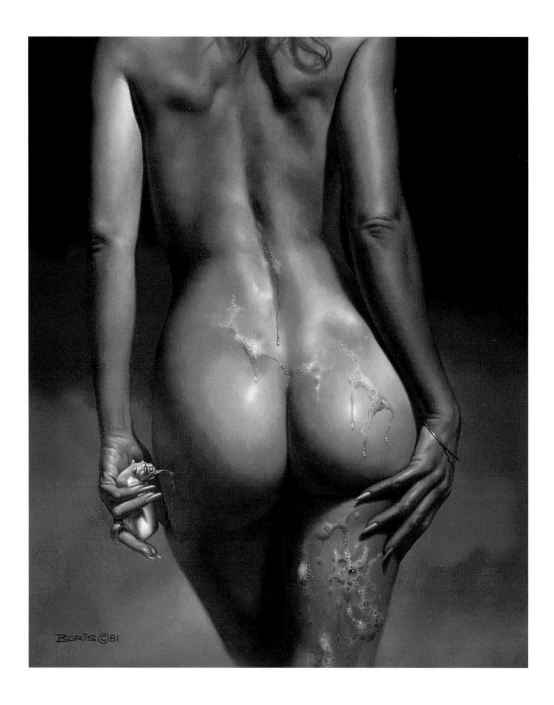

'SOAP' 1981 BORIS 'INVICTUS' 1982 BORIS

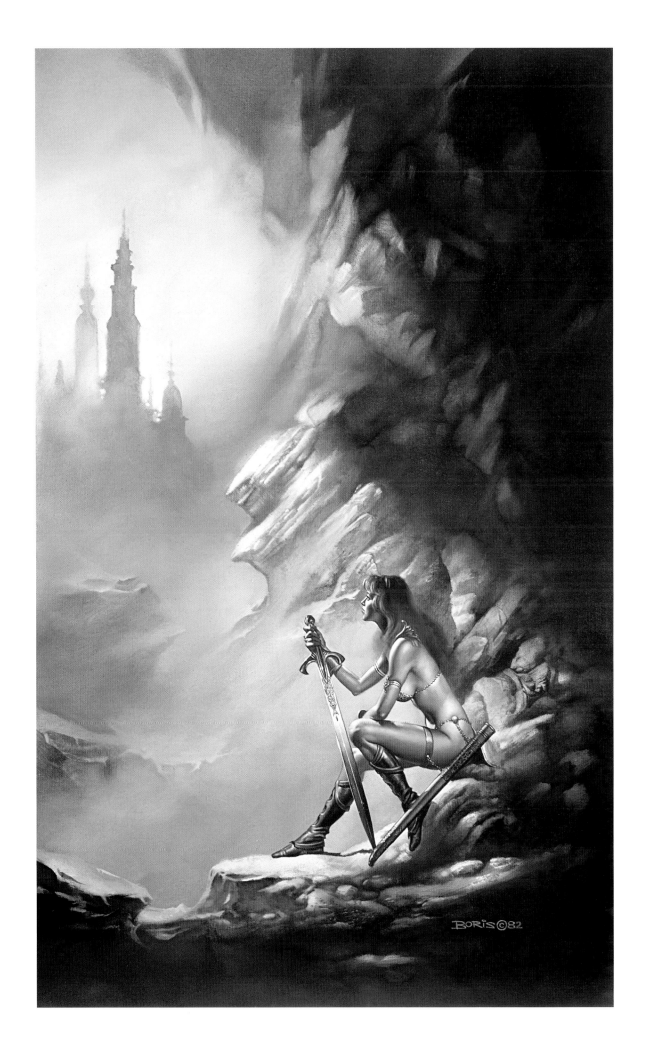

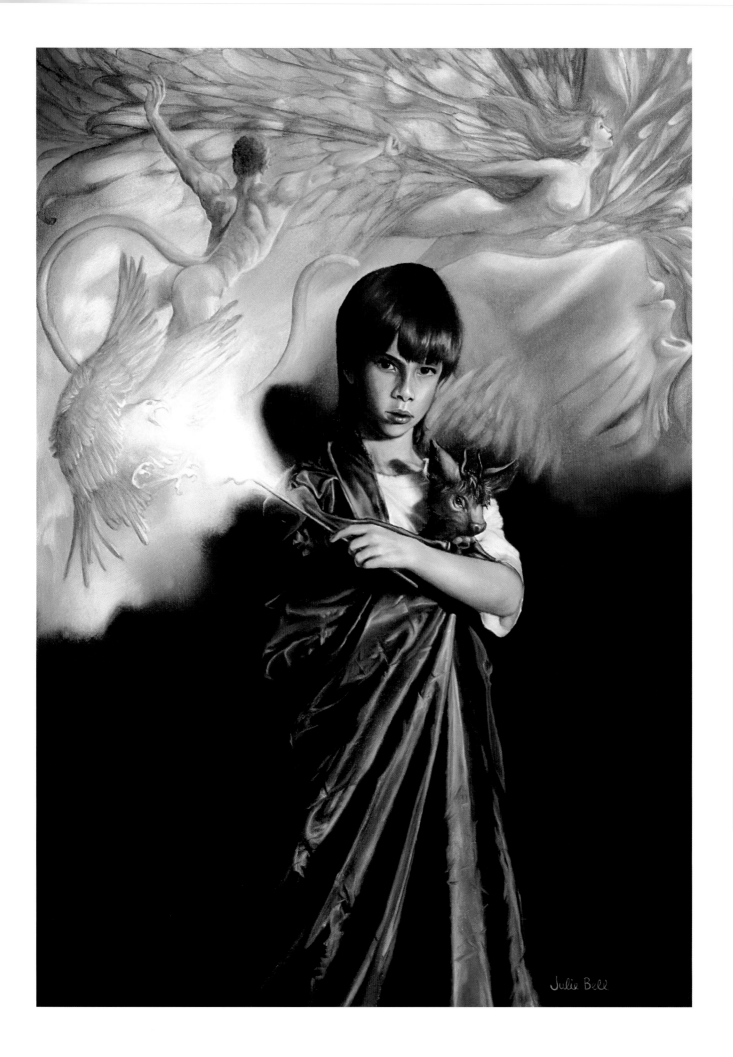

Julie Bell

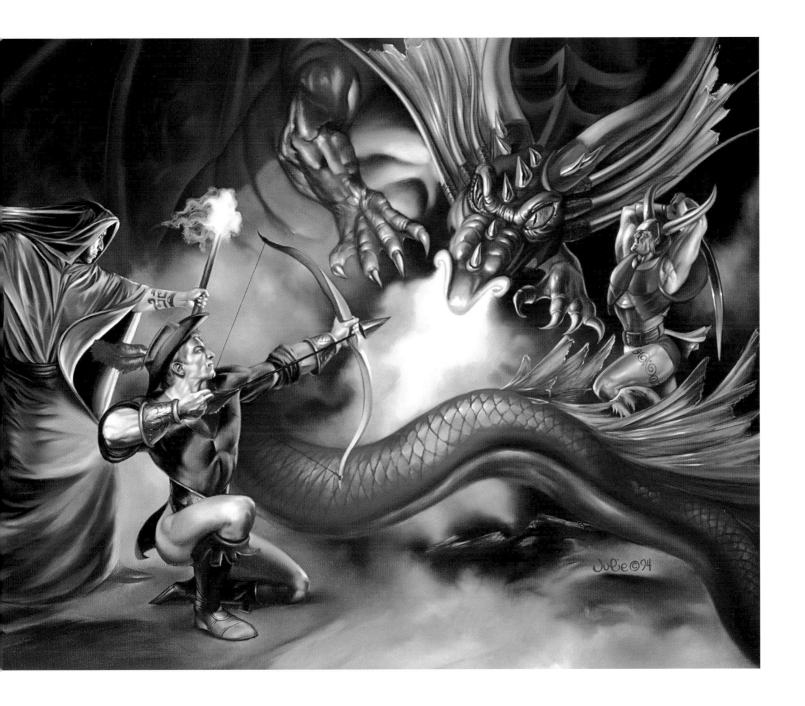

'YOUNG WIZARD' 1990 JULIE

'DRAGON BATTLE' 1994 JULIE

"When I think of Fantasy Art many artists' names cross my mind, but when I think solely of Art I often think of Vallejo. He studied the Old Masters' works to make his art outstanding and I, as a child, was deeply inspired by his strong drawing skill, the very heart of his and my art and, unconsciously, by the sensual feeling expressed in his paintings. I know something of him still lies in many of my art works, making them stronger. I only can say: 'Thanks, Boris'."

Max Bertolini
www.maxbertolini.com

'FLIGHT OF THE DRAGONS' 1981 BORIS

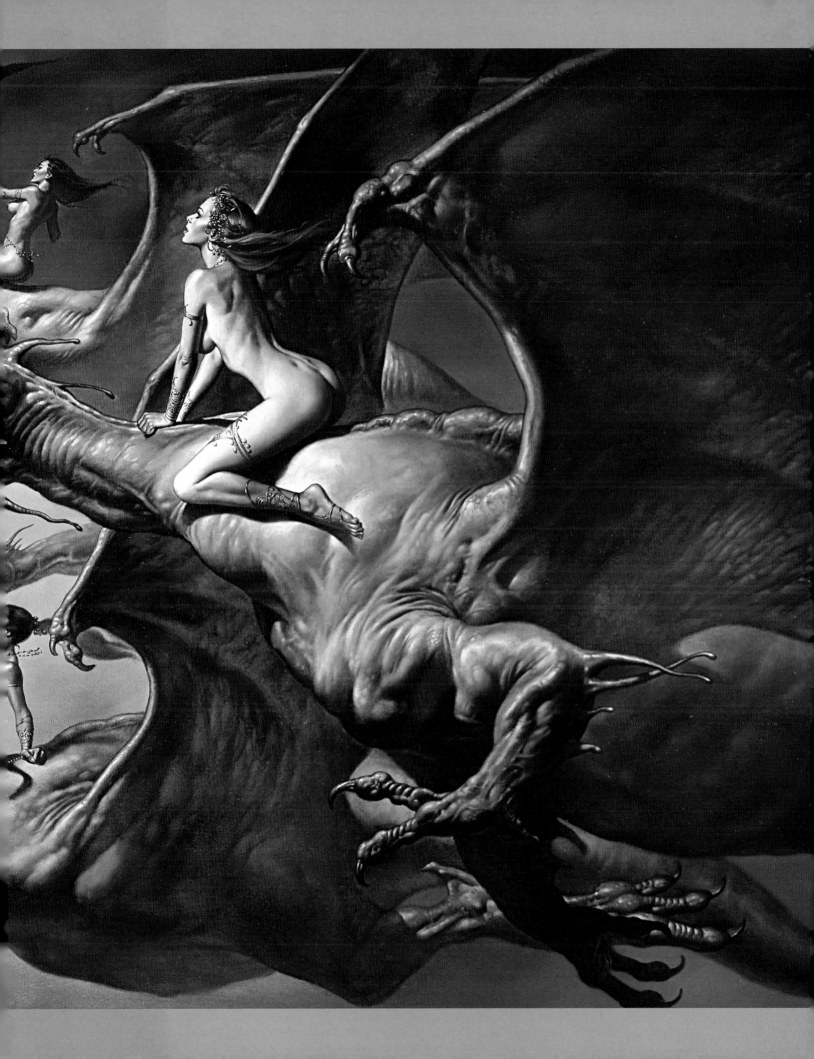

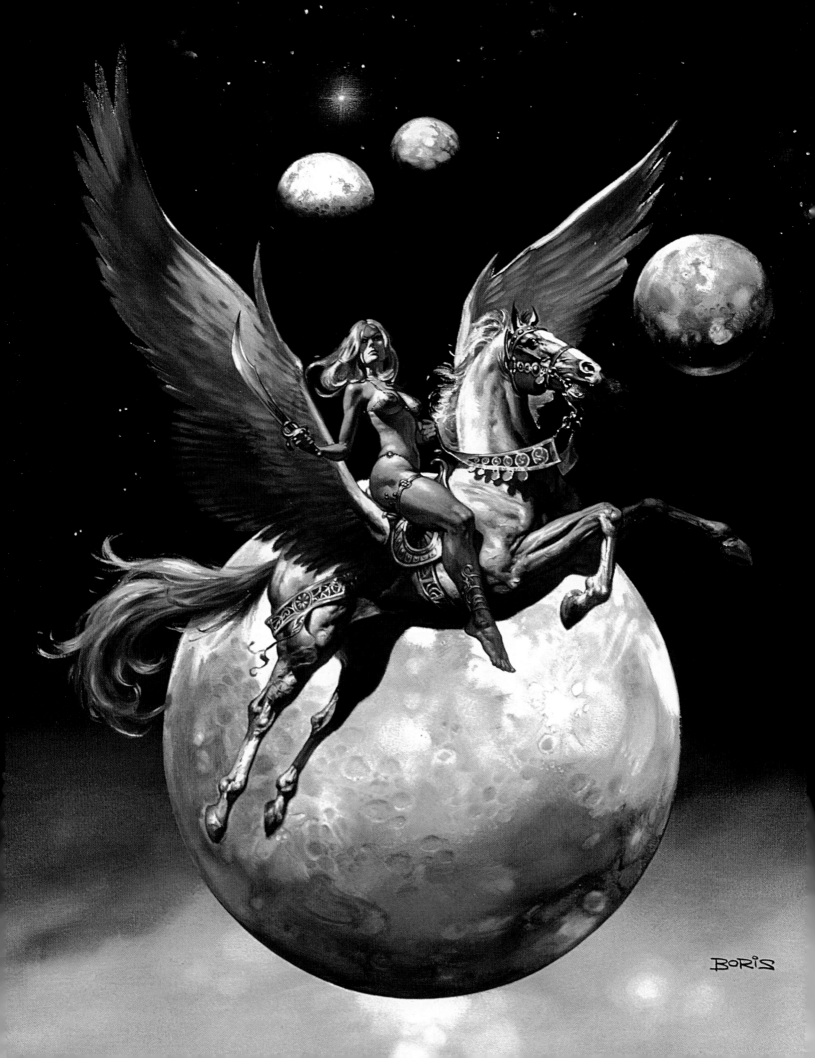

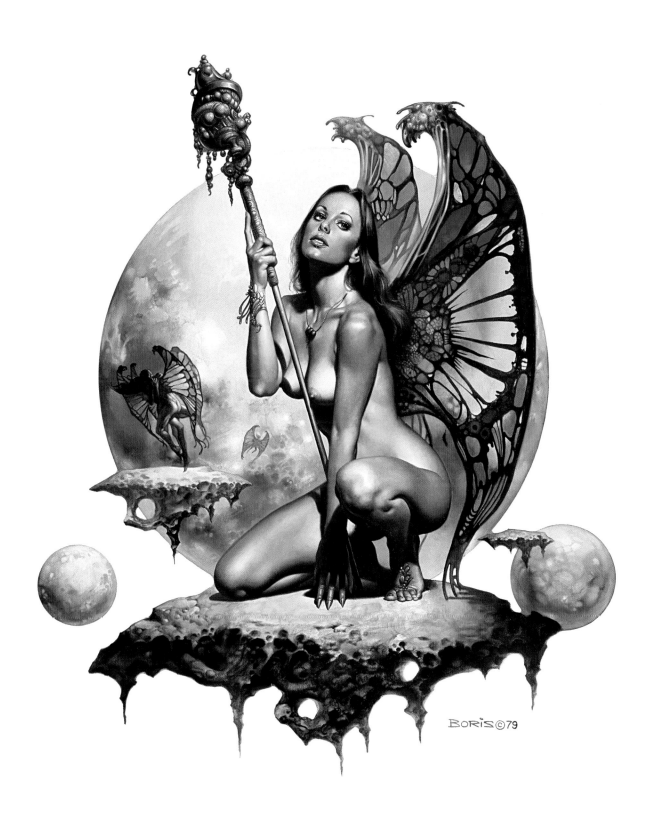

'GOLDEN WINGS' 1976 BORIS 'BUTTERFLY WINGS' 1979 BORIS

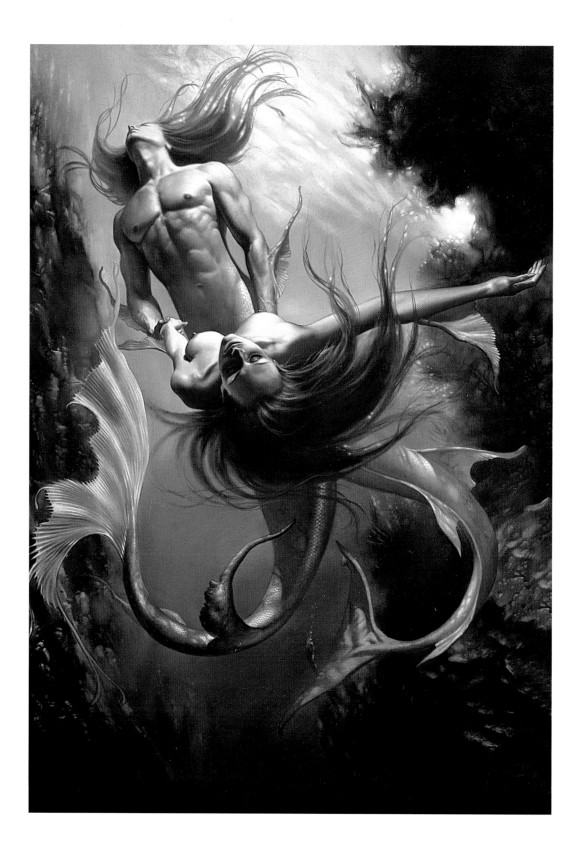

'MERMAID AND TRITON' 1981 BORIS

'THE SORCERESS' FLOWER' 1992 JULIE

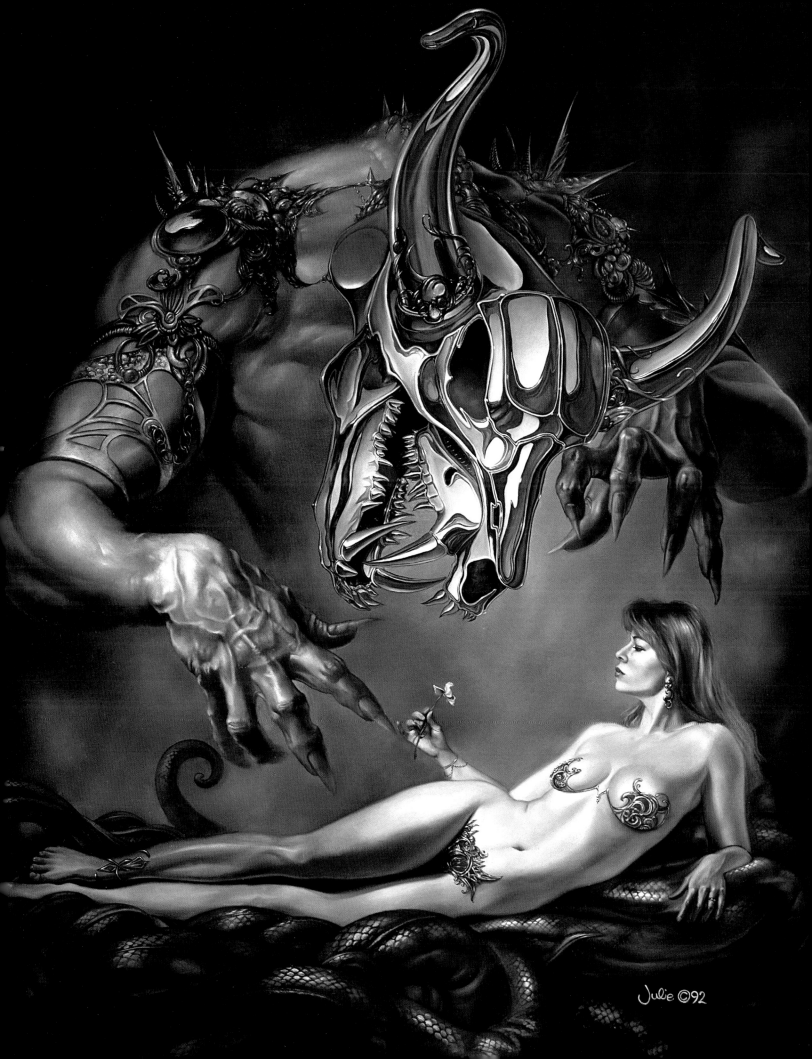

Julie ©92

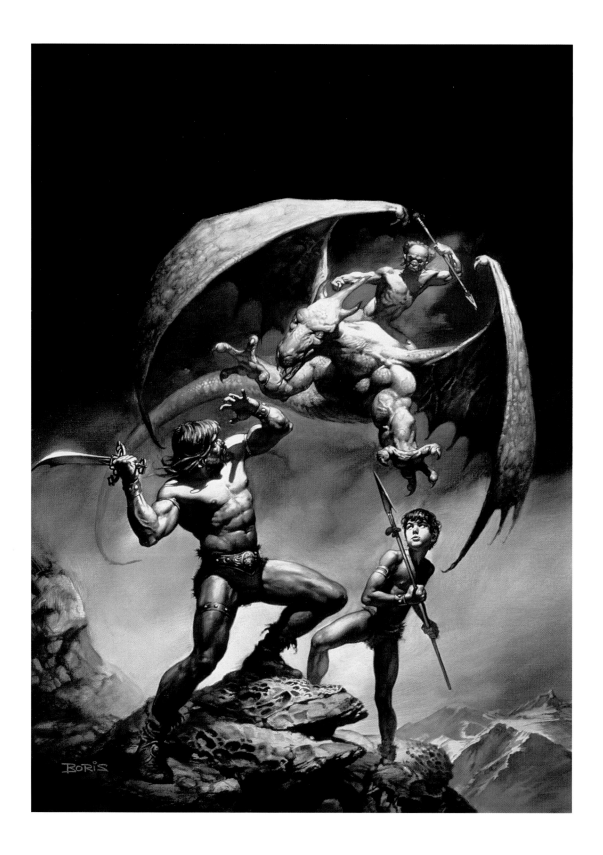

'THE AQUILONIAN' 1977 BORIS

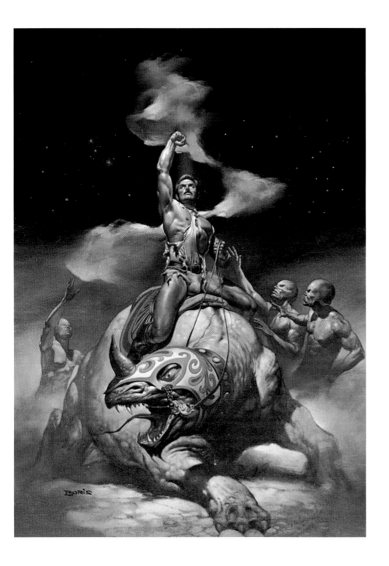

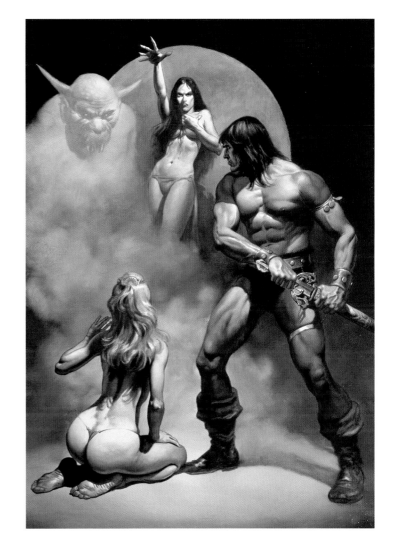

'FIST OF POWER' 1976 BORIS

'SORCERESS' SPELL' 1975 BORIS

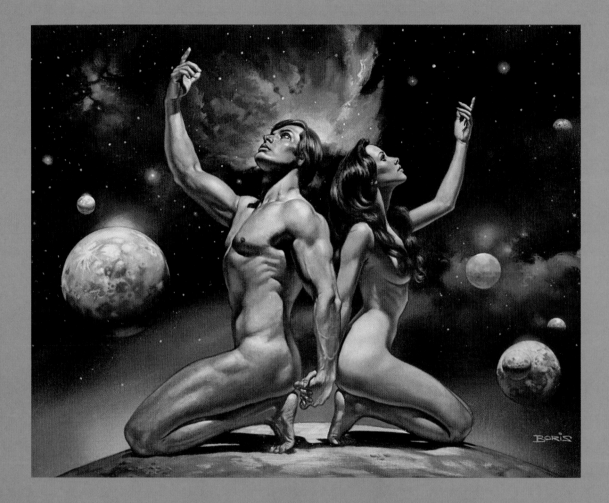

"It seemed to be a total, new look he [Boris] had with stunningly rendered barbarian men and scantily clad Amazonian women. A sensuous oil painting style, if ever there was. His wispy and ethereal backgrounds were a delight, giving an inkling of places one might want to simply walk into the painting and explore."

Bob Eggleton *www.bobeggleton.com*

'REACHING FOR THE STARS' 1976 BORIS 'AT THE EDGE OF THE WORLD' 1979 BORIS

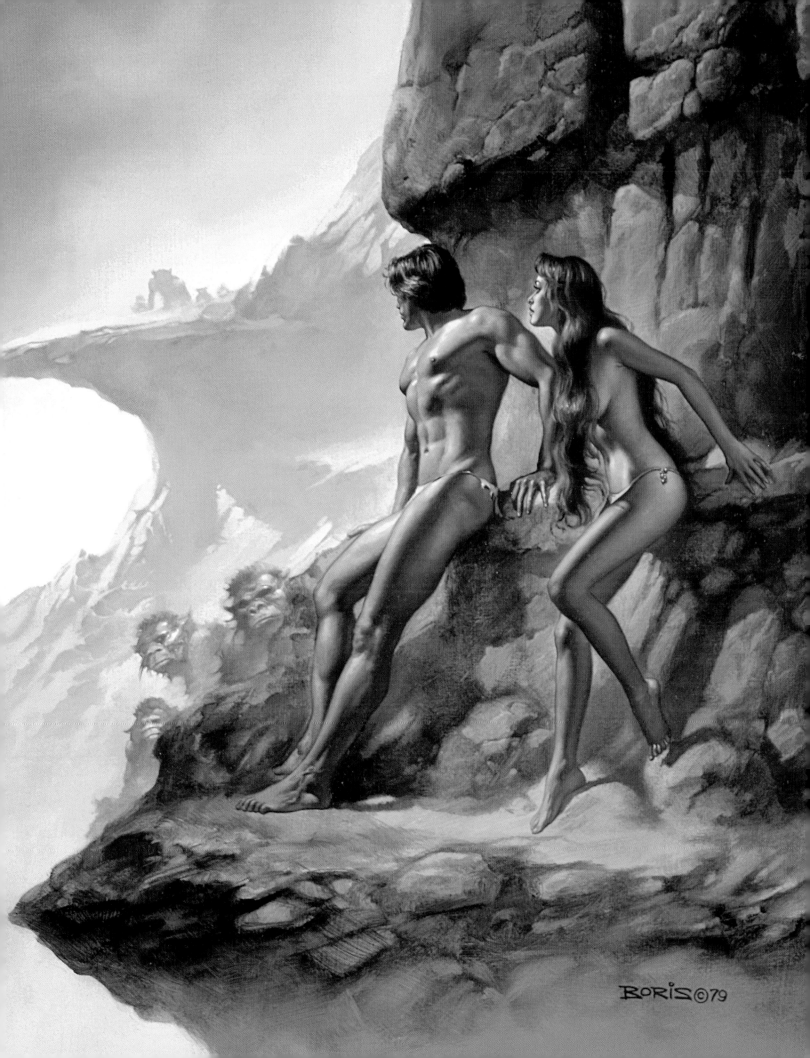

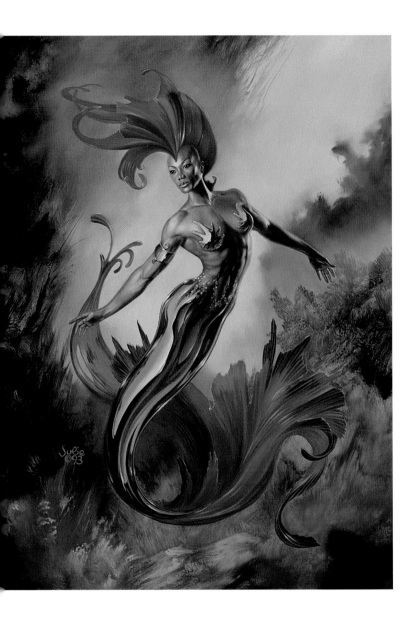

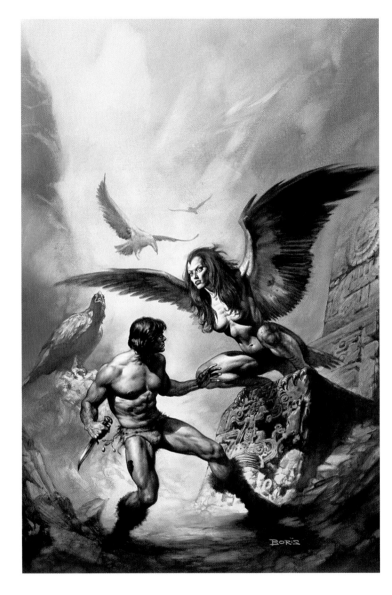

'GOLDFISH' 1993 JULIE

'THE MAKER OF THE UNIVERSE' 1977 BORIS 'THE ICE SCHOONER' 1978 BORIS

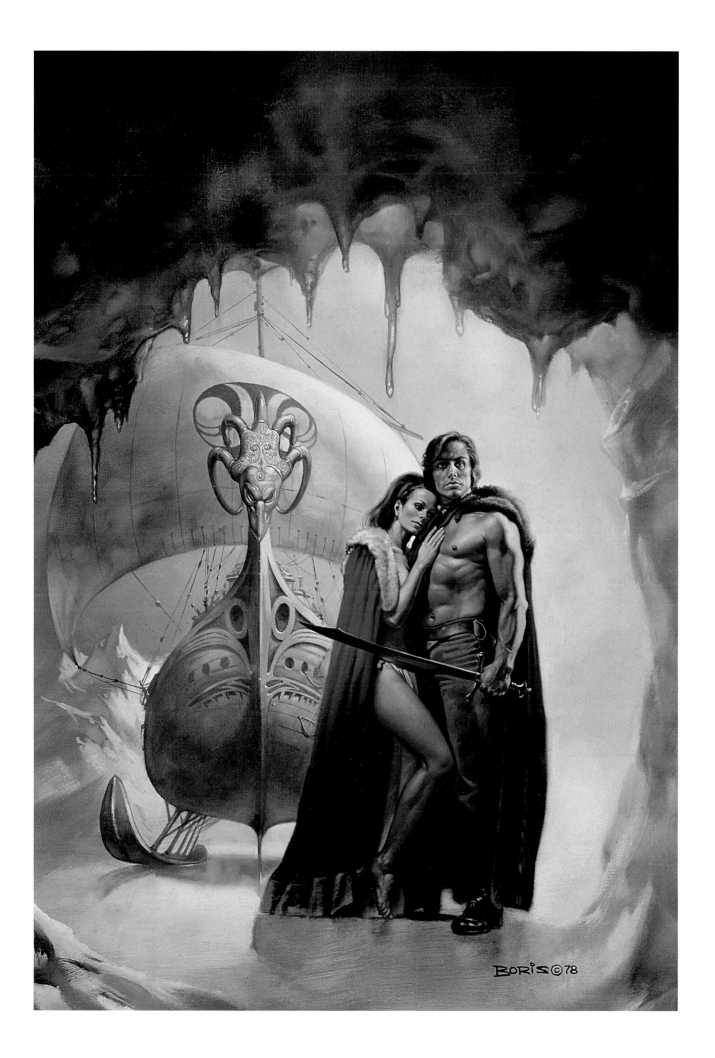

BORIS ©78

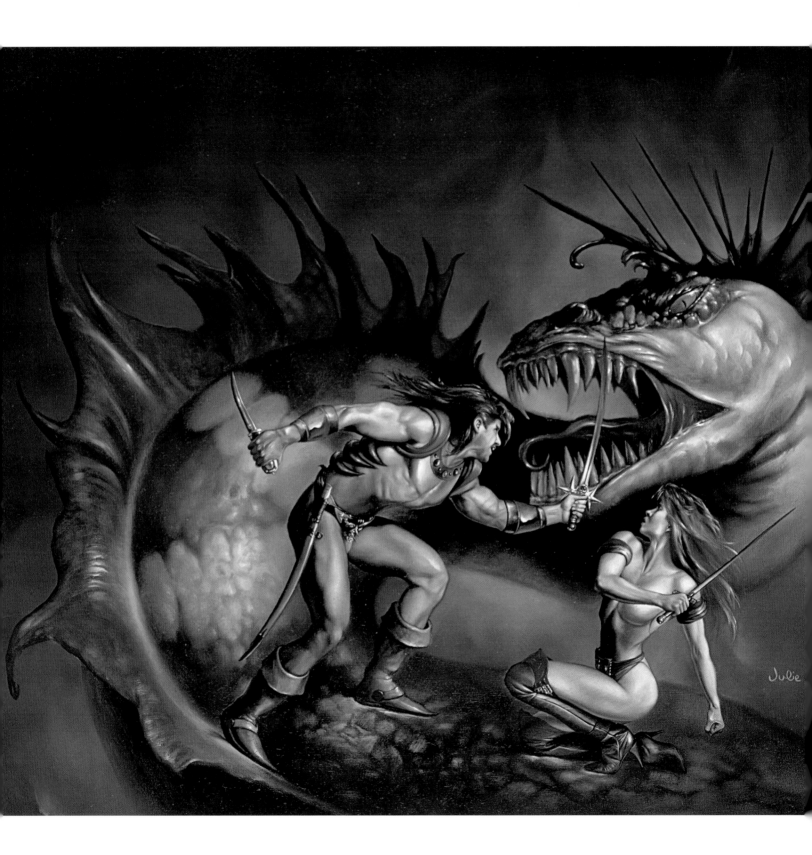

'SABRE-TOOTHED SNAKE' 1992 JULIE

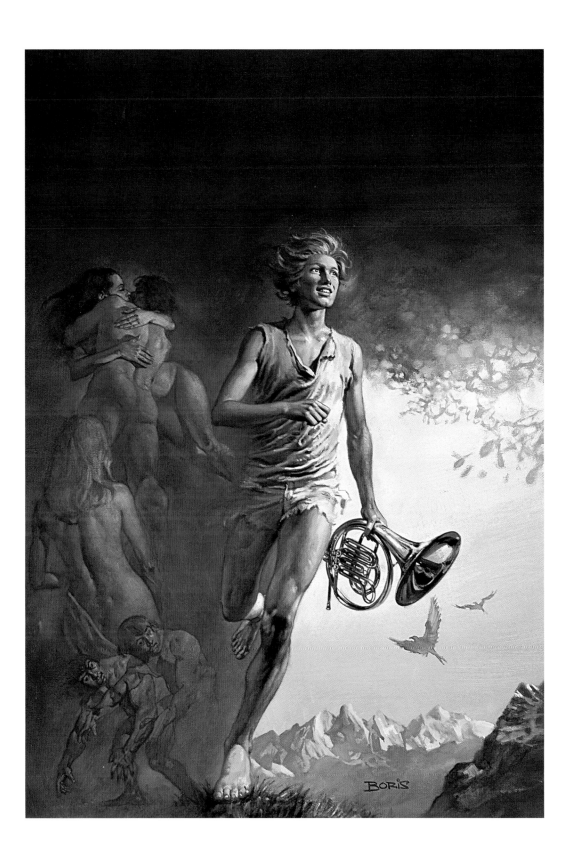

'DAVY' 1976 BORIS

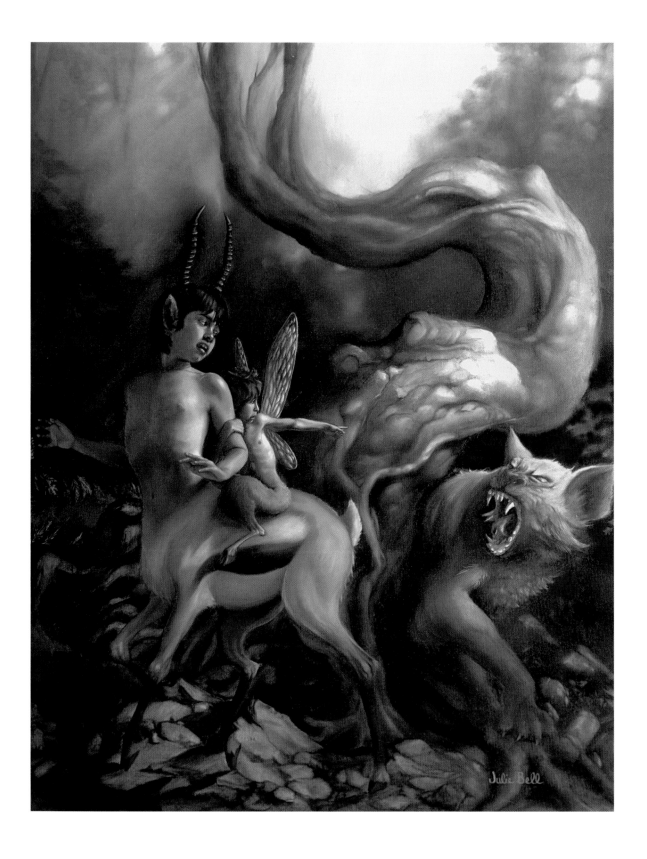

'WOODLAND CREATURES' 1990 JULIE 'SUZANNE' 1990 JULIE

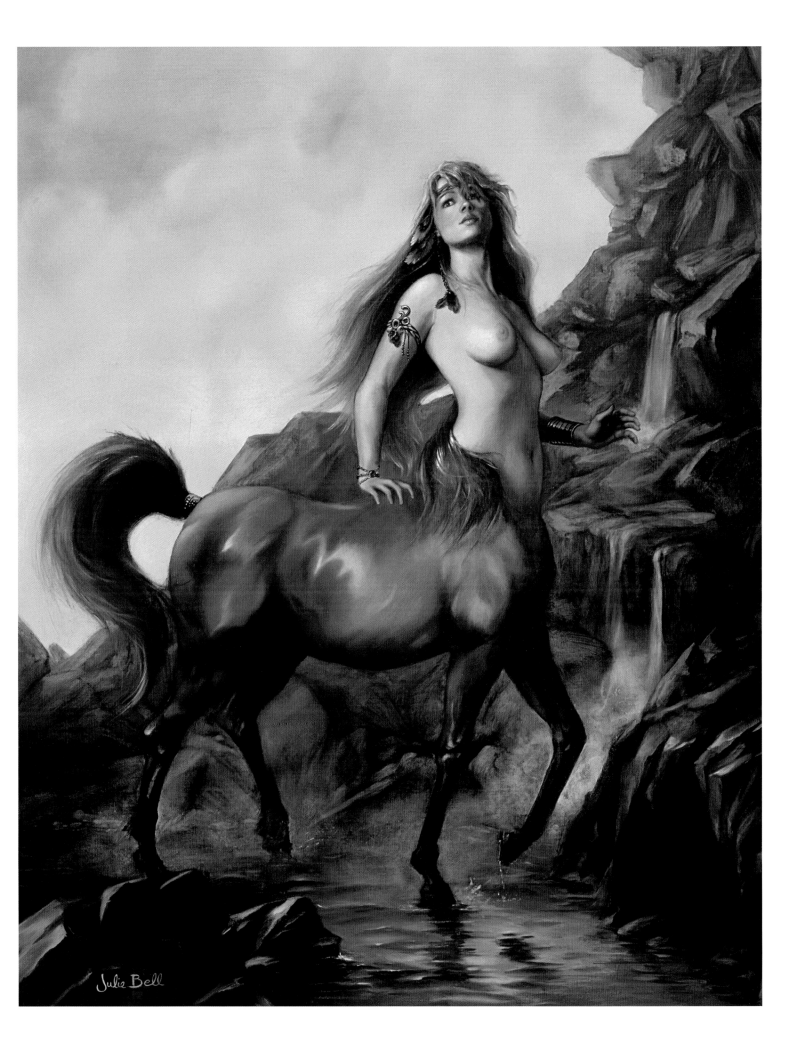

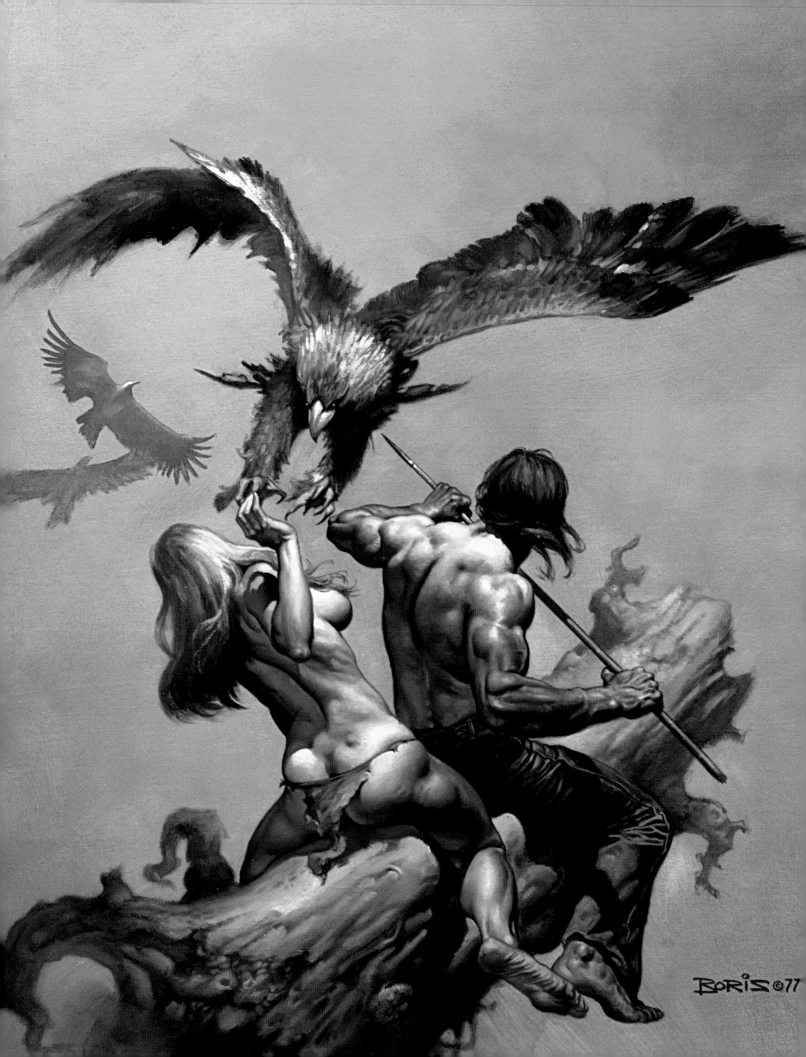

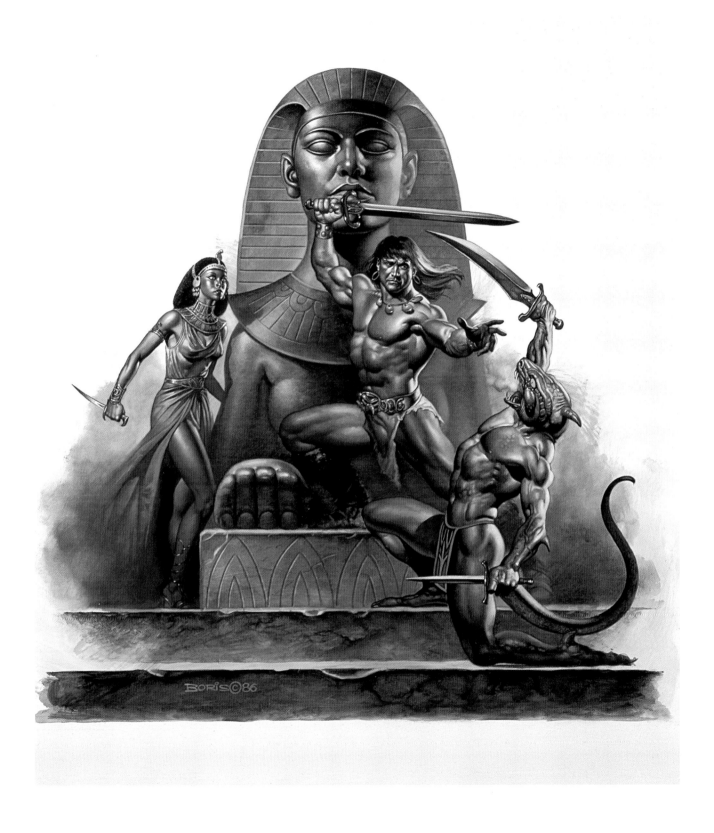

'The Lavalite World' 1977 Boris

'Sphinx' 1986 Boris

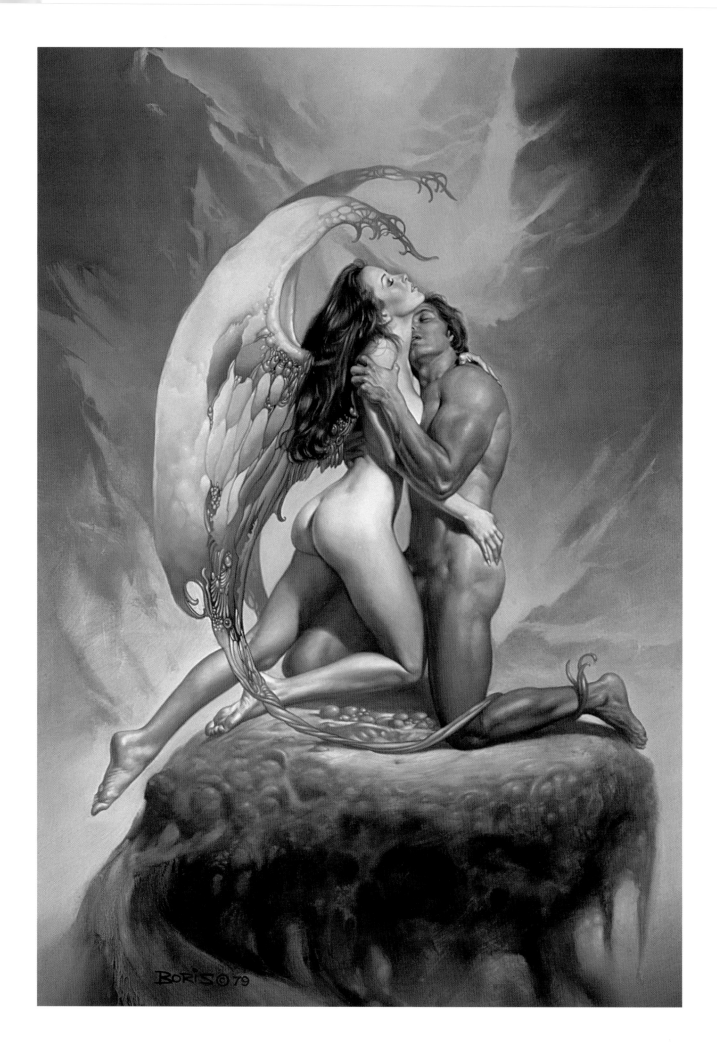

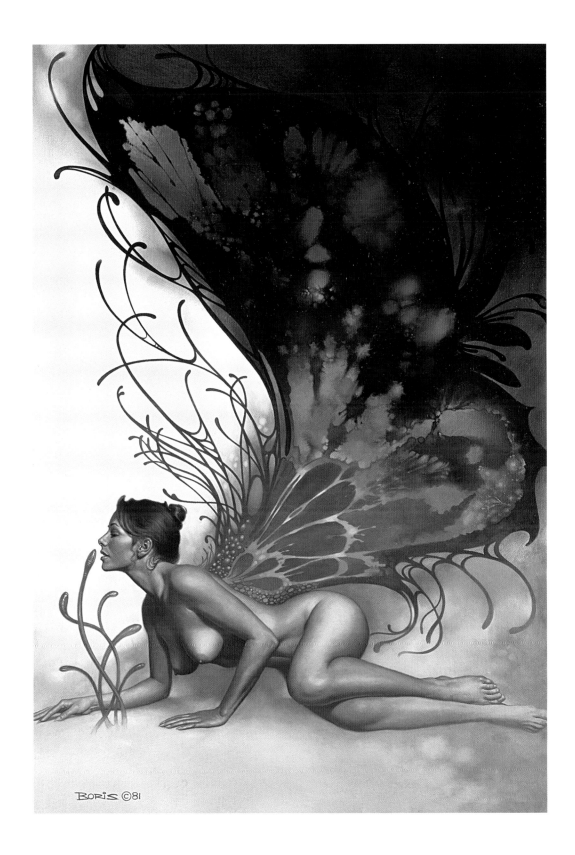

'SPRING GARDEN' 1981 BORIS

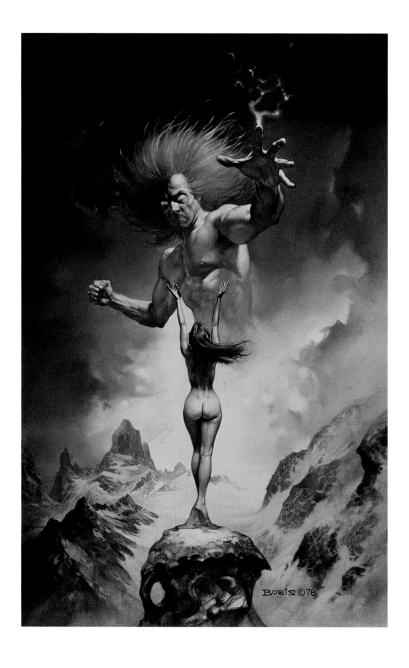

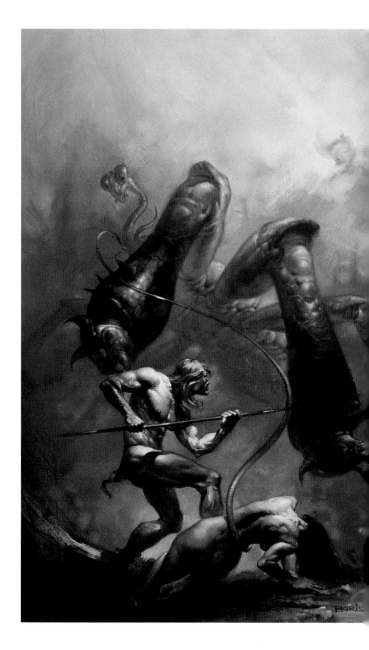

'THUNDERGOD' 1978 BORIS

'OF MEN AND MONSTERS' 1976

'KAT'S PET' 1990 JULIE

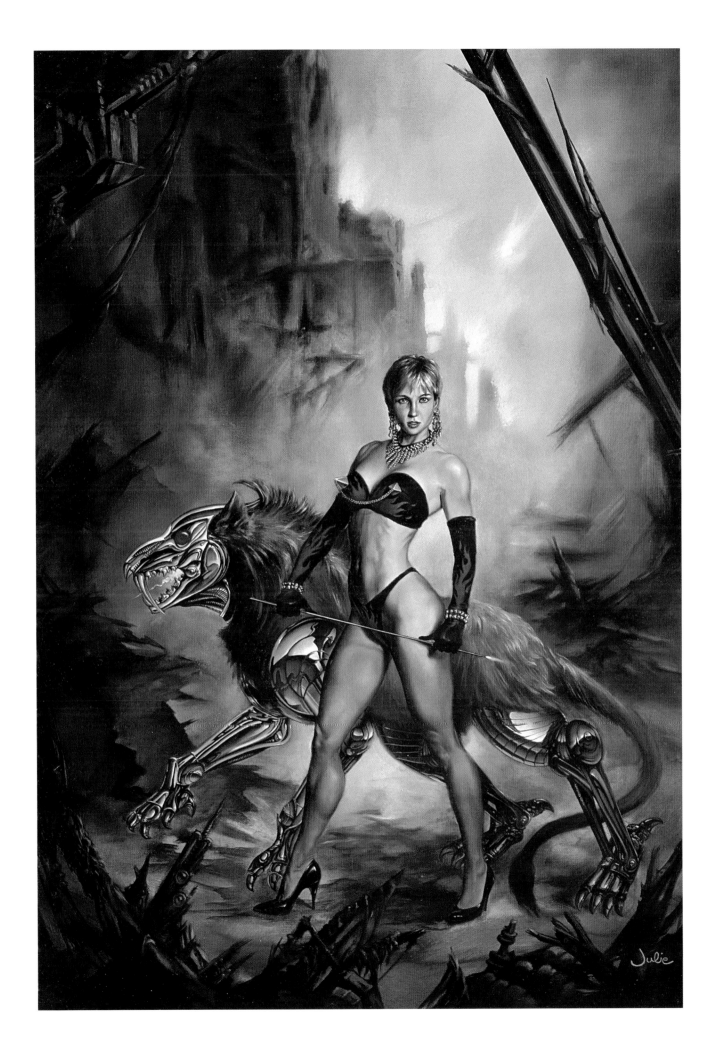

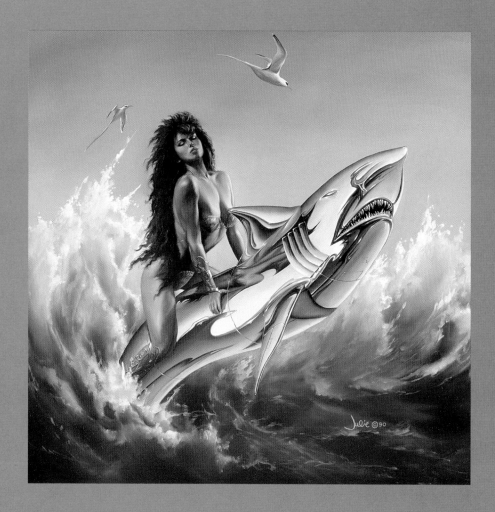

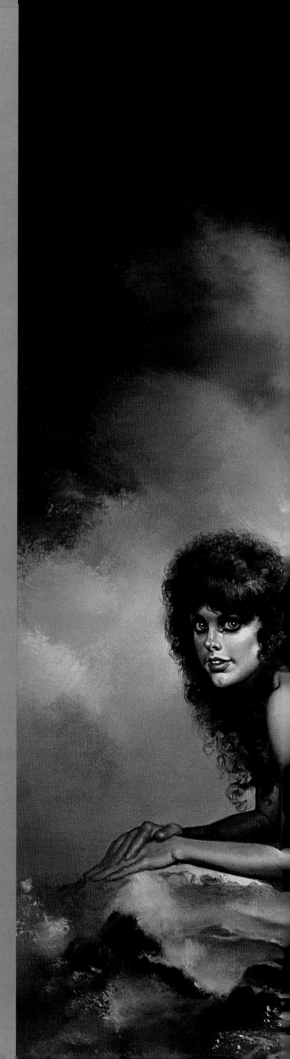

"Boris and I agree in so many aspects, we like
so many of the same things, so why should our
art not be similar as well?"

Julie Bell

'BEAUTY AND THE STEEL BEAST' 1990 JULIE 'THE SIRENS' 1988 BORIS

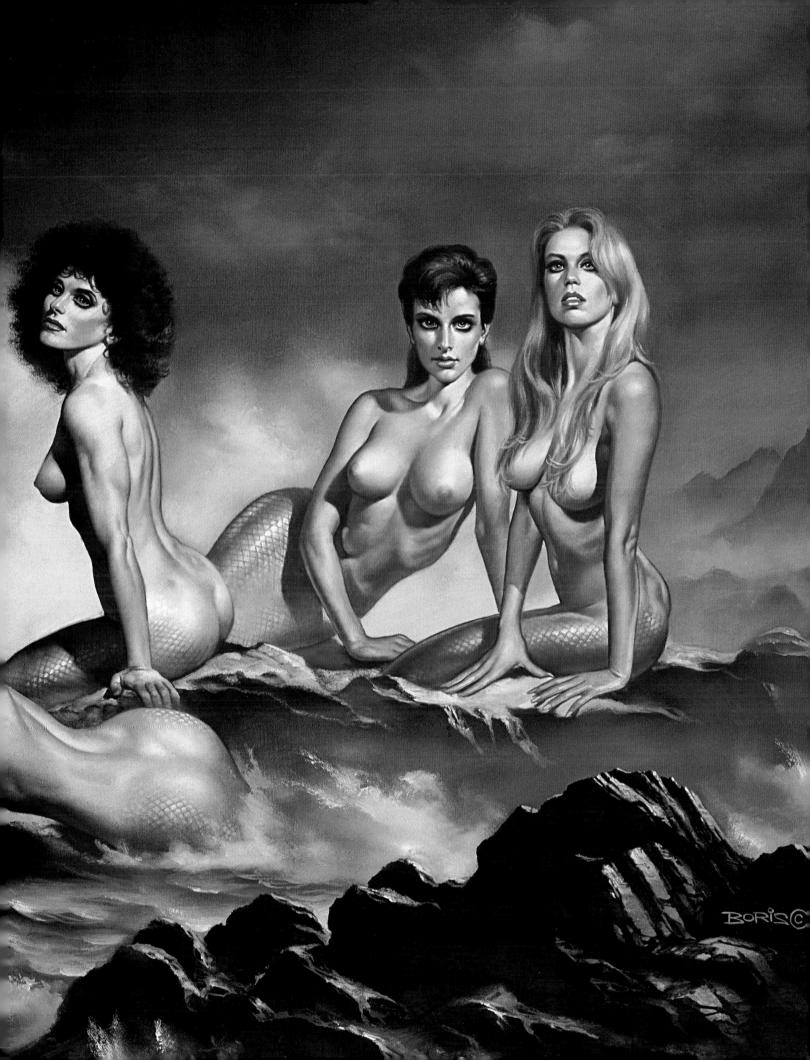

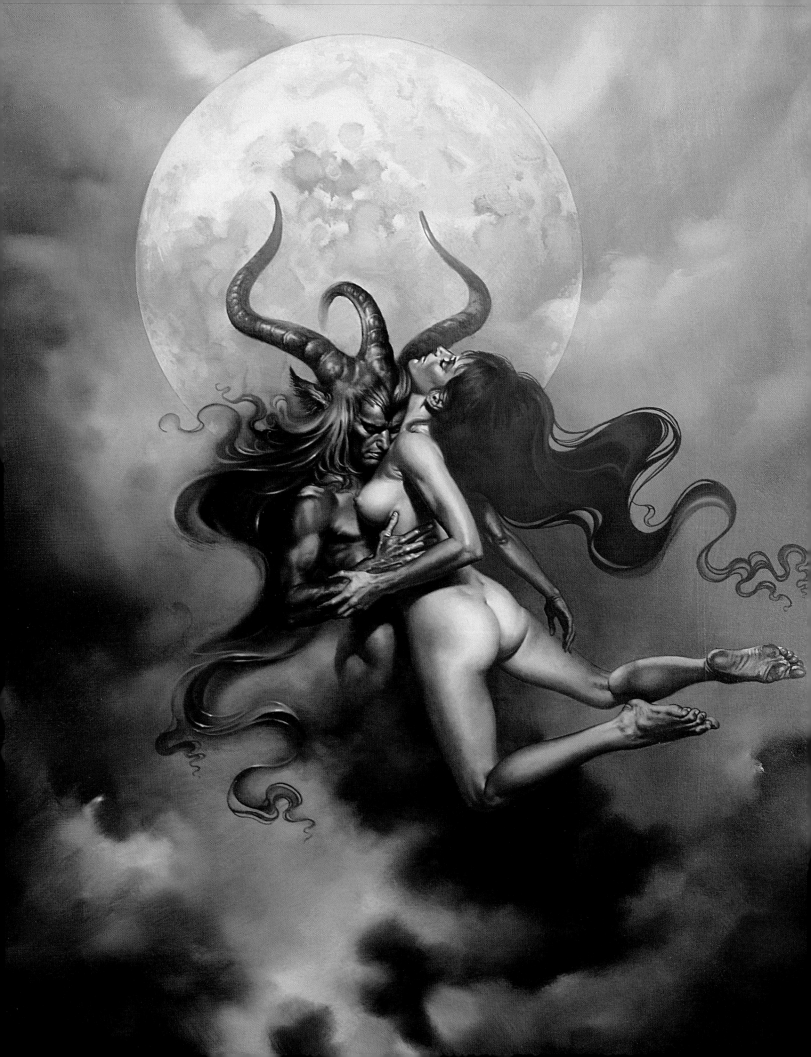

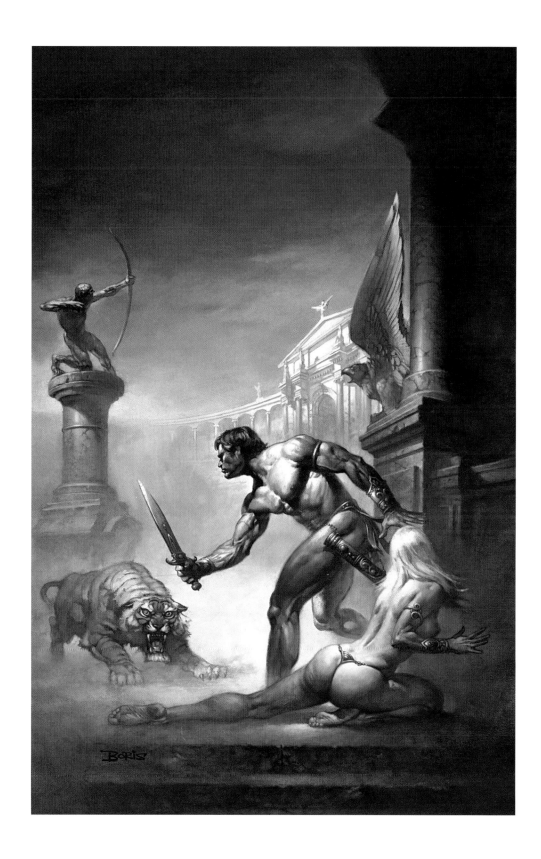

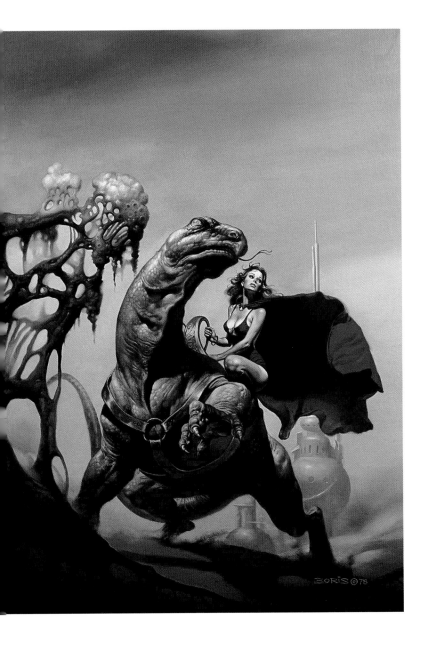

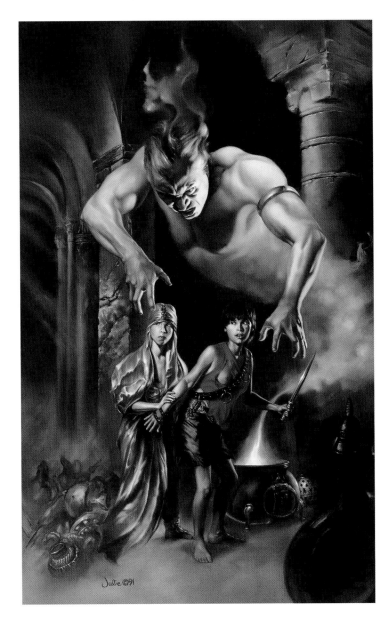

'SPACE GUARDIAN' 1978 BORIS 'RESCUE' 1991 JULIE 'LA OF OPAR' 1977 BORIS

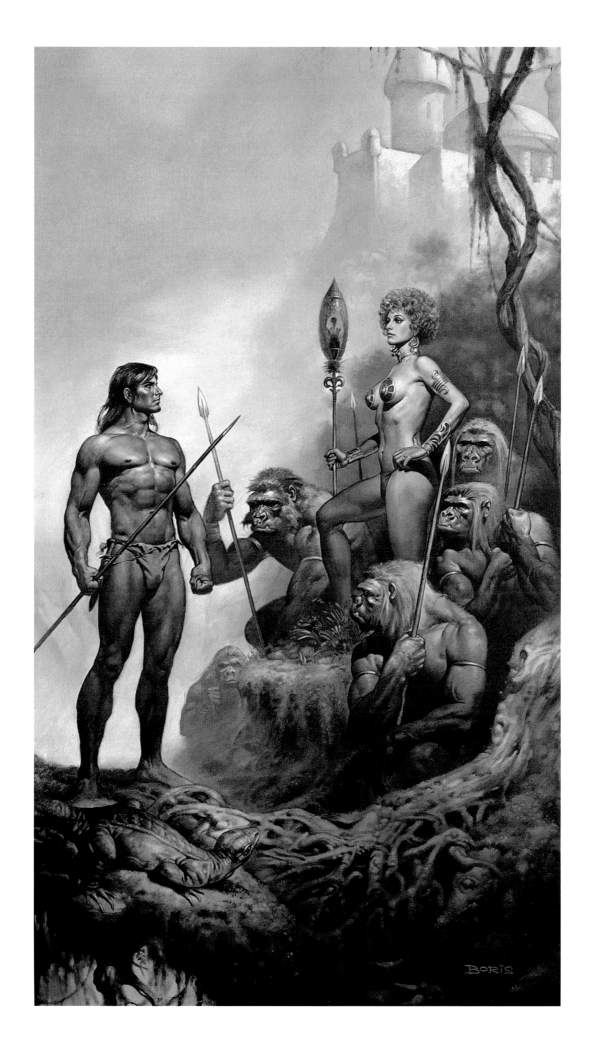

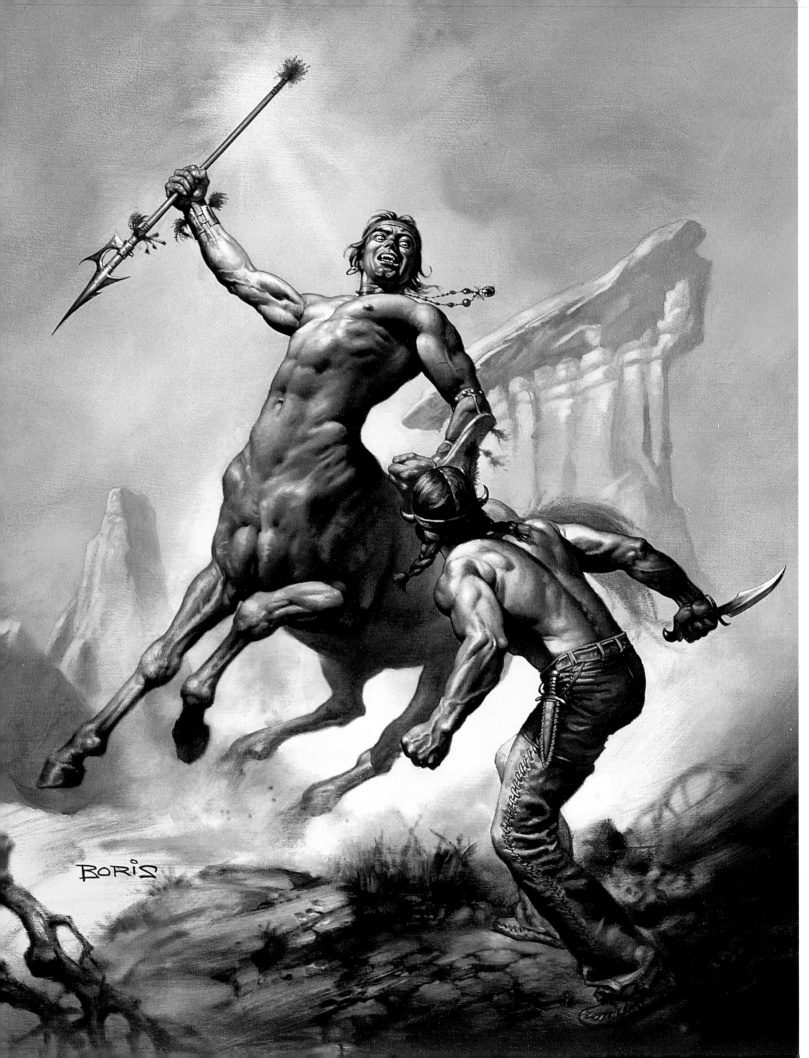

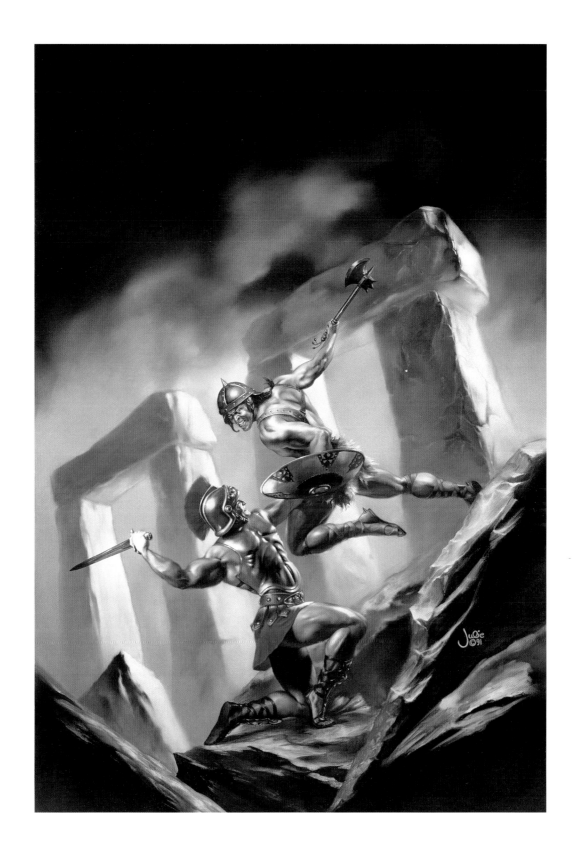

'A Private Cosmos' 1975 Boris

'Battle at Stonehenge' 1991 Julie

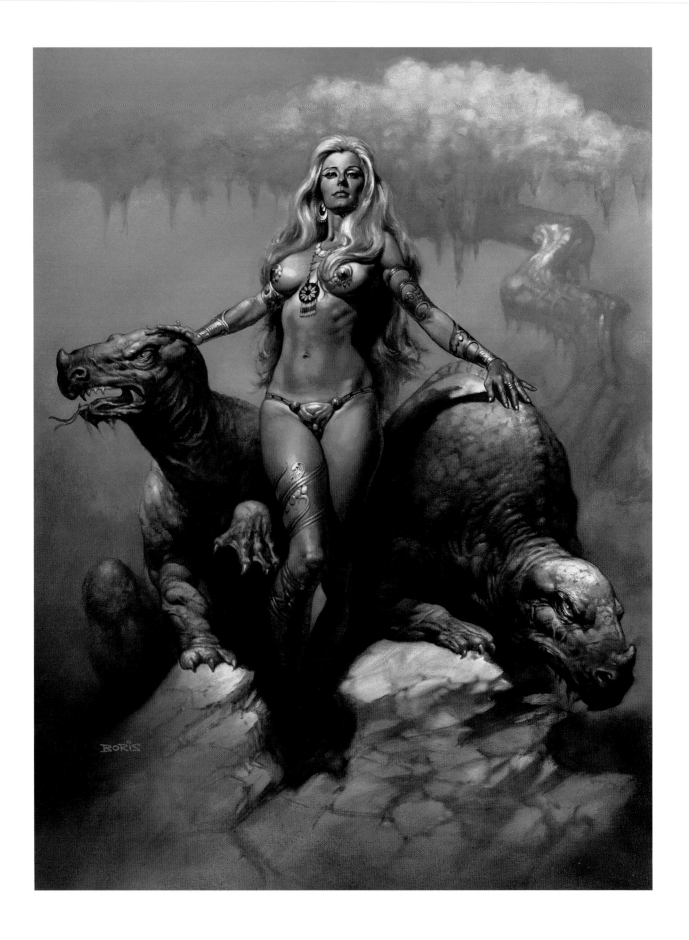

'PRIMAEVAL PRINCESS' 1976 BORIS 'LEATHER JACKET' 1980 BORIS

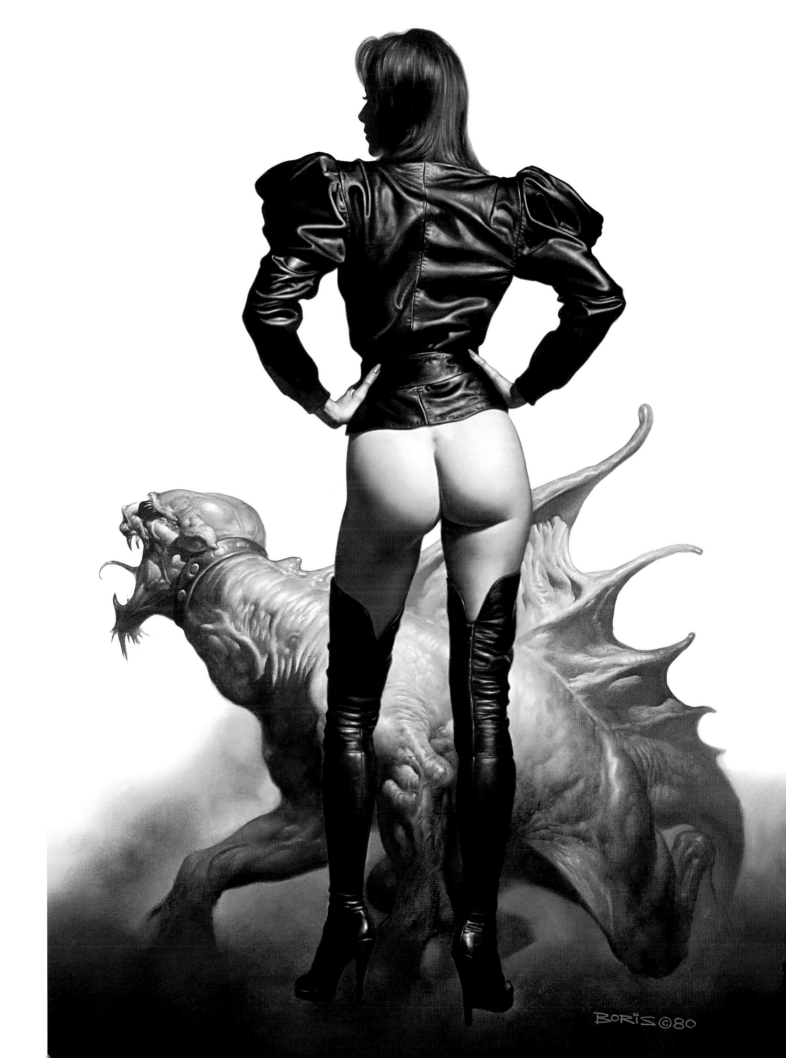

BORIS ©80

MIDDLE PERIOD

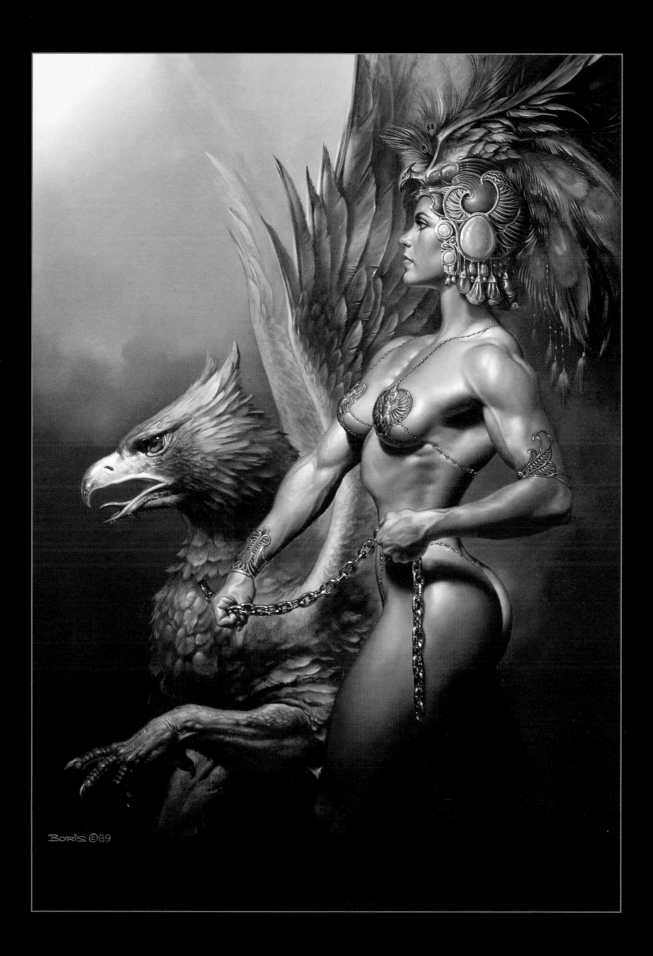

BORIS ©89

MIDDLE PERIOD

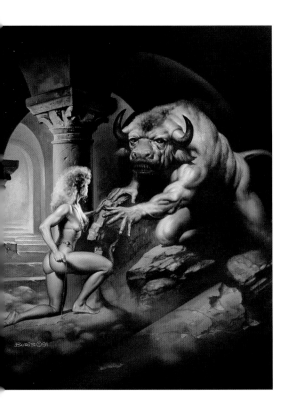

'The Minotaur' 1991 Boris

Previous Page: 'Gryphon Keeper' 1989 Boris

Julie's paintings for this period mostly appeared in her second book, *Soft as Steel*, which included a chapter of her non-fantasy paintings – straight landscapes, still lives and portraits. For both artists the skill of drawing or painting from life, completely naturalistically, is a foundation of their work. However exaggerated the effects called for in their more famous fantasy pictures, they are based on a firm grasp of realistic painting that they continue to practise regularly to this day.

Boris, however, only rarely paints landscapes from life, being uncomfortable about working outdoors. He can manage at exhibitions when asked to paint under the eye of an audience, so it's not the distractions that bother him. It's something he can't quite put his finger on, but whatever the reason, it means that when landscape references are called for he usually uses photographs.

Although she came much later to professional painting than Boris, Julie soon learned to work at the same speed and skill; but although they usually paint side by side, it was a while before they tried actually working on a picture together. The only examples in this collection are 'Pyramids' on page 145 and 'Monica' right at the end of the book, but in future we are likely to see many more collaborations because they are finding that for them it seems an ideal way to work, for reasons they will explain themselves later.

For now though, what general attitudes did they find helpful in getting through their respective 'Middle Periods'?

Julie: Once I started getting recognition and felt I was establishing myself as an artist, one challenge was keeping motivated to the same degree – keeping that early insecurity going. I remember one Art Director warning

me: 'You always have to take care of your roots.' Meaning that whatever direction you stray in because of the work that comes along, you have to keep fresh the interests that brought you into art in the first place.

Boris: For me, going back to my roots in the middle period meant maintaining solid drawing skills – going back to doing life drawing. To me this is really important. You can have a great sense of composition and colour, but without drawing skills they don't really mean much. This becomes clearer as you go on with a career. The basic thing is that technique must be second nature. If not, the picture is in control, not you. You need the skills to meet the challenges that a picture will produce.

Julie: It was the same for me too and at one point I was even teaching life drawing for a while. Apart from anything else, it would help with sketches for clients and just working out ideas.

Boris: I cannot emphasize enough – you have to be in control of a painting. True, you have to let it take on a life of its own but then you have to be ready to steer it in the direction you have to go.

Julie: It's like riding a horse and chariot – there is an energy with a mind of its own but you have to be able to direct it. It's a kind of controlled randomness.

Boris: You have to be able to take advantage of whatever happens.

Julie: It's kind of like learning how to pick out and keep the things you want out of randomness . . .

Boris: . . . in order to avoid the fear. At one time I used to wake up every morning afraid that I had forgotten how to paint.

Julie: Boris! It still is like that sometimes. You really do believe you've forgotten how to make a picture.

Boris: What you have to do is develop devices to avoid this fear. The main one is just to force yourself through the fear and do it. Often I will just stare at a painting for a couple of hours till I can find a way in. Also I have

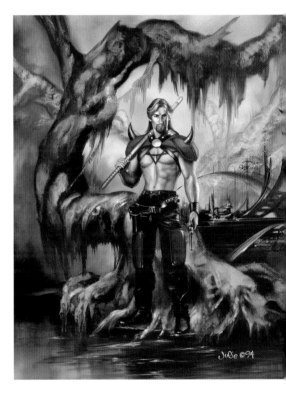

'SWAMPLORD' 1994 JULIE

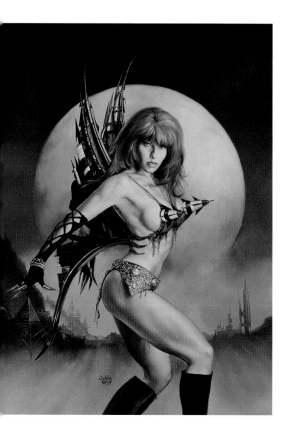

'TORPEDOES ON PLANET PINK' 1997 JULIE

always listened to music as a way of distracting my mind from the painting. And doing this often you will find your hands practically going on their own while your brain concentrates on the music. Often I start with a painting I don't know what to do with and three hours later I find it's done. I use this trick up to this day – apart from the fact I really love music.

In the past I just used to listen to classical music but more recently, thanks to Julie, I've learned to appreciate any type of music really. If it's good, it doesn't matter what category it falls into. But it's taken most of my life to get to this point.

Julie: We take turns to be DJ, and for me working to music is just the same as with Boris – it distracts from the fear.

Boris: To begin with I used to work just by myself, alone in the studio, and had to deal with all the ghosts, demons and fears alone. But at this point – now – I have Julie there who is my greatest inspiration. Julie seems totally fearless when she's working – really fast – I marvel at the things she can do. It's great encouragement if I am struggling, a great inspiration, and as we work side by side, listening to music and chatting, everything just flows.

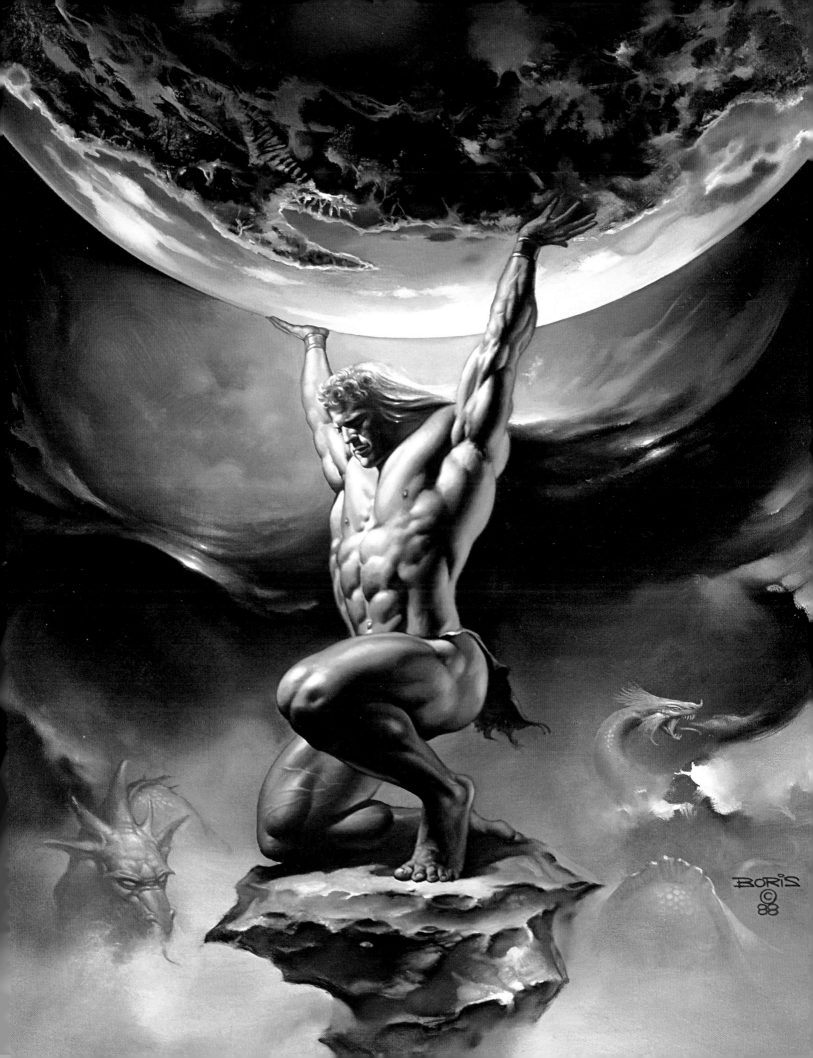

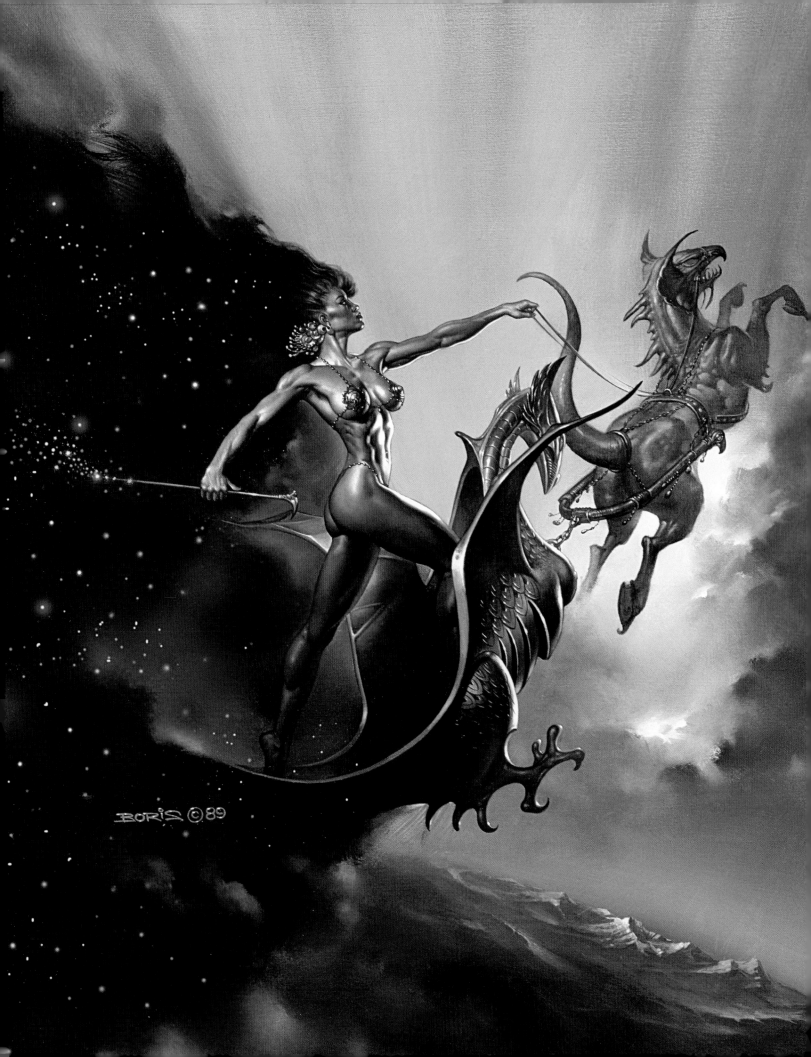

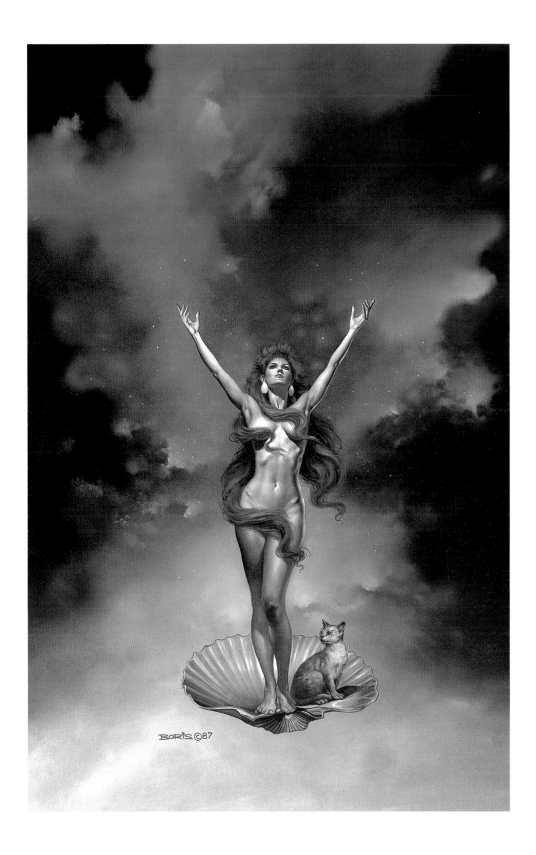

'Night' 1989 Boris

'Venus in the Half Shell' Boris 1987

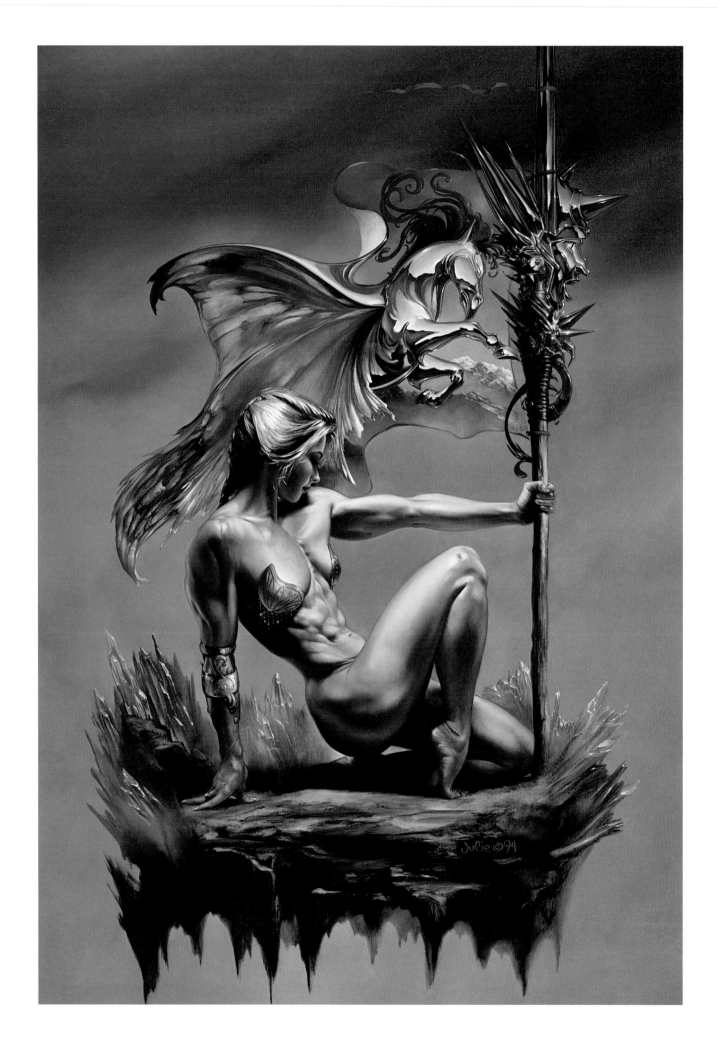

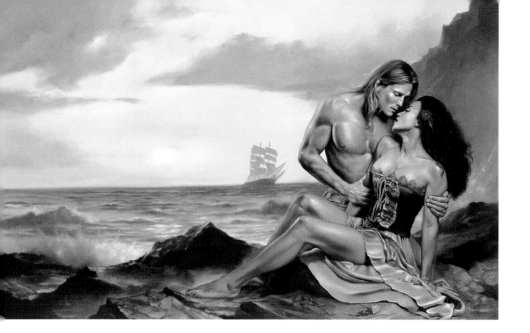

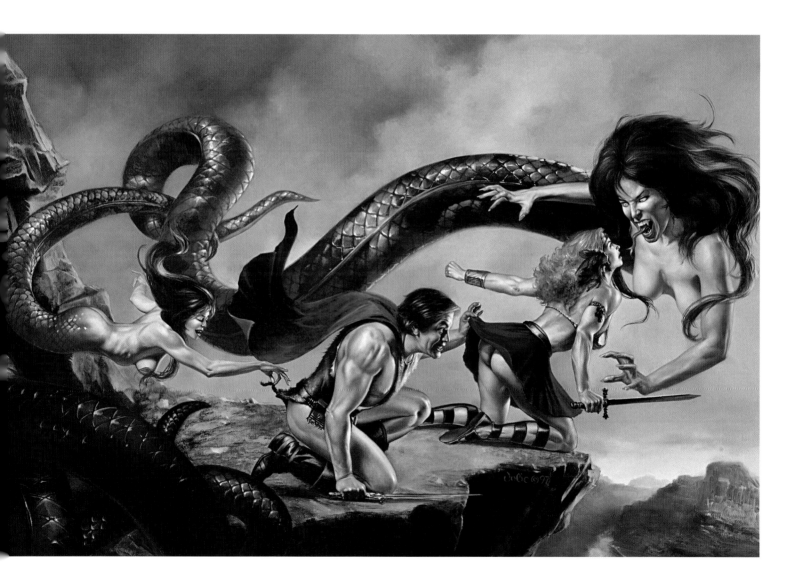

'SOFT AS STEEL' 1994 JULIE　　　　　TOP: 'LOVE ON THE BEACH' 1997 JULIE　　　　　'VALLEY OF THE SNAKE WORM' 1997 JULIE

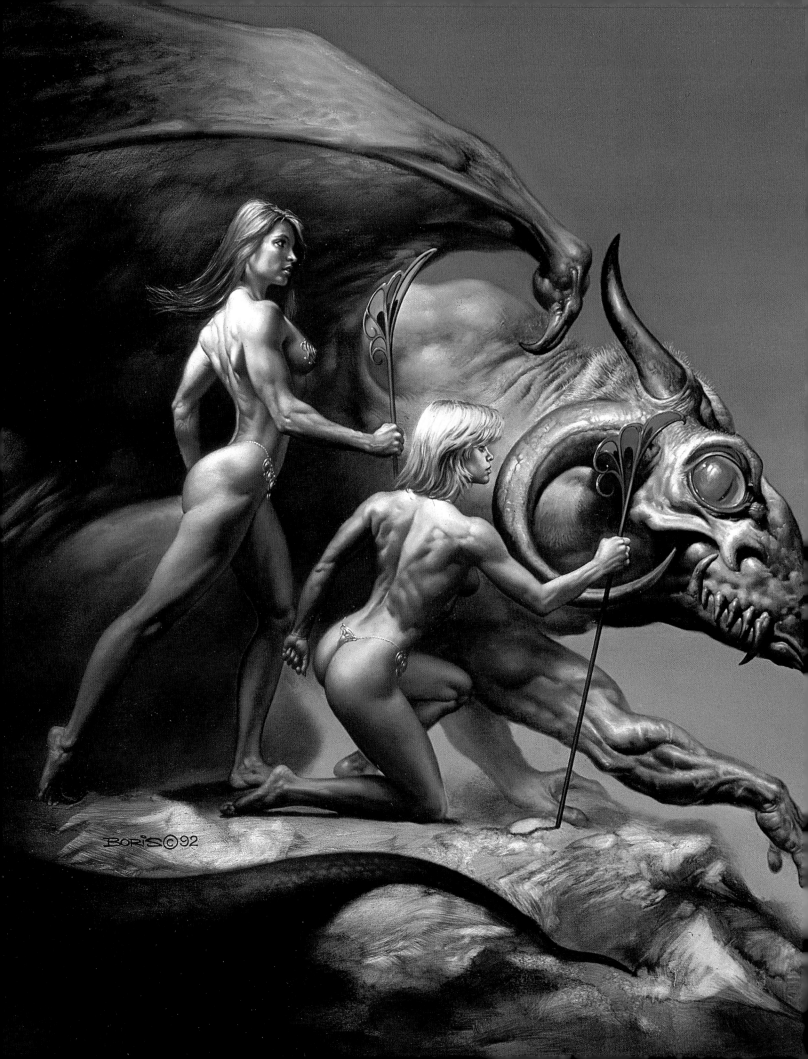

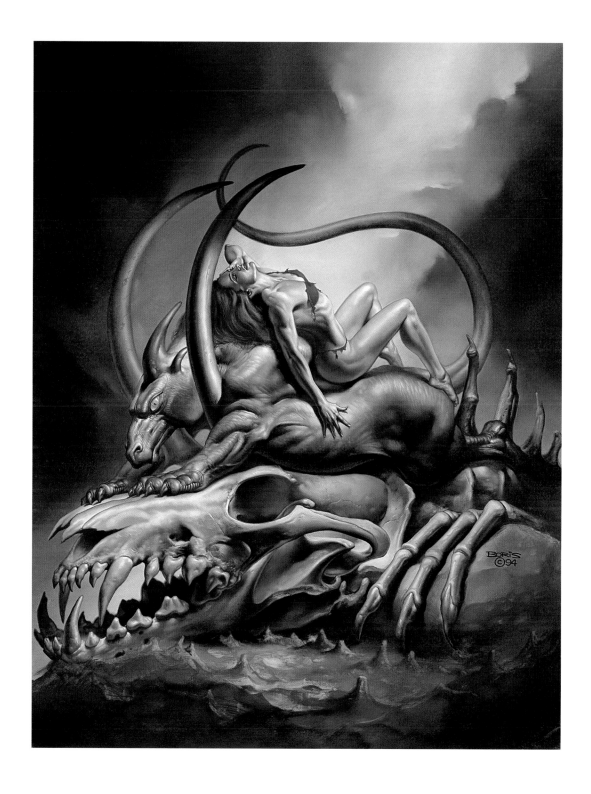

'FRIENDS' 1992 BORIS

'LIGHT OF LIFE' 1994 BORIS

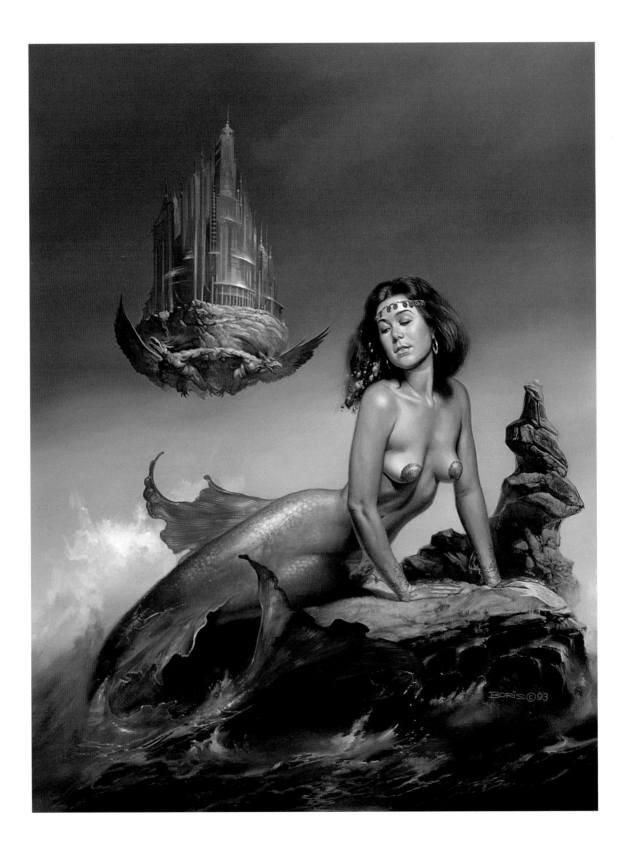

'MERMAID' 1993 BORIS

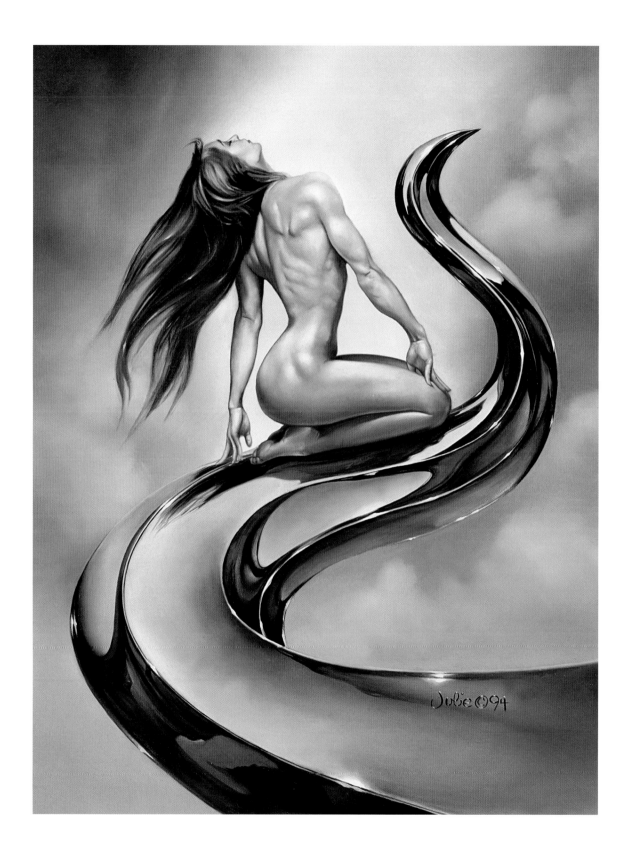

'TEMPEST' 1994 JULIE

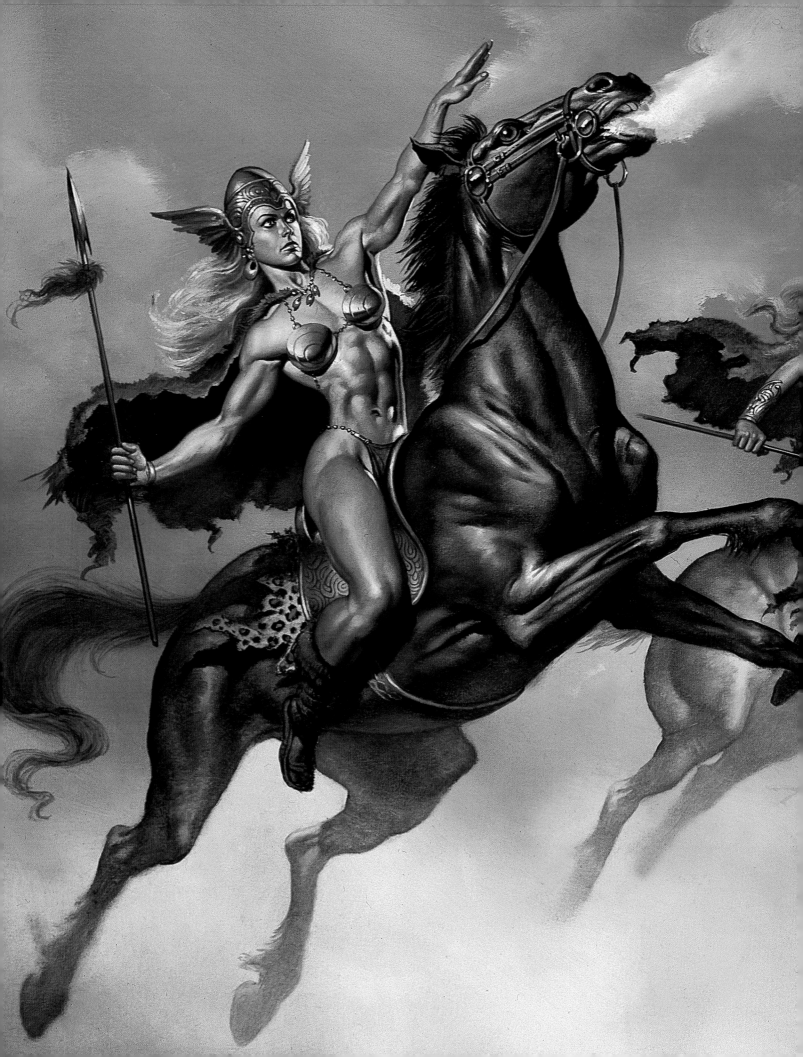

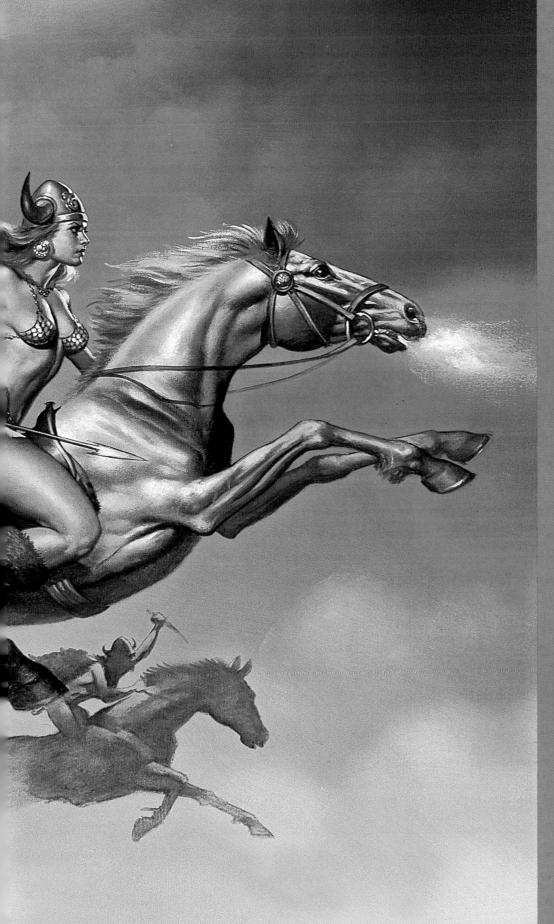

"Boris and Julie create works of art that make what's real look like a fantasy – and turn fantasy into reality. Their genius lies in the ability to be transformative in that way, blurring the divide between what is imagined, and what truly exists. Whether the subjects are creatures or human figures, they bring the unbelievable to life, with unparalleled imagination and technique."

Jane & Howard Frank (Art Collectors)

www.wow-art.com

'THE VALKYRIES' 1987 BORIS

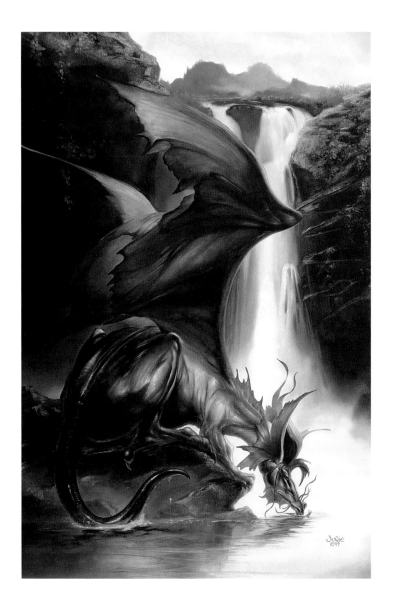

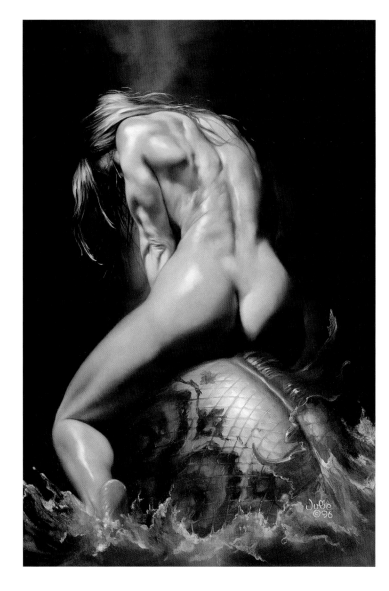

'AFTERNOON DRINK' 1997 JULIE 'WET' 1996 JULIE 'THE BASILISK' 1990 BORIS

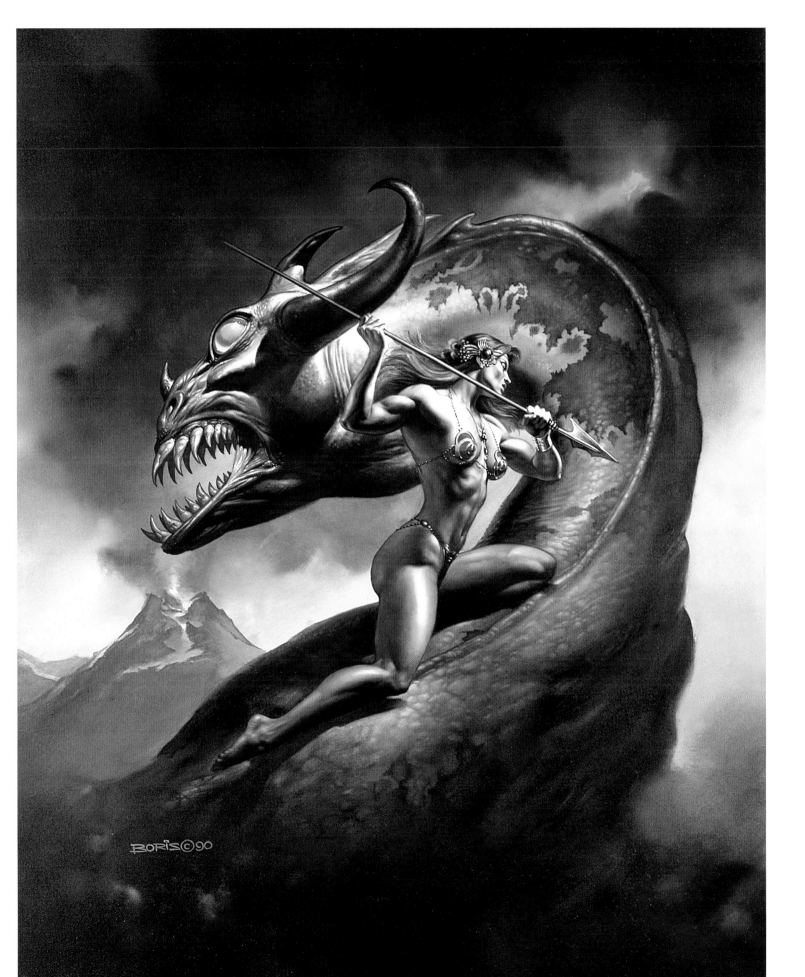

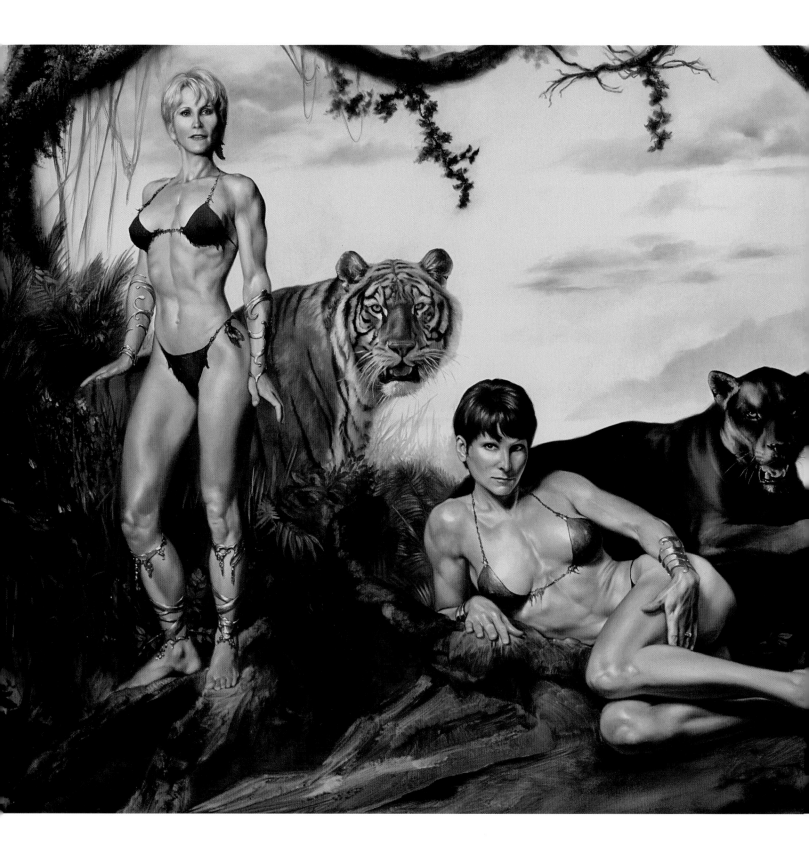

'PARADISE' 1997 JULIE

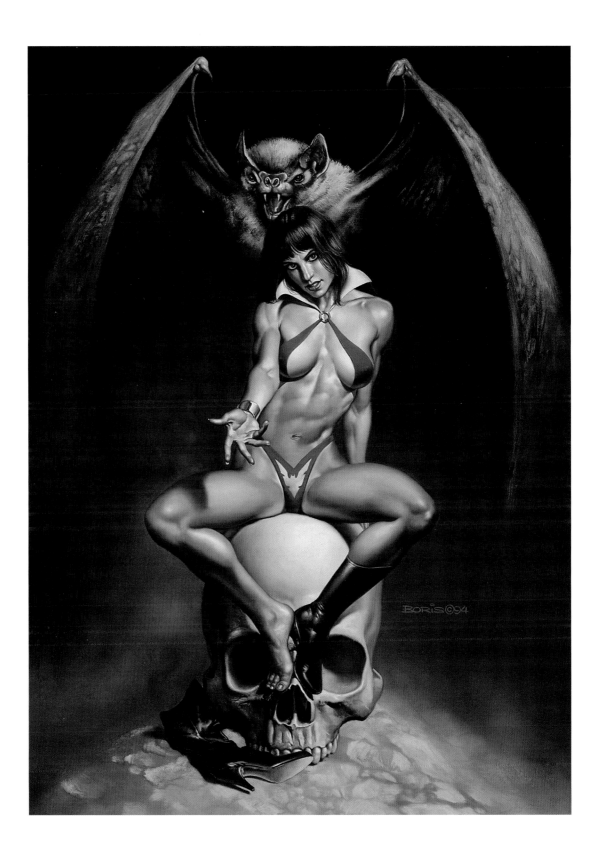

'VAMPY' 1994 BORIS

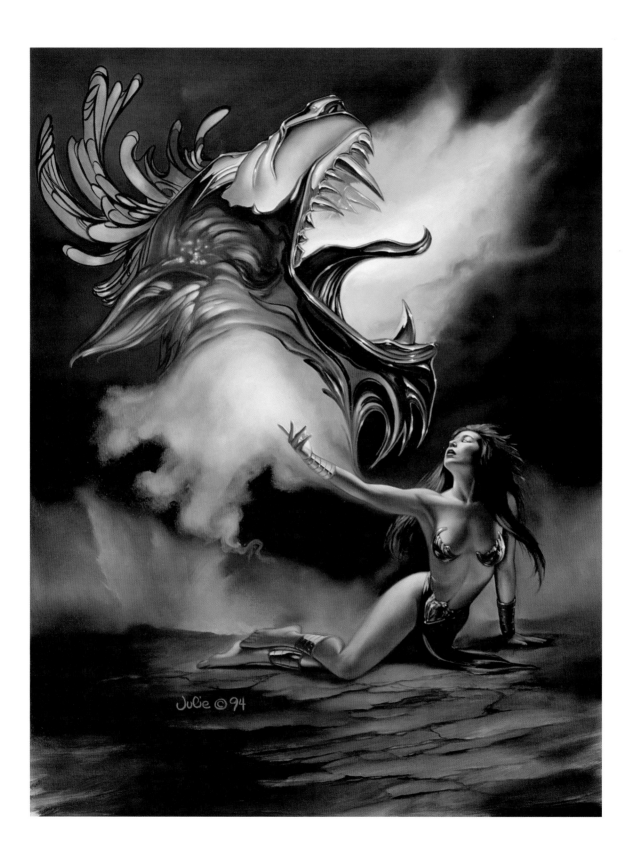

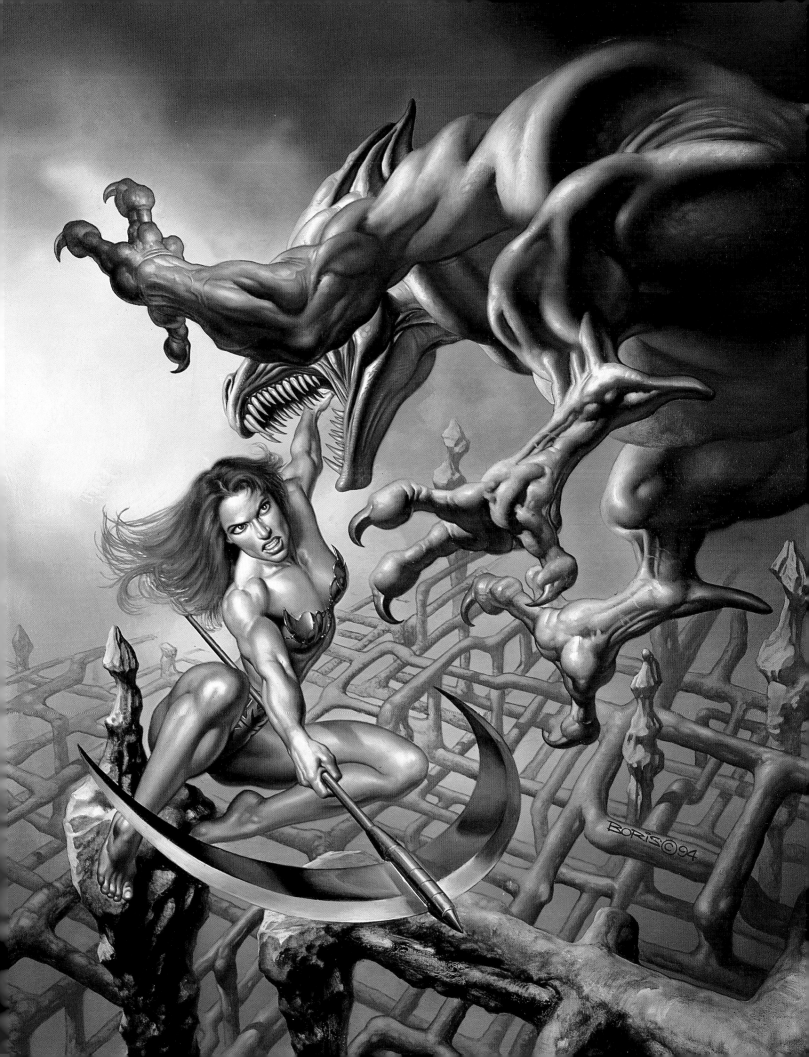

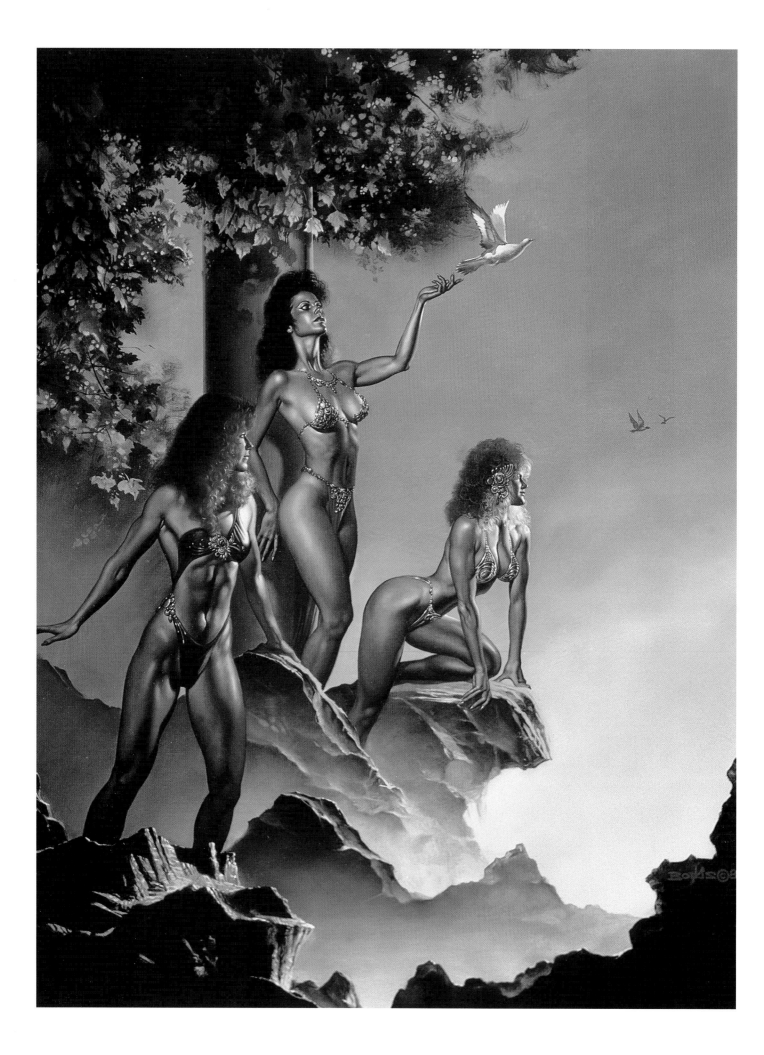

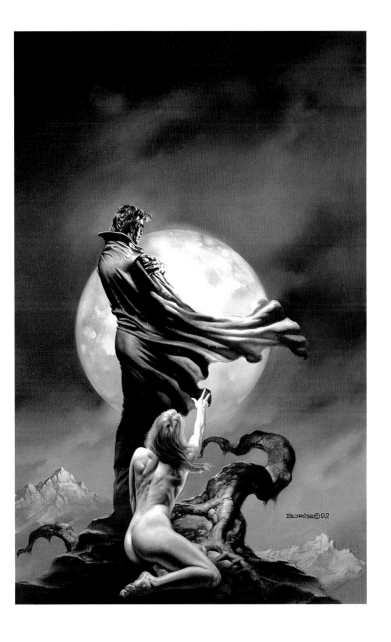

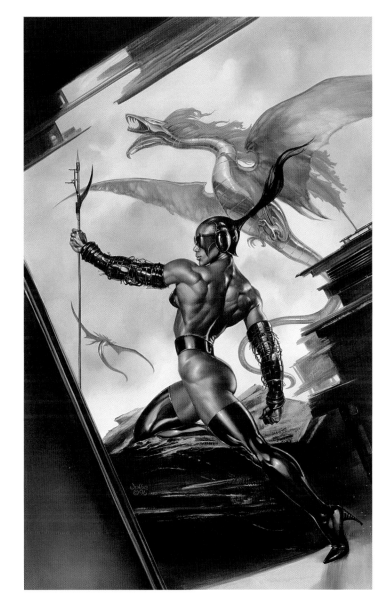

'Horizon' 1989 Boris 'Dracula' 1992 Boris 'The Huntress' 1996 Julie

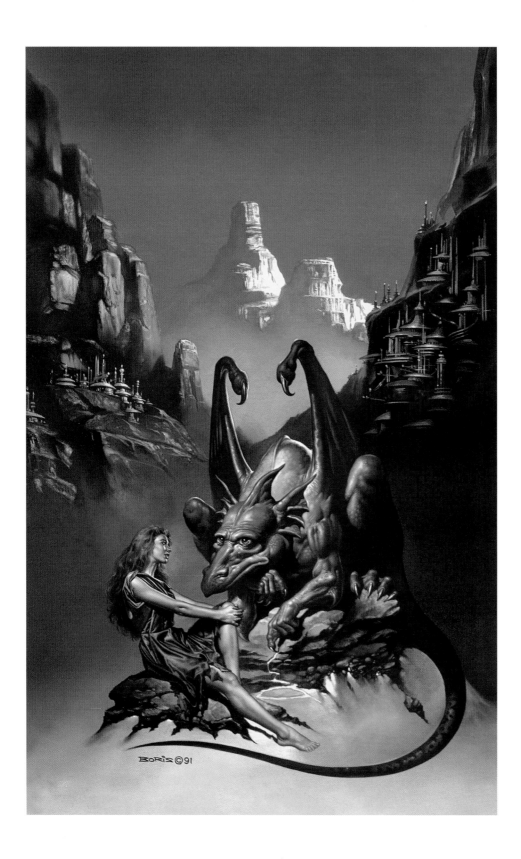

'THE ELVENBAND' 1991 BORIS 'THE SUMMIT' 1994 BORIS

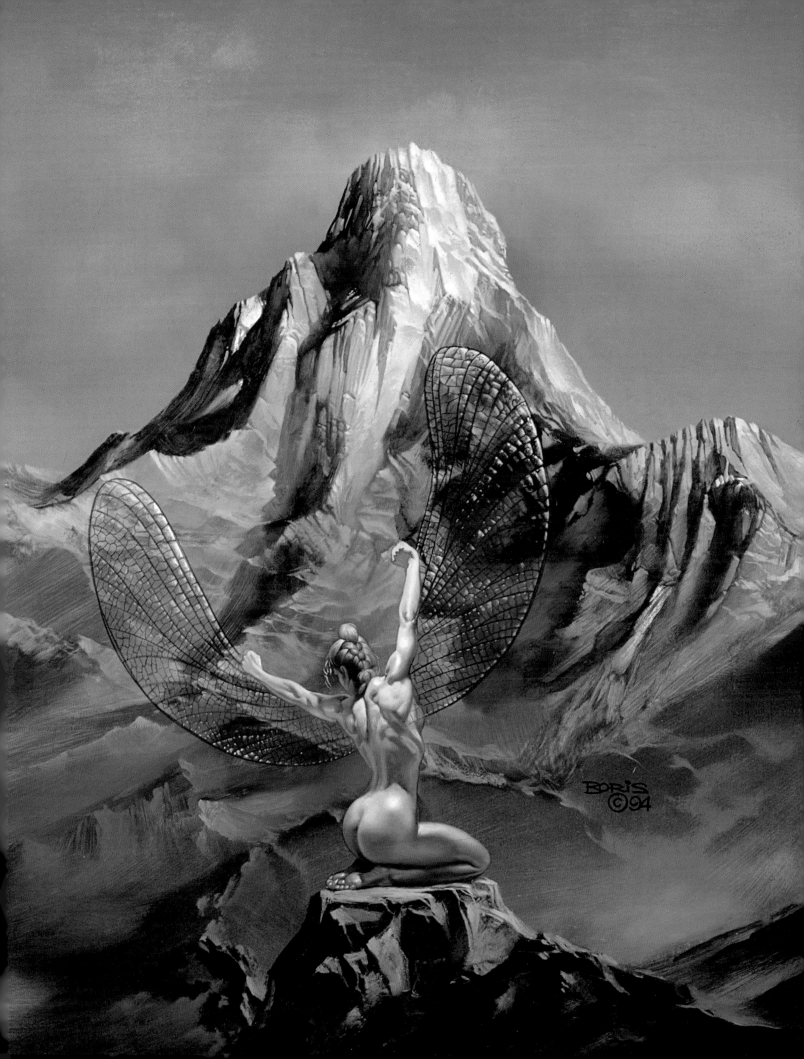

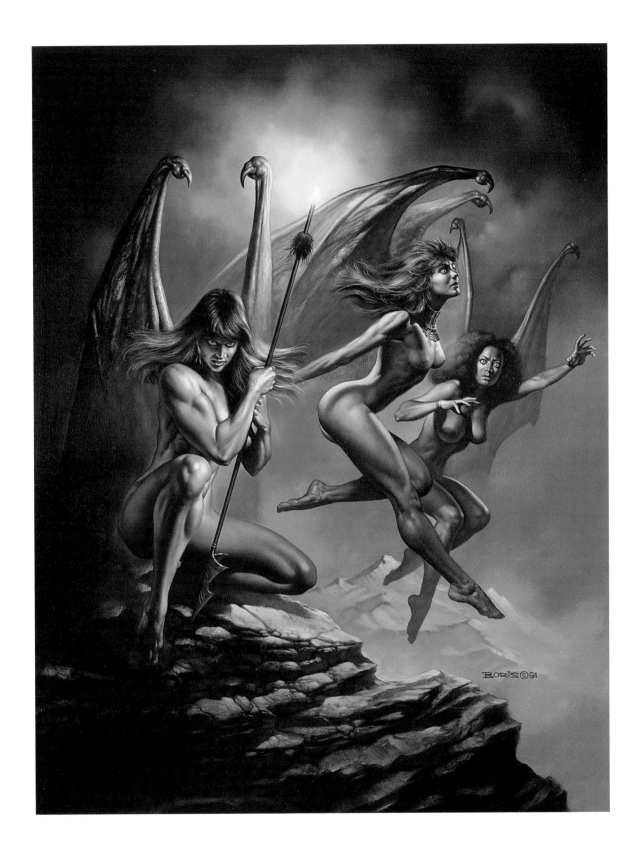

'THE FURIES' 1991 BORIS

'CINDY' 1995 JULIE

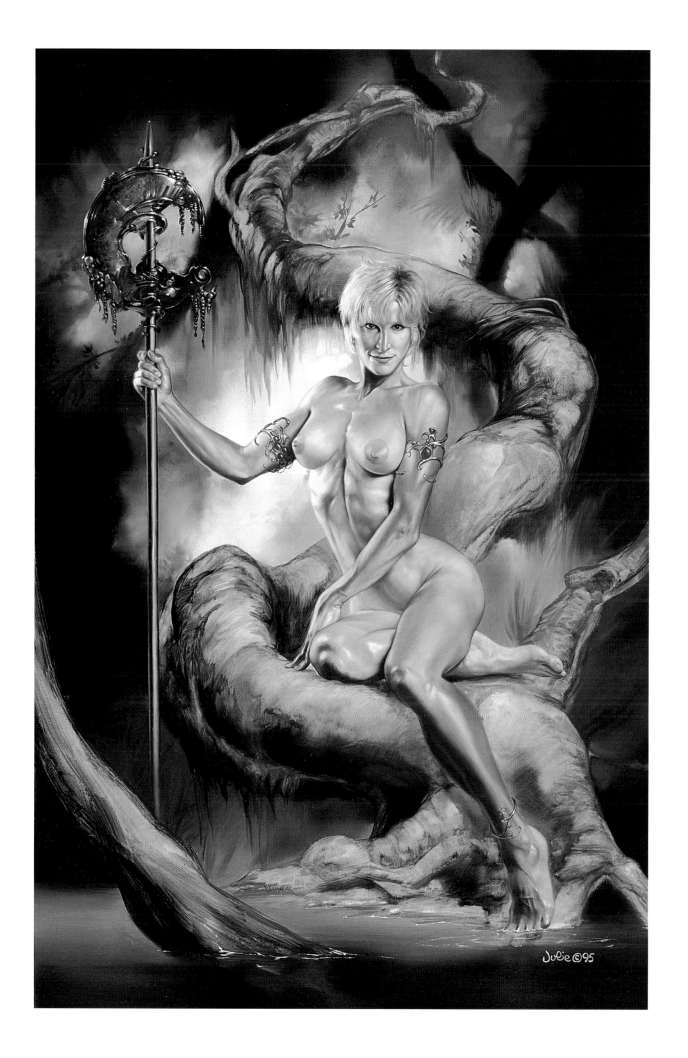

Julie ©95

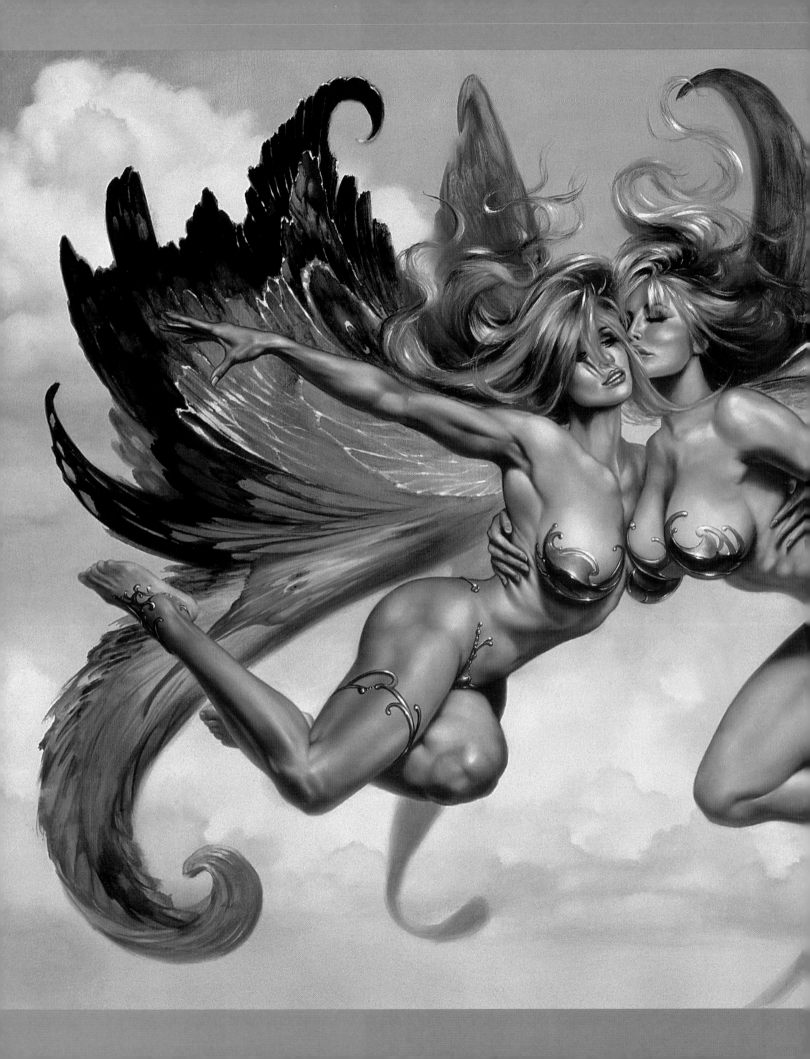

Julie ©95

"Someone once said: 'You can't get up every morning and be a genius'. Well, leave the 'genius' out of that but consider the fact that Boris and I (if I may include myself in this) have been getting up every morning and getting on with our work, commissioned or not, for over thirty years now. This takes real dedication and self-discipline. What I most like about Boris' work is his considerable skill with oils. He can paint anything with them from a rock or a tree trunk to shiny black leather or chrome steel – to those fabulous tones and hues that bring to life the fantastic double-curves and muscles that we all so love to see.

Then there's Julie. How lucky is Boris to connect with a lovely lady like that, one so beautiful and talented? A true companion. If I sound a little envious it's because I must be. The end result is that we now have twice the volume of great art than before. Long may you both live and prosper!"

Chris Achilleos www.chrisachilleos.co.uk

'HEAVENLY TWINS' 1995 JULIE

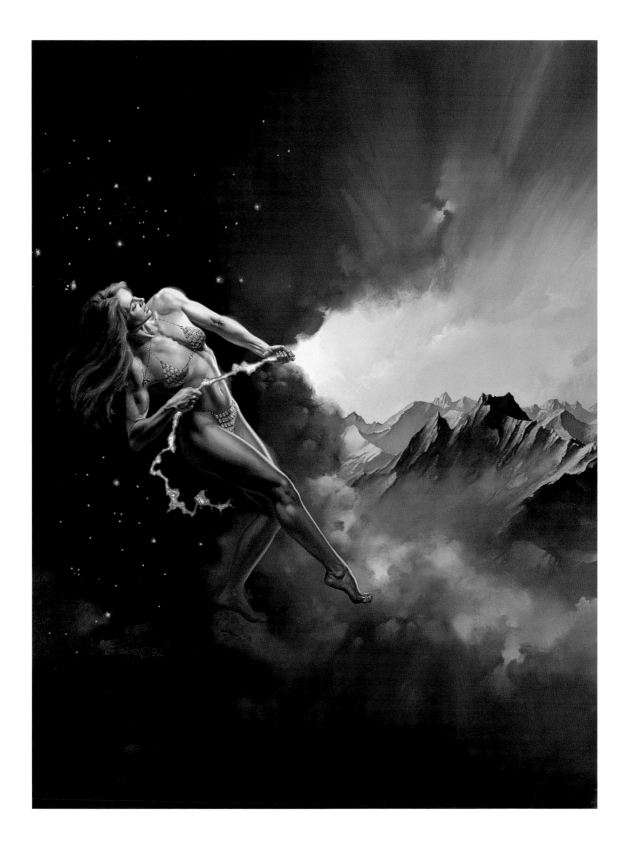

'DAWN' 1992 BORIS

'TYRANNOSAURUS REX' 1992 BORIS

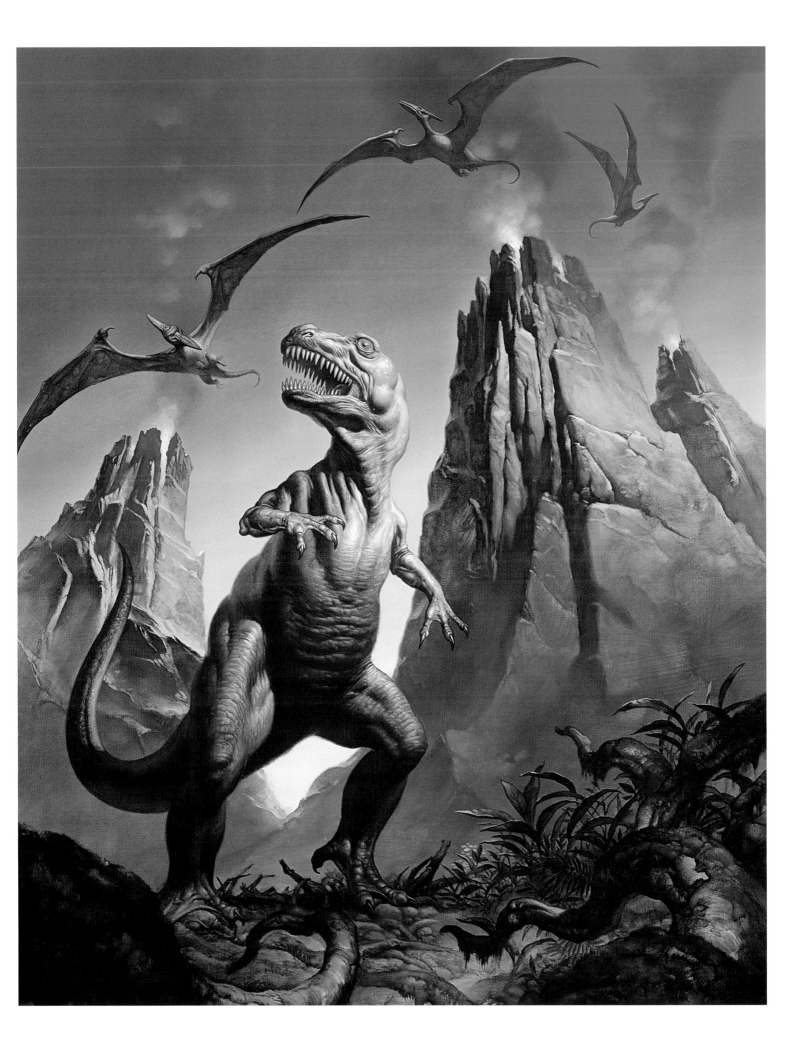

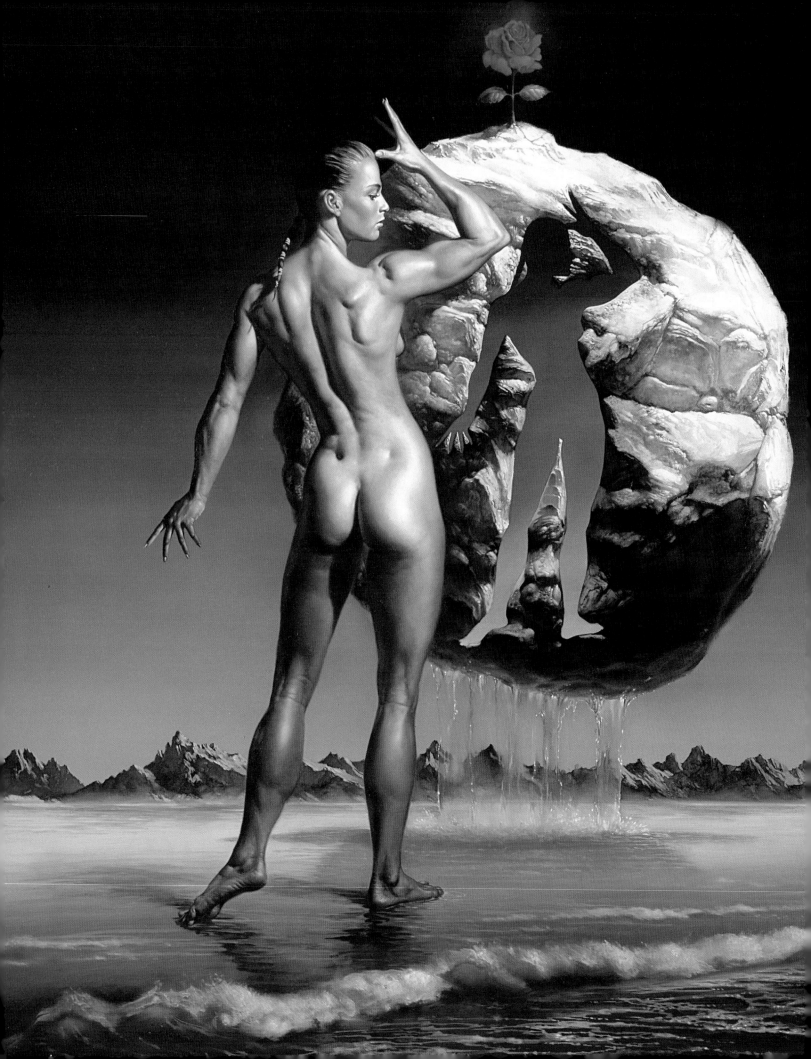

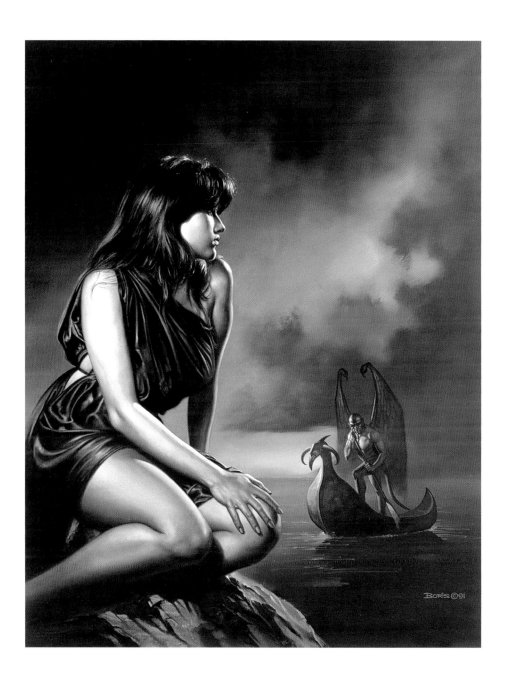

'ERIKA' 1992 BORIS 'EURIDICE' 1991 BORIS

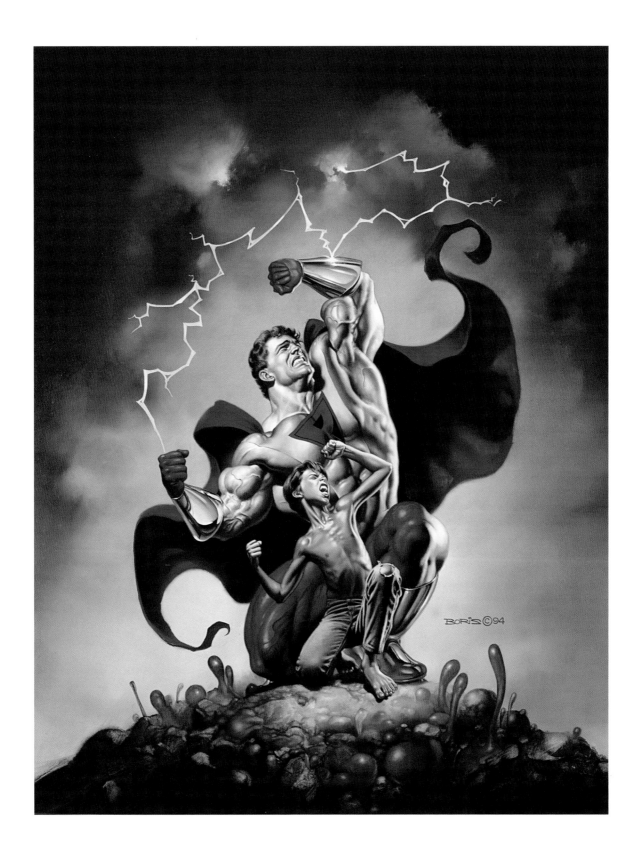

'PRIME' 1994 BORIS

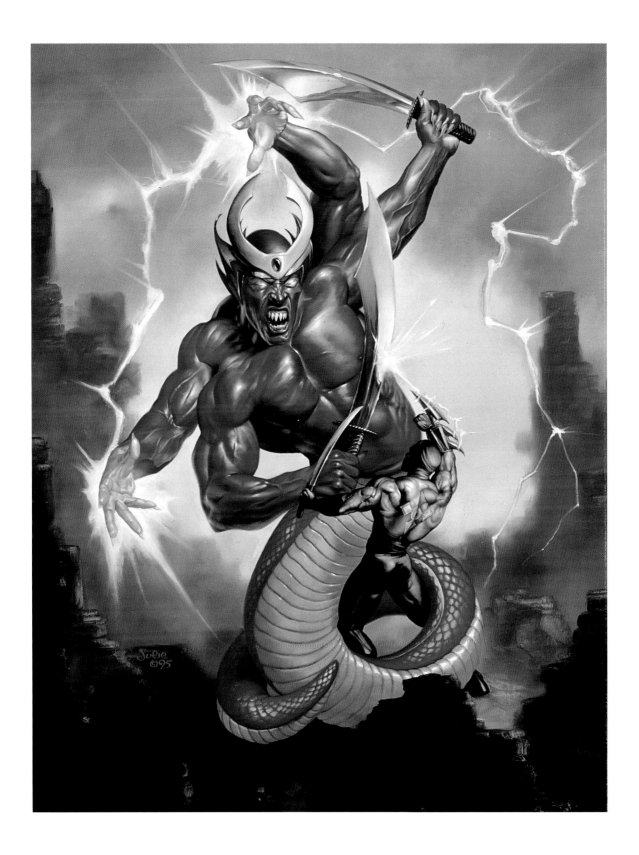

'RED DEMON' 1995 JULIE

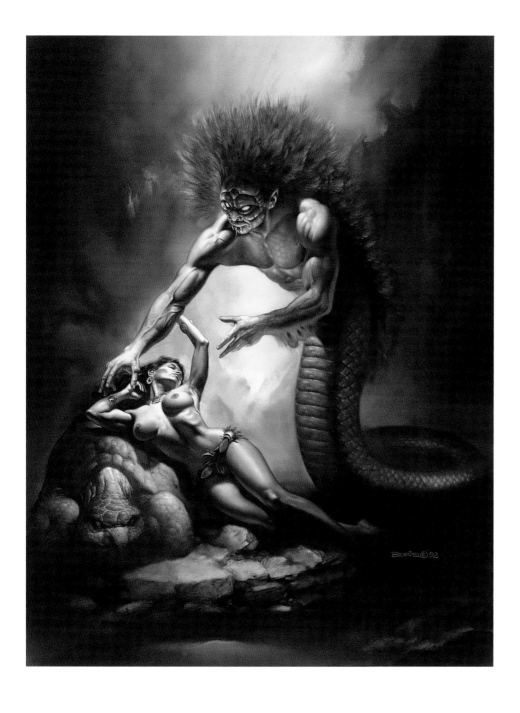

'QUETZALCOATL' 1992 BORIS

'ABDUCTED' 1987 BORIS

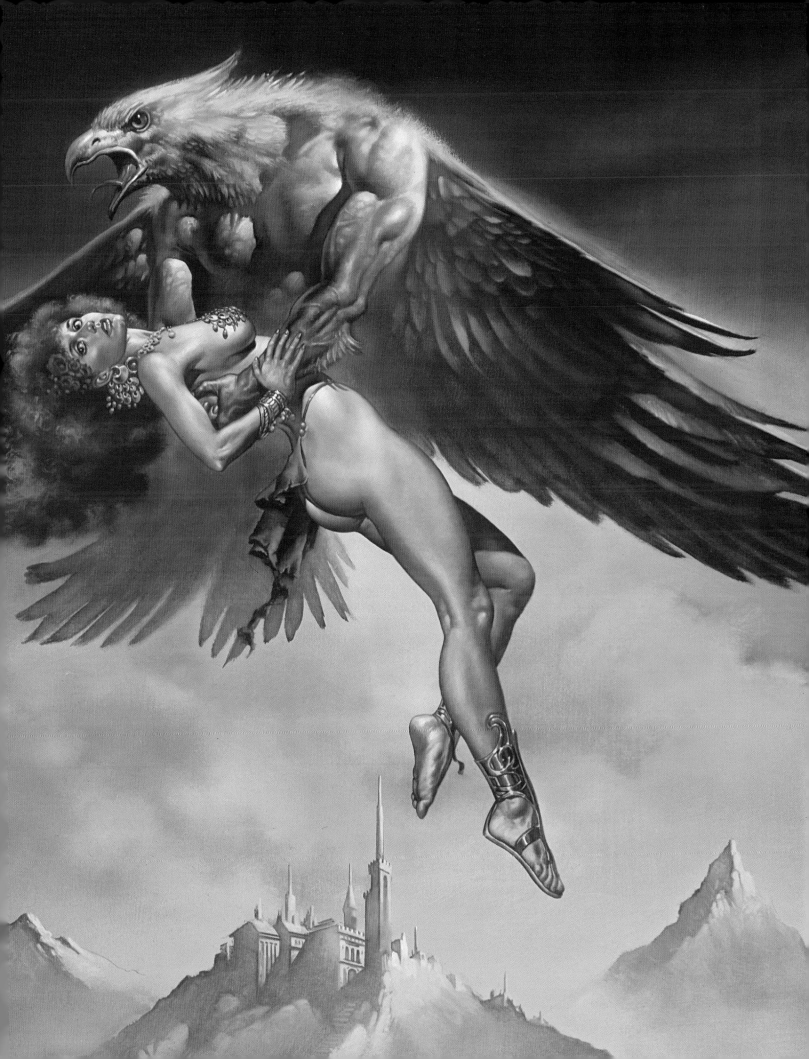

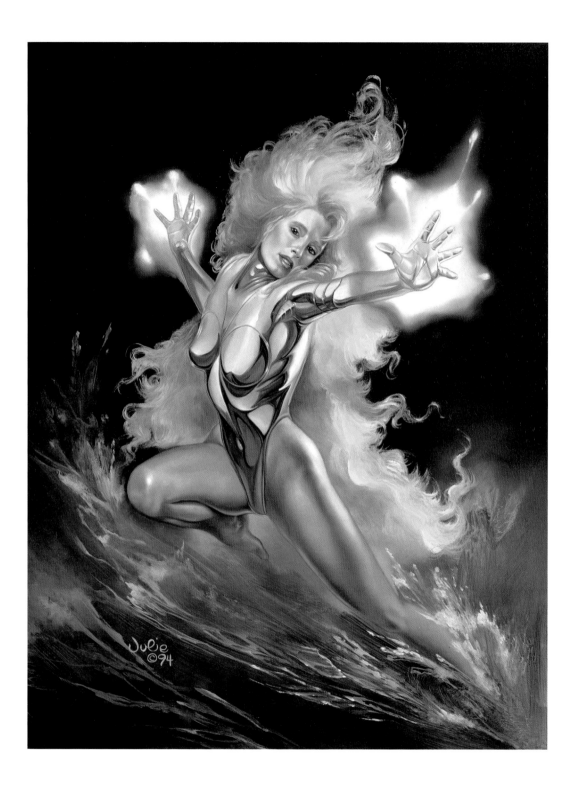

'Princess Mustang' 1994 Julie

'The Hippocampus' 1991 Boris

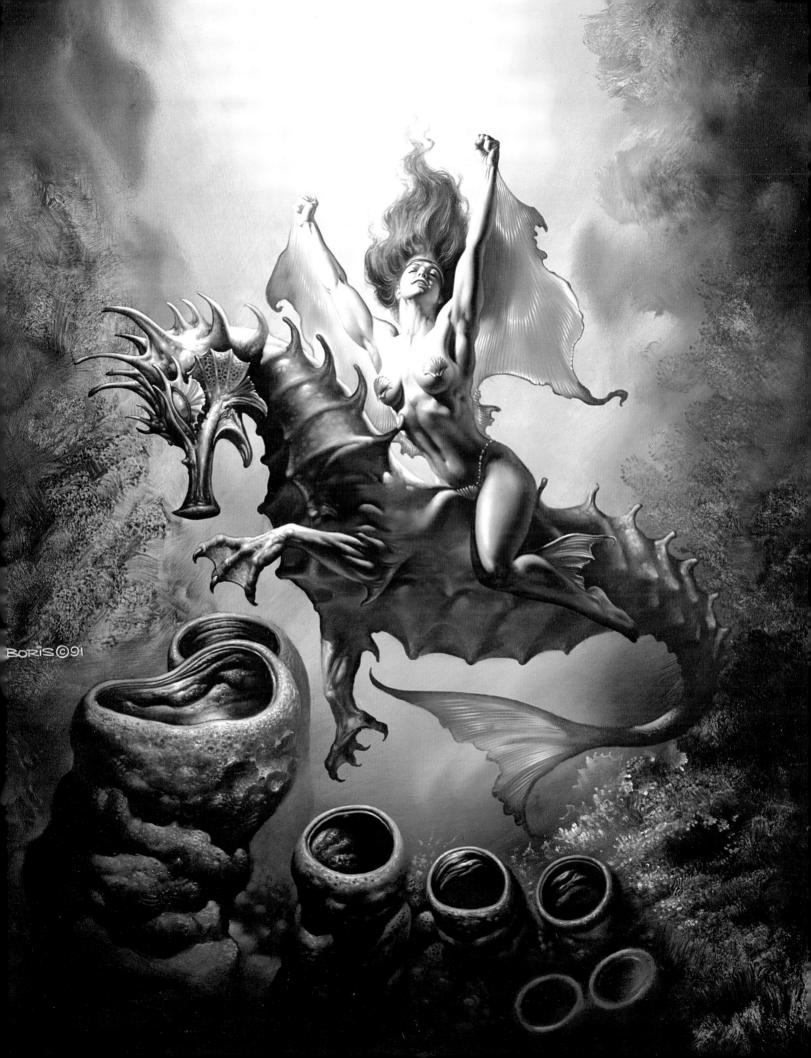

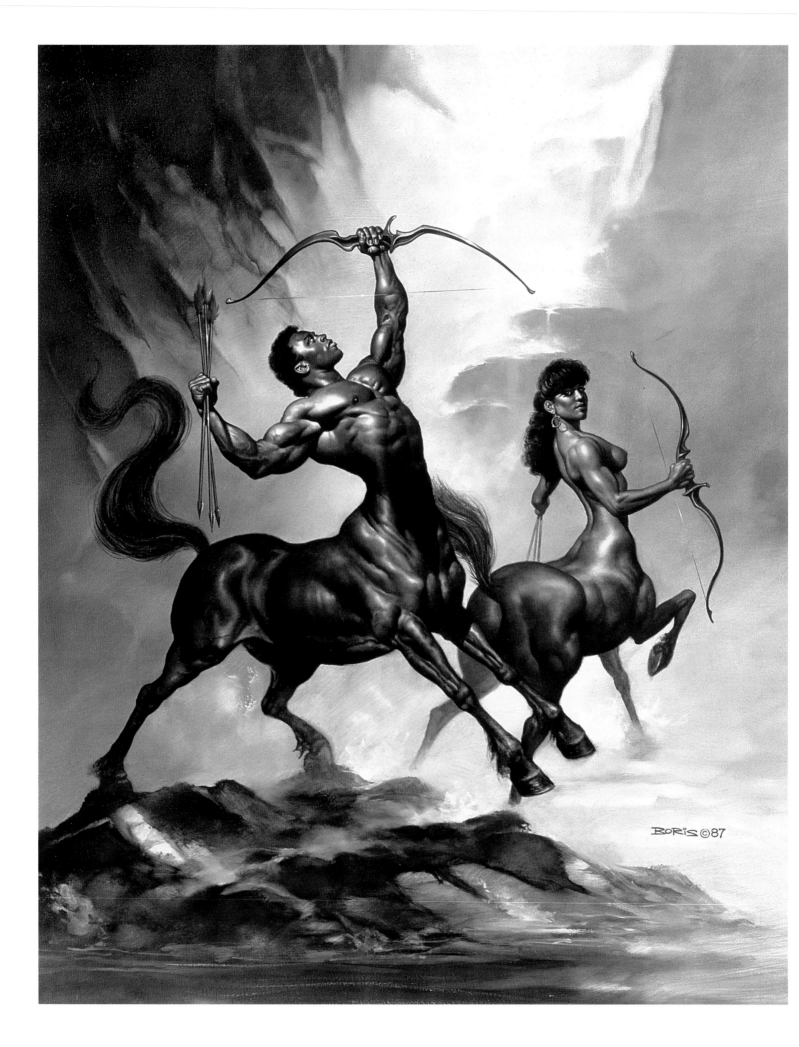

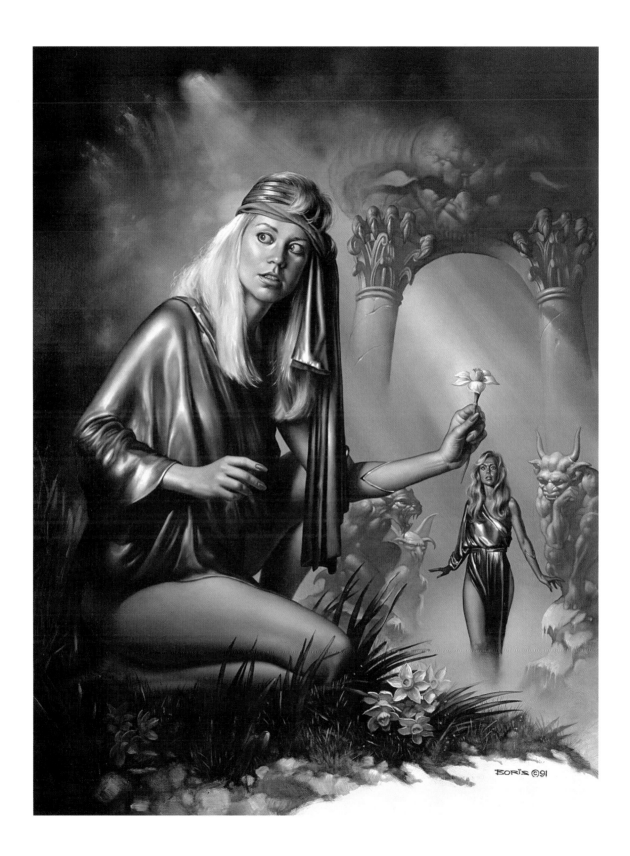

'CENTAUR COUPLE' 1987 BORIS 'PERSEPHONE' 1991 BORIS

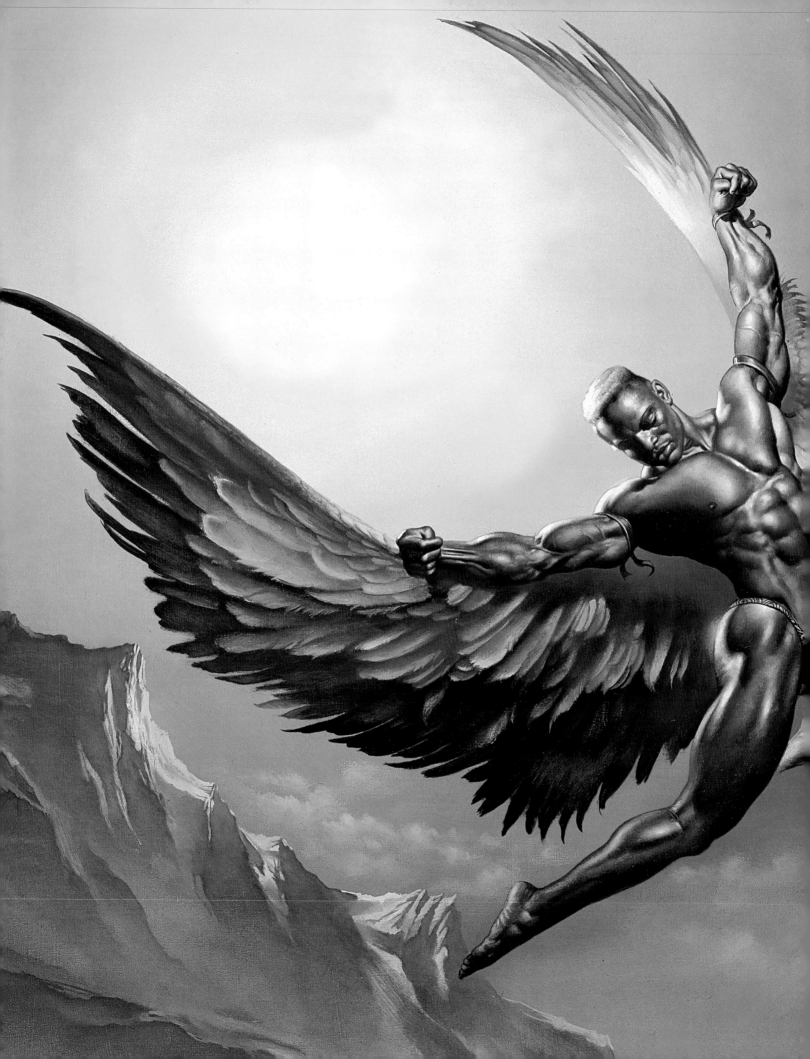

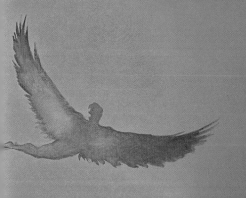

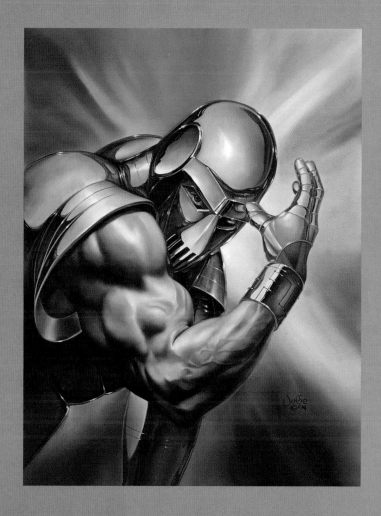

"Being an artist allows you a freedom to have this whole other world which you can bring into your life at any time."

Julie Bell

'ICARUS' 1988 BORIS

'KRONO' 1994 JULIE

BORIS©88

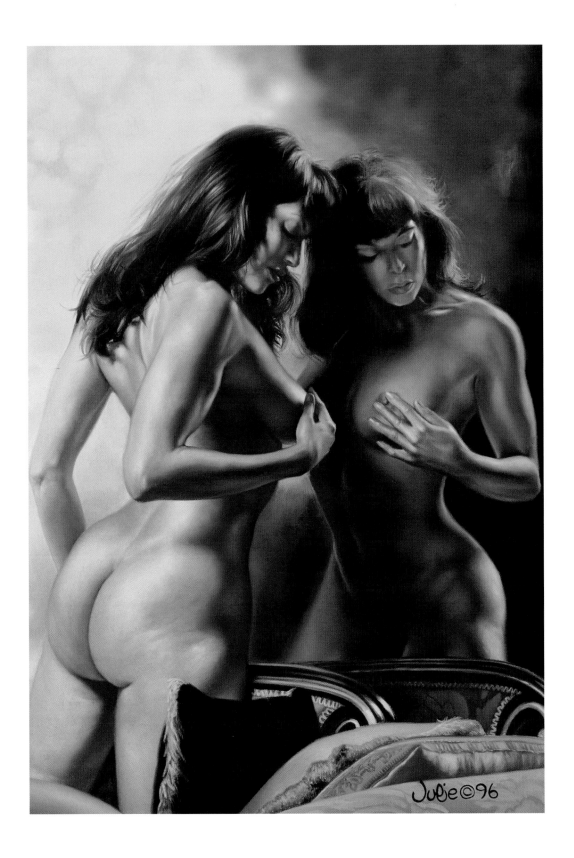

'REFLECTING' 1996 JULIE

'THE COLLECTOR' 1995 BORIS

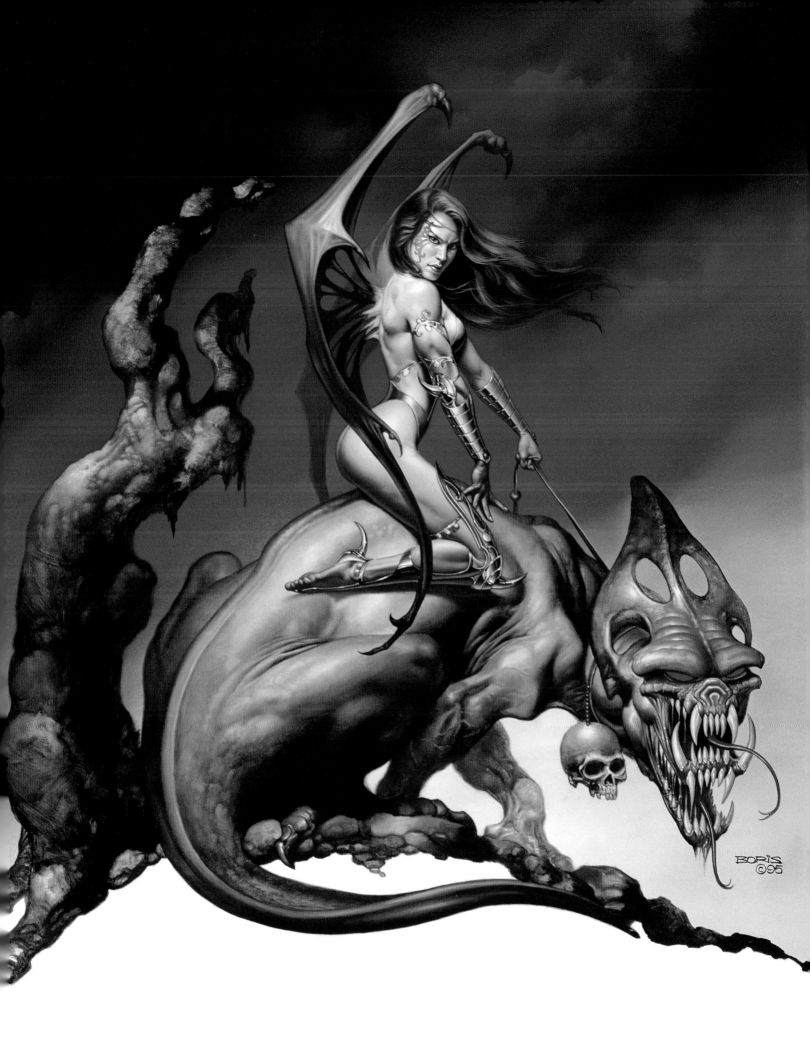

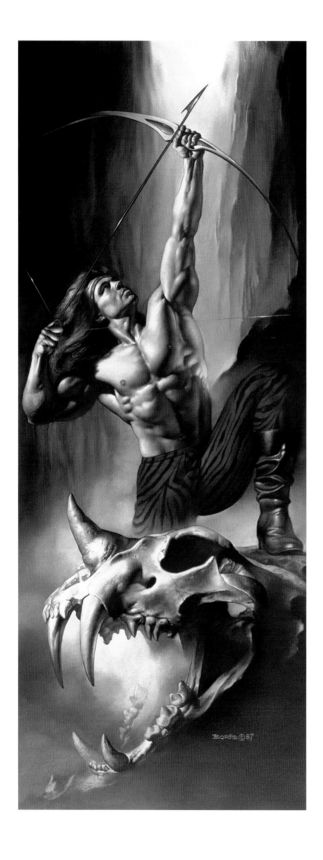

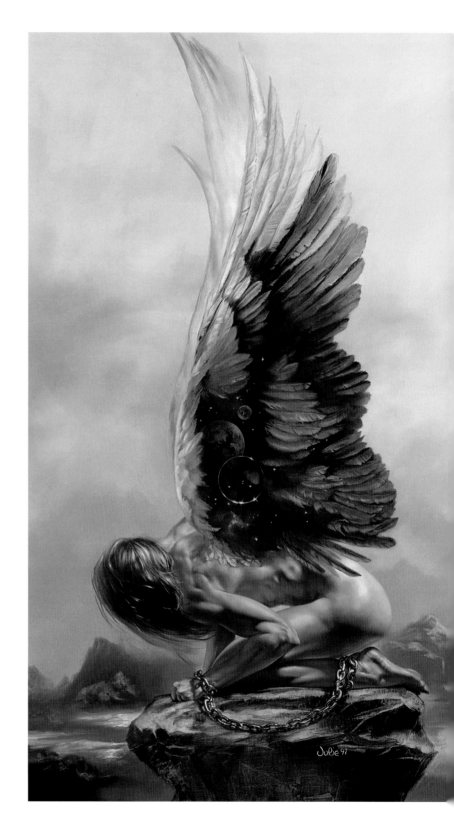

'ARCHER AND SKULL' 1987 BORIS

'POSSIBILITIES BOUND' 1997 JULIE

'THE BOMB' 1995 JULIE

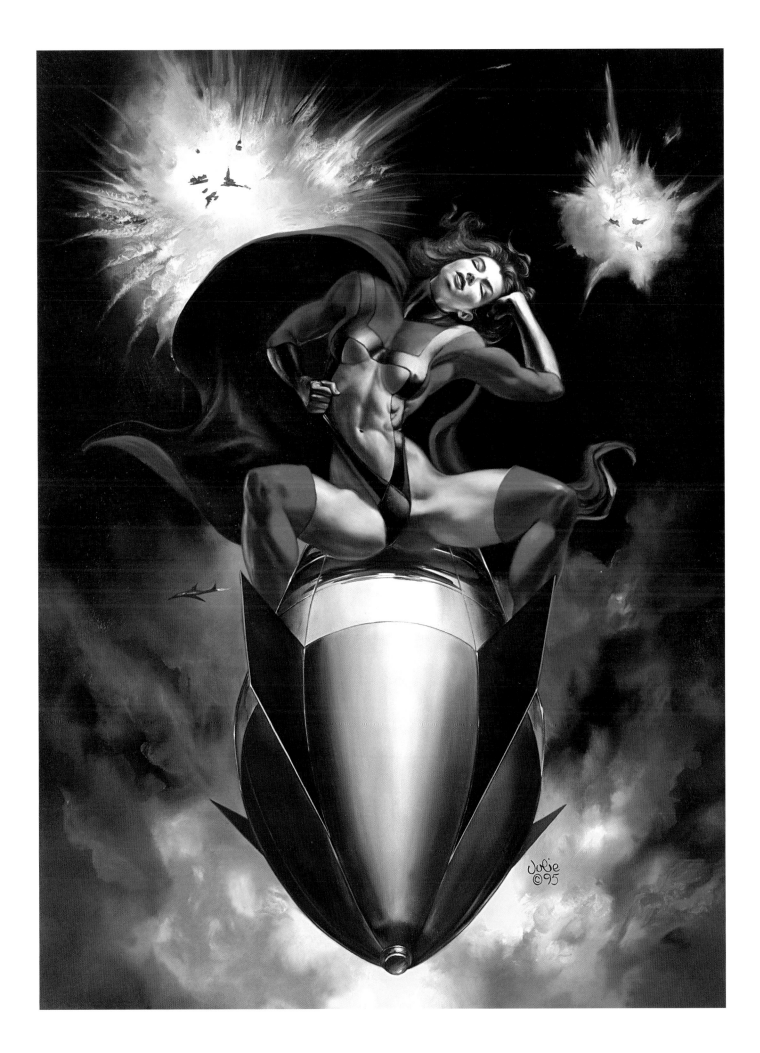

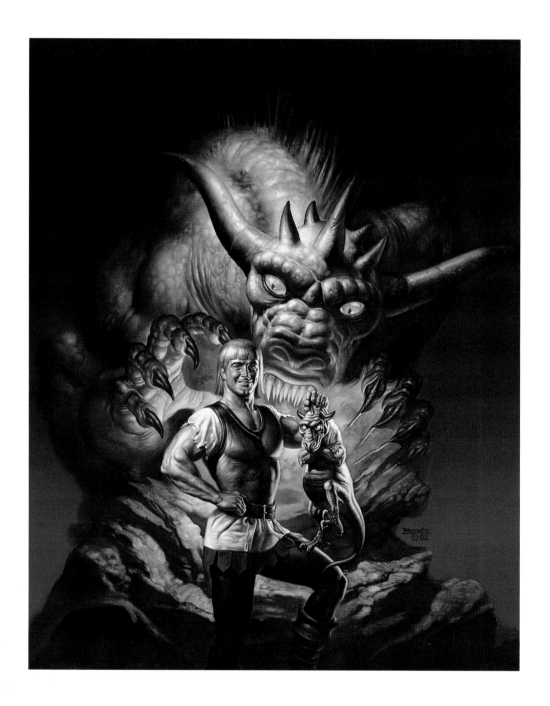

'MOTHER'S LOVE' 1992 BORIS

'GOLDEN APPLE' 1992 BORIS

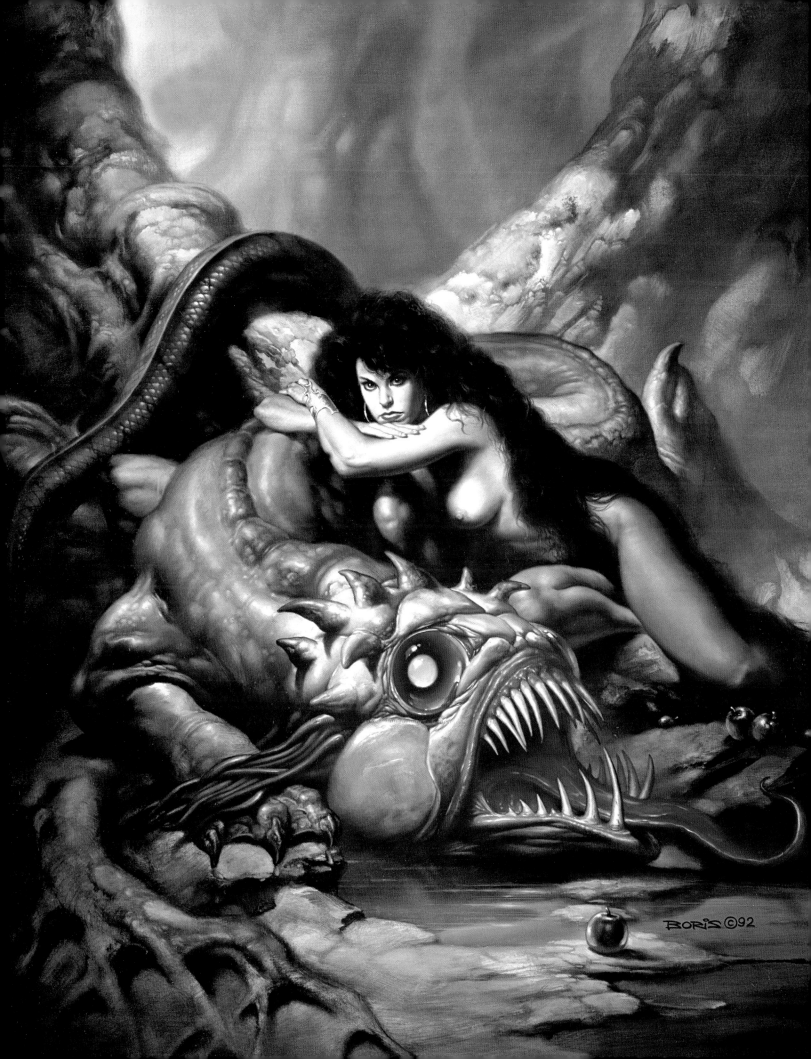

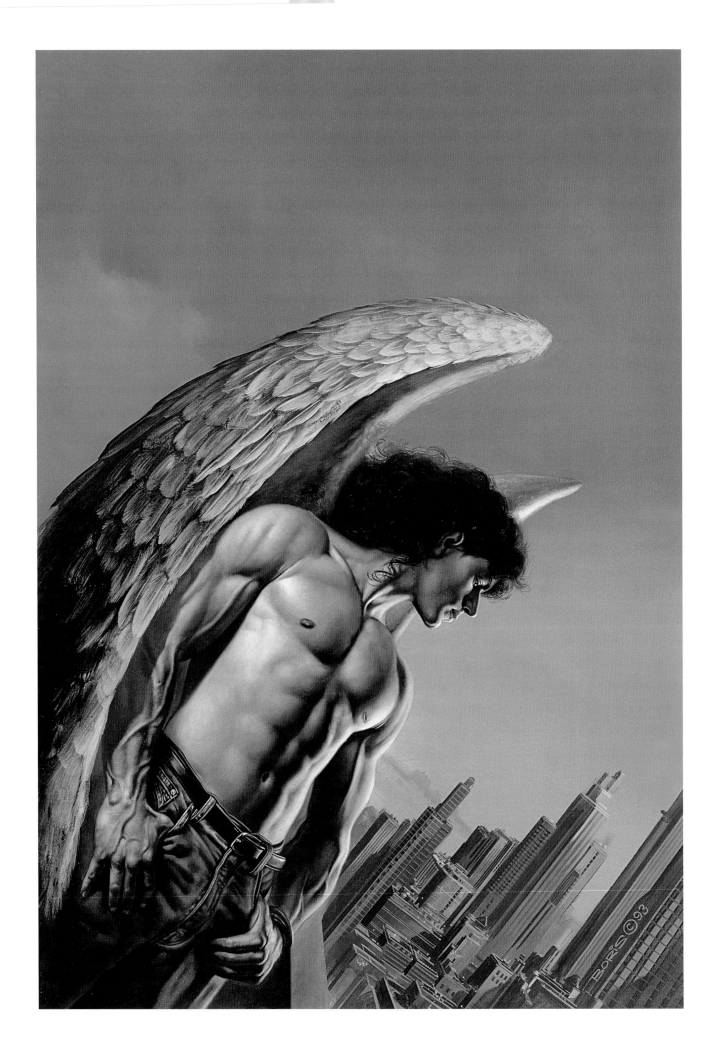

'Angel of the City' 1993 Boris

'Storm Approaching' 1997 Julie

LATE PERIOD

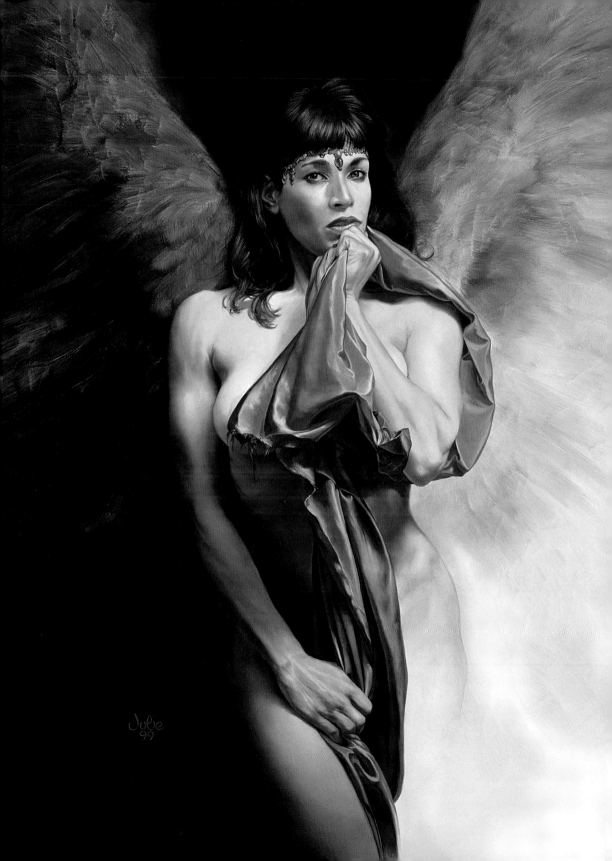

LATE PERIOD

One of the refreshing things about meeting Boris and Julie is that they lack any trace of world-weariness or cynicism about their work. Their enthusiasm for fresh ideas and techniques is as keen as any beginner's and this shows in the quality of their work, particularly their paintings for calendars, or their ongoing Tarot series, where the brief is very loose and they can more or less please themselves.

Also remarkable is their admission of still sometimes feeling raw fear in front of a blank canvas or when attempting a new technique; and that despite having hundreds of paintings behind them, they still sometimes wake up wondering if they can remember how to paint.

Because of all the experimentation and the directions that commissions sometimes take, Boris and Julie's styles inevitably change with time, and not always to the delight of their fans:

Boris: Occasionally we get emails from people saying they like one period of our art better than another but it doesn't really affect our attitude to work. We're aware that you can never please everybody. We've found that in art the first person you have to please is yourself. You have to be happy with what you do and not dependent on other people's opinions. That doesn't mean we're complacent. As artists we're always looking for new ways of expressing ideas. We're always experimenting and the whole character of our work changes with time.

Julie: Just as we're changing as people.

Boris: As we get older our approach naturally changes. Although our general style is established, it's always possible to grow and develop. We always want to try doing things in different ways.

'SEARCHING THE SKIES' 1999 JULIE

PREVIOUS PAGE: 'ANGEL WINGS' 1999 JULIE

Julie: We're always getting inspired by other artists and so that shifts our direction.

Boris: In the early days inspiration used to come from how certain favourite artists worked, but at this point in time we get inspired by anything – artists, nature, anything. I sometimes get puzzled when people ask how we get motivated and inspired. I'm amazed that people ask because inspiration is everywhere. We just wish we had time to do more.

Julie: The most important thing to say about how we work now is how much fun we have. We're not working to achieve anything like making our names – we just love what we do.

Boris: We don't think 'What's going to happen next?' We just do whatever comes along.

Julie: One important thing we've learned is that fear is anti-art. It still comes at the beginning of a picture but we've learned how to bypass it, we know it's going to pass.

Boris: For instance, we recently got a commission from the Saatchi agency in London that called for an elaborate painting to be finished and sent off in only three days. Almost impossible, and in the past it would have been terrifying but this time there was no fear and no question about taking it on. We just did it together and enjoyed the whole process. What happens is that when one of us gets scared, the other is confident. So working together has made a great difference to our lives. Not that we often work on the same painting – that is quite a new development.

Julie: What happens if we both get scared at the same time, I don't know. It hasn't happened yet. Boris is always there when I need him.

Boris: Same thing for me. Sometimes I get stuck and not able to realize why, but here I have a partner with a fresh look at what I'm doing.

Julie: We both still get afraid but are always confident that the other can see the way through.

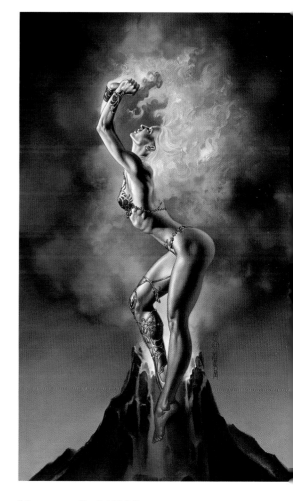

'MISTRESS OF FIRE' 1996 BORIS

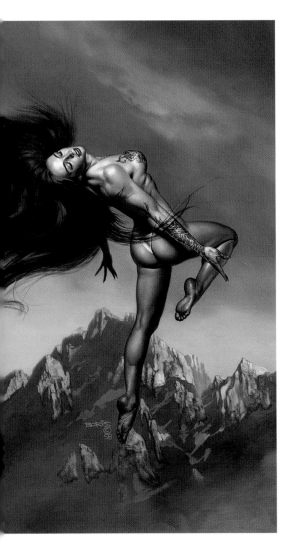

'MISTRESS OF THE AIR' 1998 BORIS

Boris: True. If I get stuck I turn to Julie and say 'What do you think?' And she will tell me. She not only has a fresh eye but the authority to see what's wrong. One of the things we do now is work together on paintings, which means we can take over from each other whenever one runs out of energy.

Julie: When we do these paintings together, we work totally for the sake of the painting. There's no ego and thinking 'this bit is mine' or 'that bit is mine'. It's 'ours together'.

Boris: We've come to learn the most important thing – the love of painting just for itself, not what it means to our careers or anything.

Julie: If you can ignore your ego it puts a whole different perspective on your art. When we work together we totally let go of the fear, our egos are in a different place entirely and it's really comfortable not to be dealing with that.

Boris: When I first started out I felt I had to prove to the world that I was as good as this or that artist, but now I have nothing to prove. I'm not trying to be 'best' at anything in art, because who's to say what is best? Maybe you like one picture better than any other but no-one can say that this or that picture is the best there has ever been.

Julie: Me too. We really enjoy other artists' work and get great inspiration from it but there's no need to get competitive about it. The biggest thing for me personally about working together on something as personal as art is that it has taught me a lot about competitiveness. We still are competitive in the sense of trying to bring out the best in each other's painting, but not in any personal way. Working together has really changed my outlook as a person. It's great to let go of that feeling of identity and just concentrate on the picture itself.

Boris: Oh yes, and working together on paintings is probably something we'll be doing a lot more of in future.

'TIGER MAGIC' 1998 JULIE

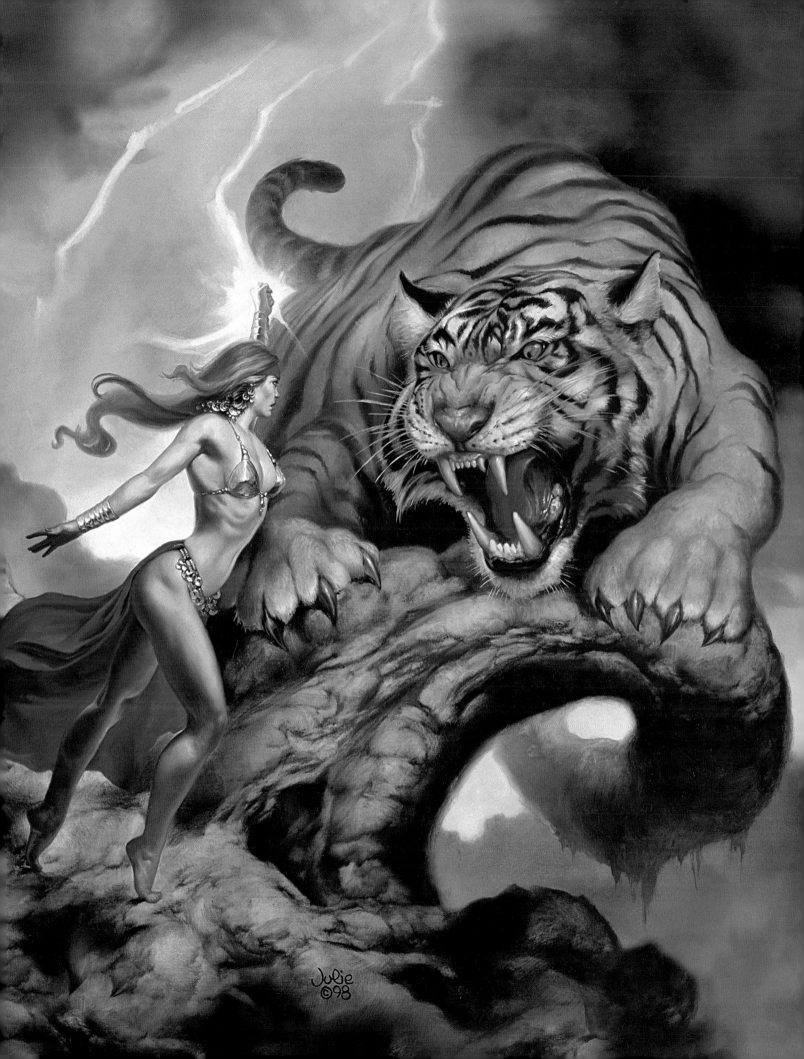

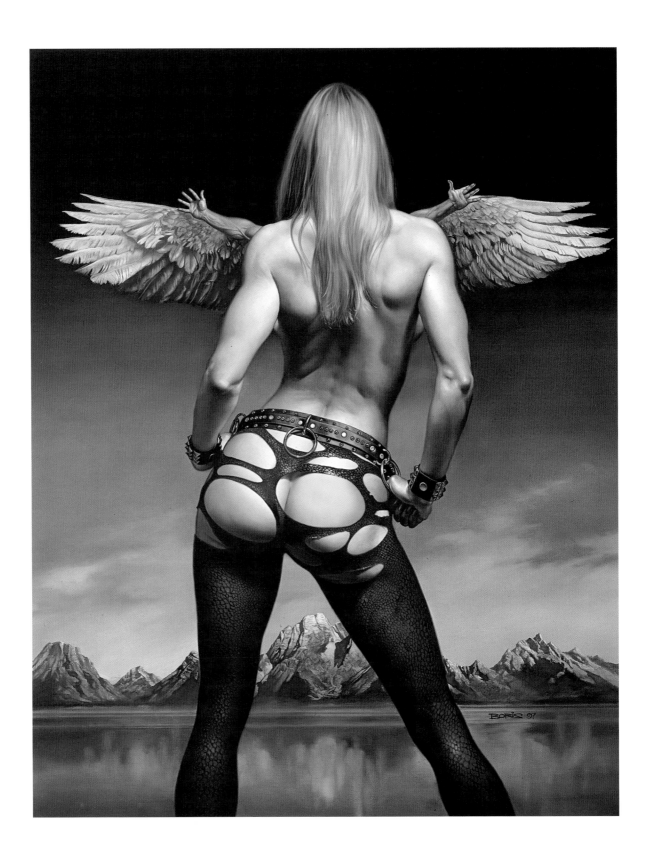

'WAITING FOR THE ANGEL' 1997 BORIS 'WINGS OF NIGHT' 1998 BORIS

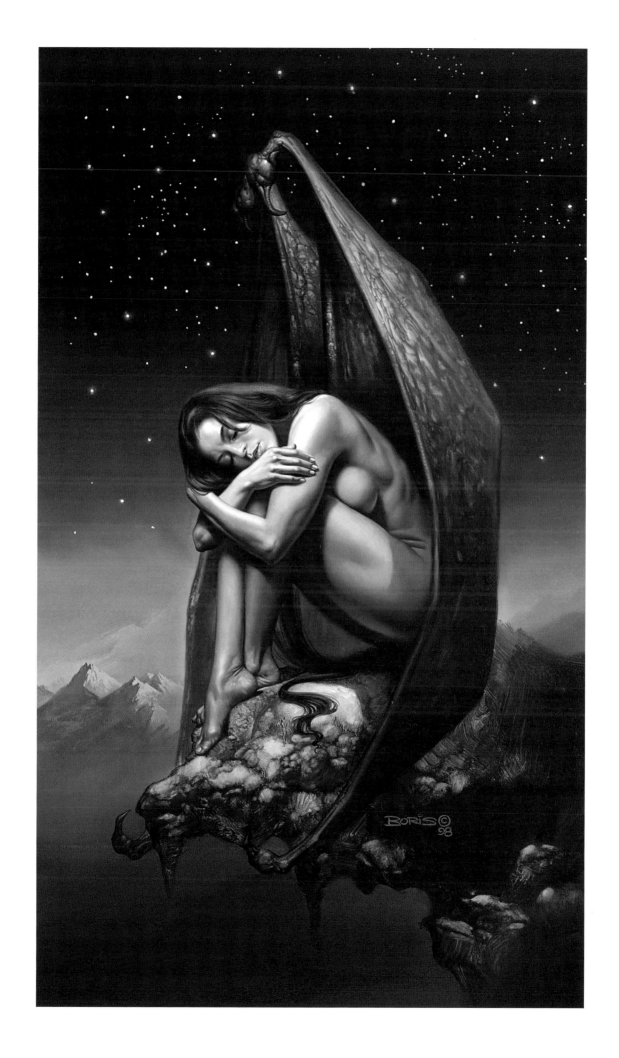

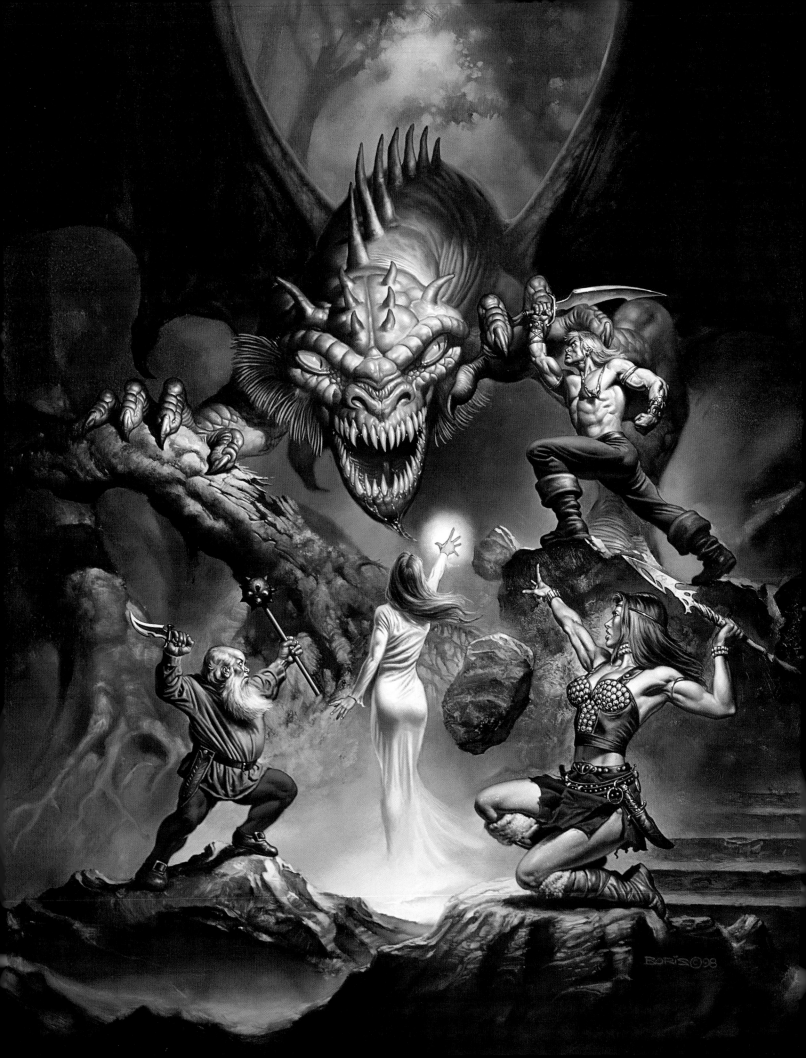

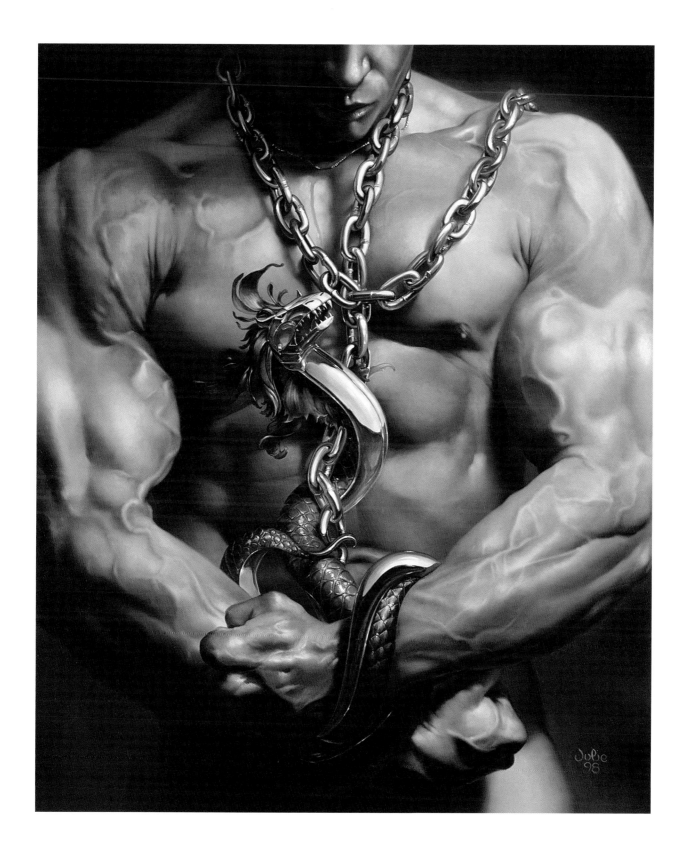

'Myth and Magic' 1998 Boris

'The Albatross' 1998 Julie

"In the early days inspiration used to come from how certain favourite artists worked, but at this point in time we get inspired by different things – artists, nature, anything."

Boris Vallejo

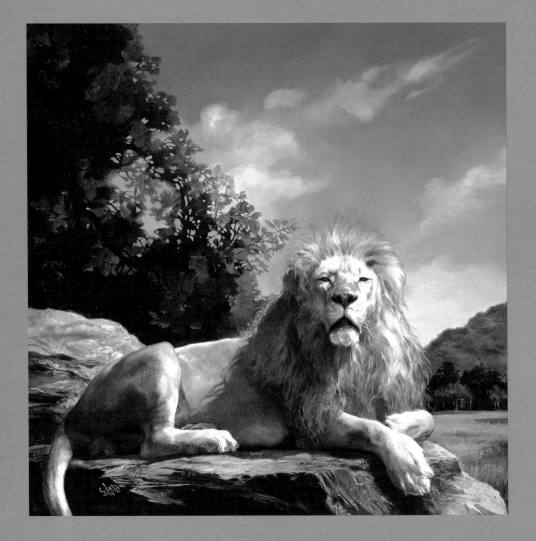

'PHILADELPHIA LION' 2001 JULIE 'KISS MY HAND' 2001 BORIS

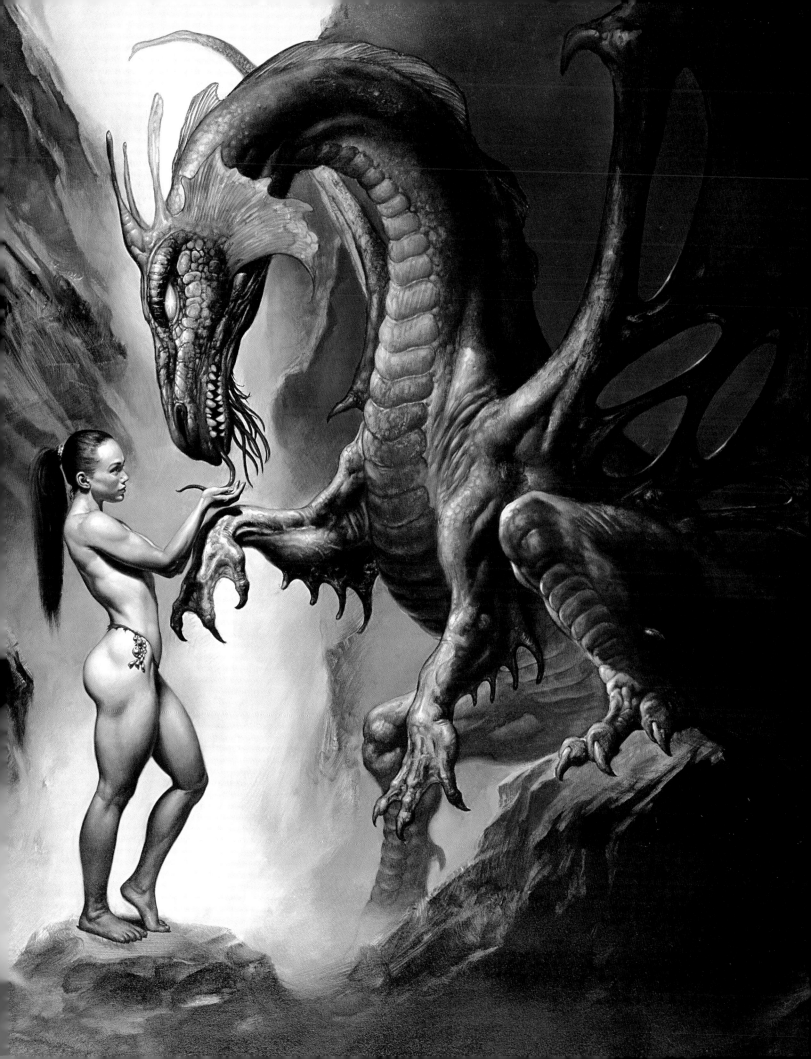

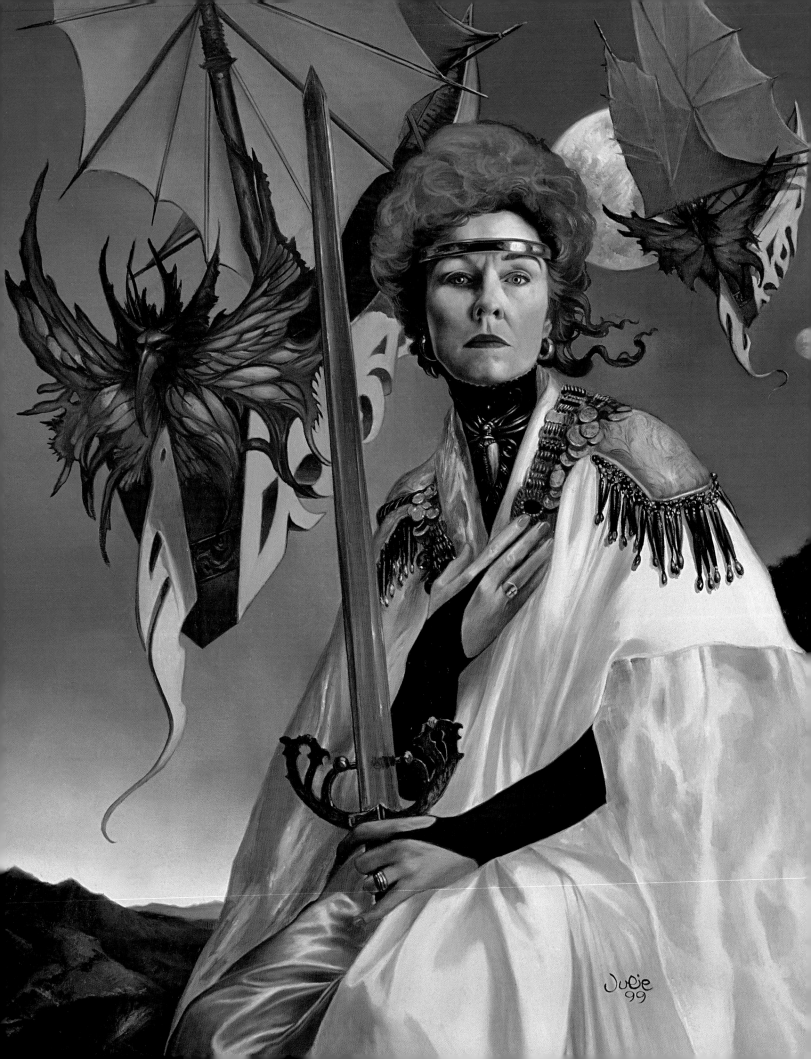

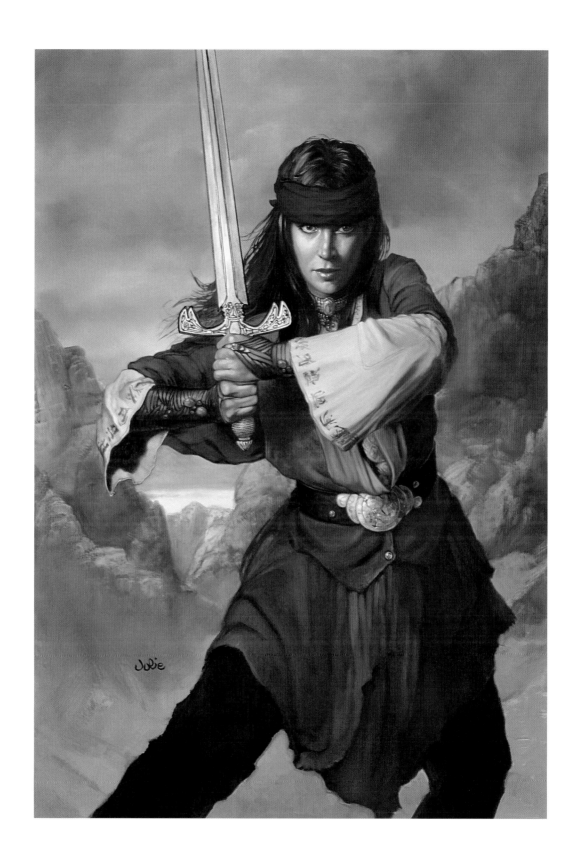

'Passage' 1999 Julie

'Tarot Face' 2003 Julie

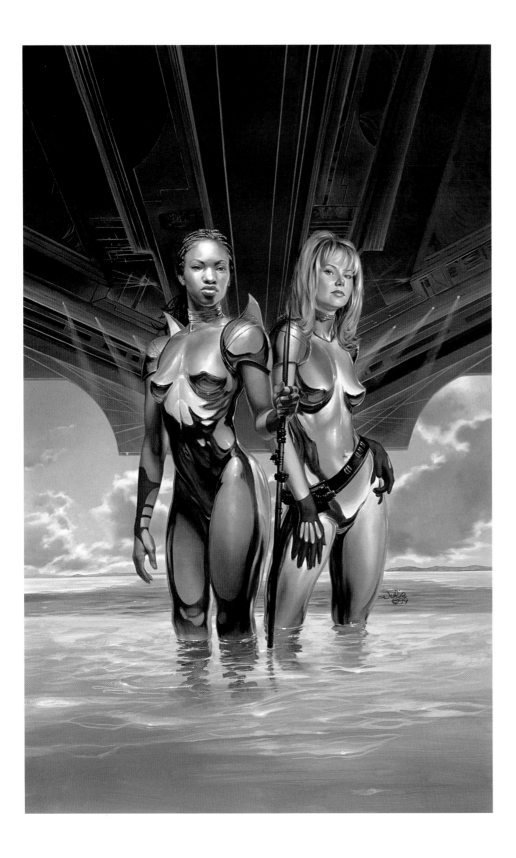

'COMMANDOS' 1999 JULIE 'SUNSHINE BREAK' 2000 JULIE

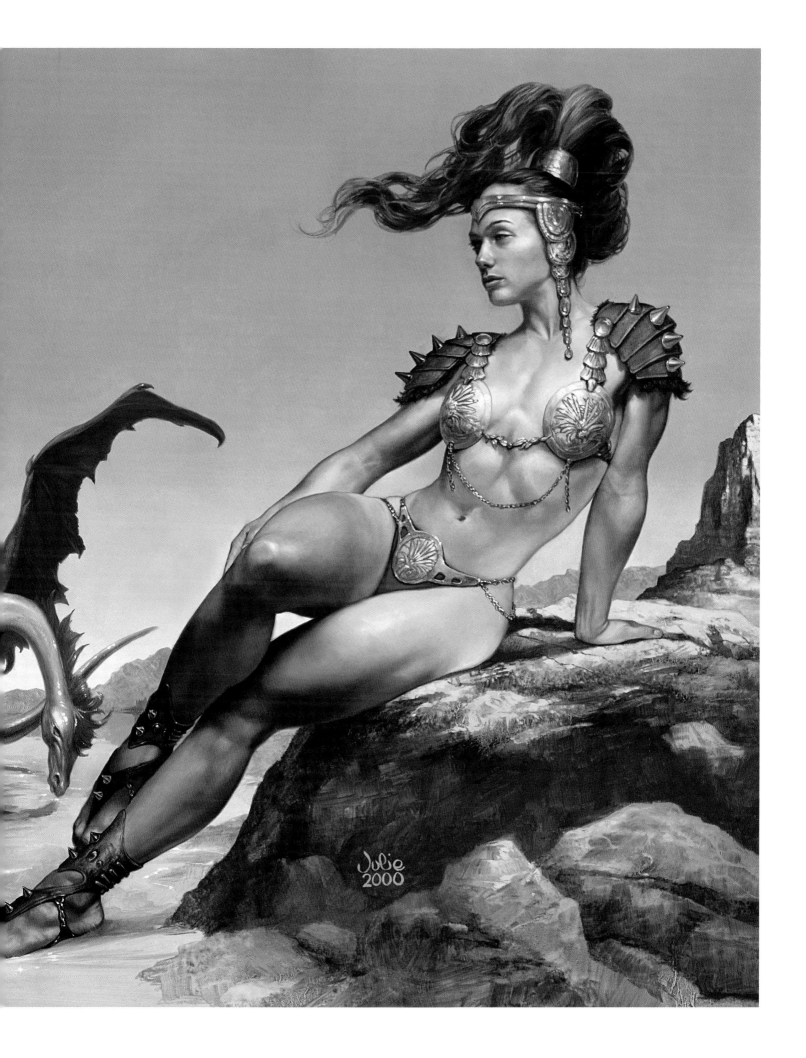

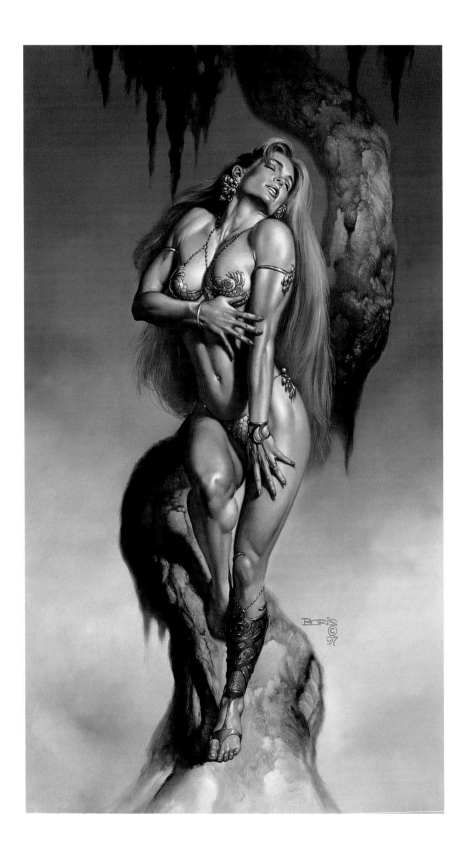

'DESIRE' 1997 BORIS

'SEE THE BUTTERFLIES' 1998 BORIS

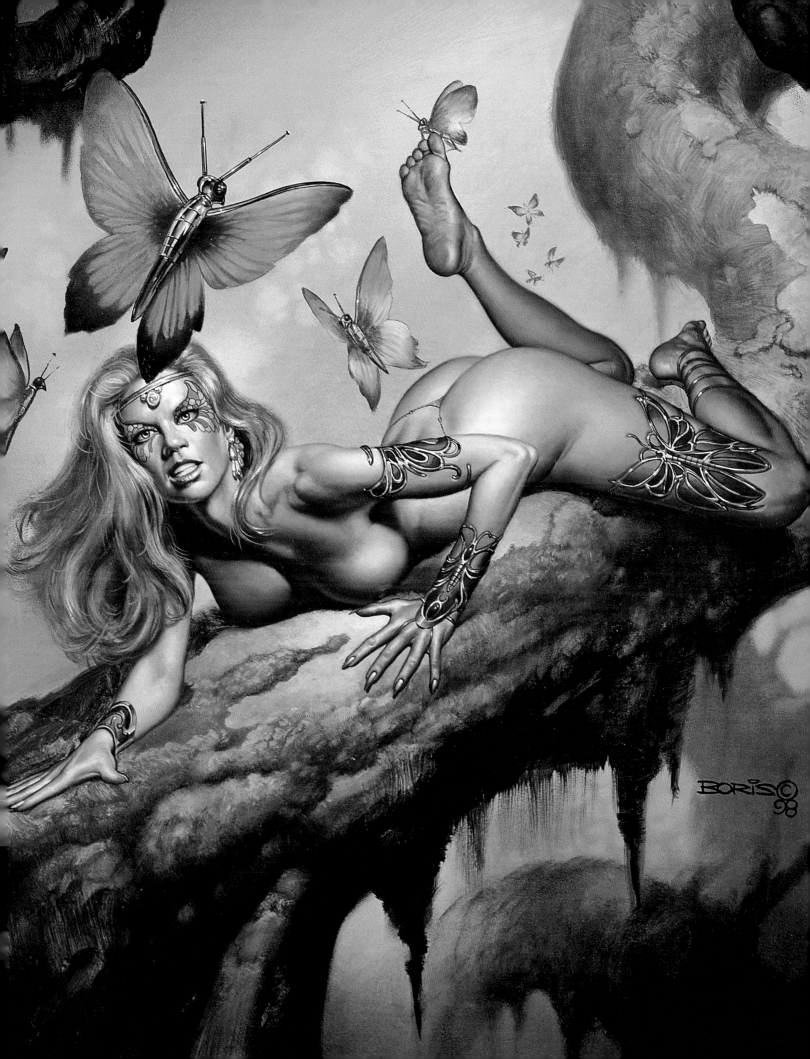

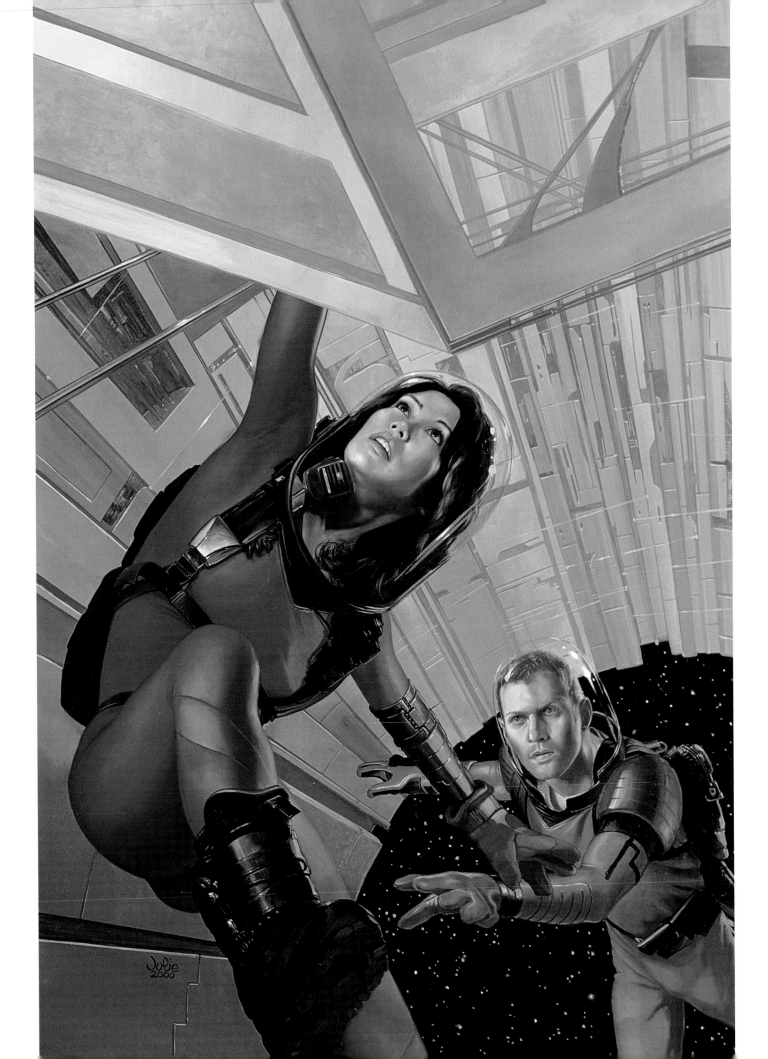

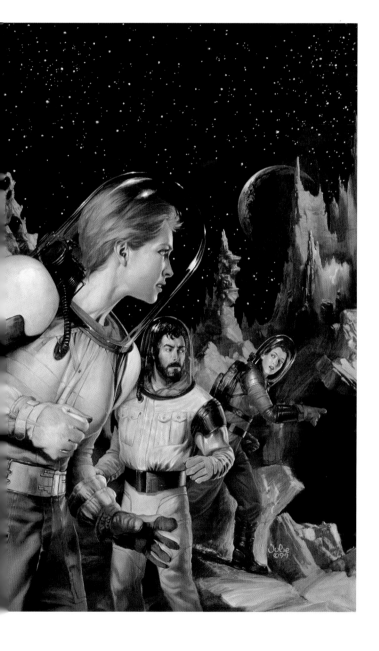

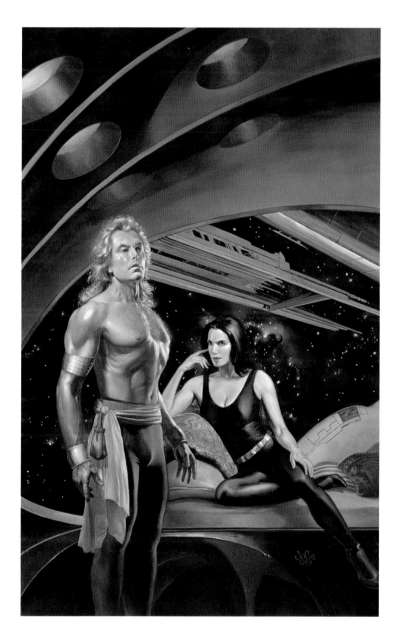

'TUNE-UP' 2000 JULIE 'DISCOVERY ON ASTEROID X-72' 1999 JULIE 'THE PRIZE' 1999 JULIE

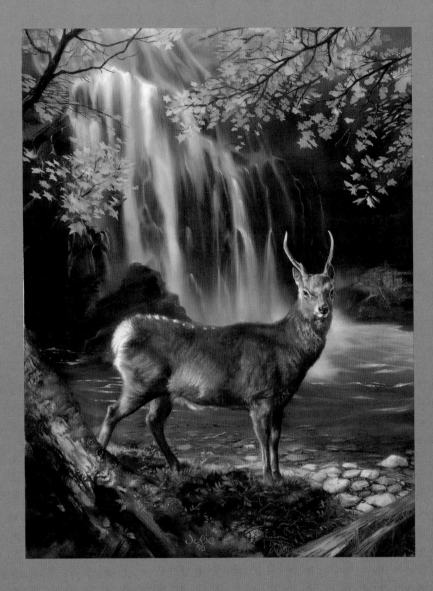

"Working together on paintings [right] is probably something we'll be doing a lot more of in future."

Boris Vallejo

'DEER' 1998 JULIE 'PYRAMIDS' 1999 BORIS & JULIE

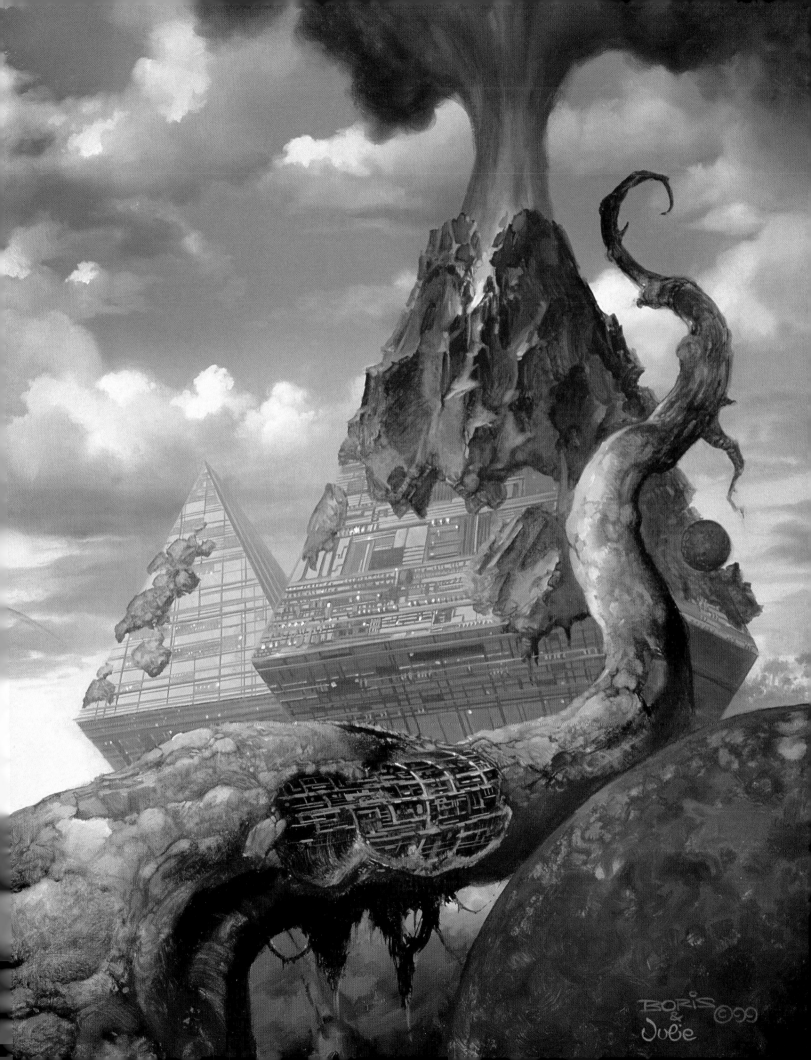

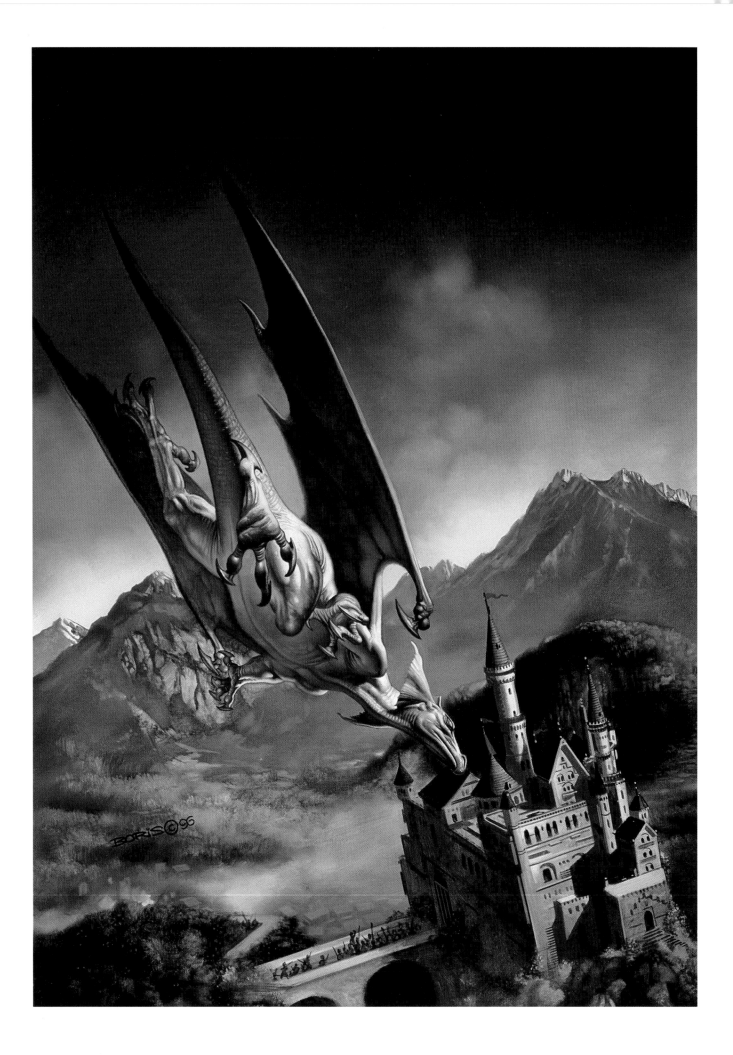

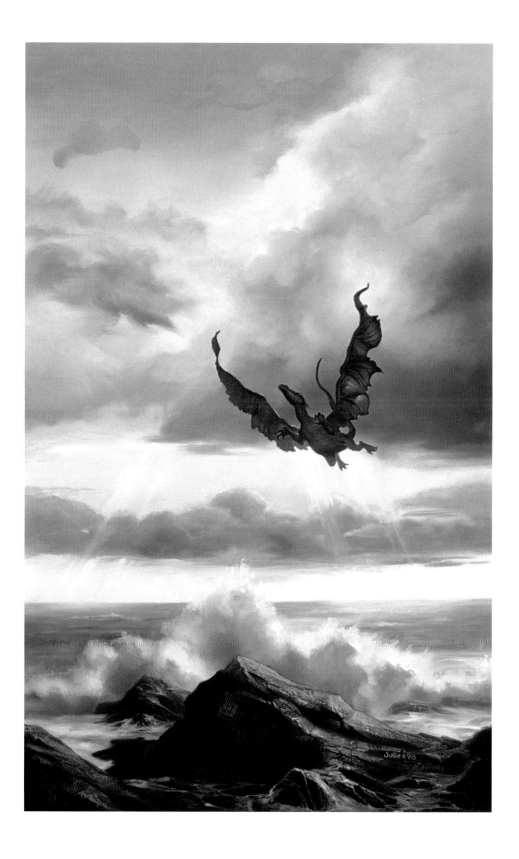

'DIVING DRAGON' 1996 BORIS

'HAPPY MORNING DRAGON' 1998 JULIE

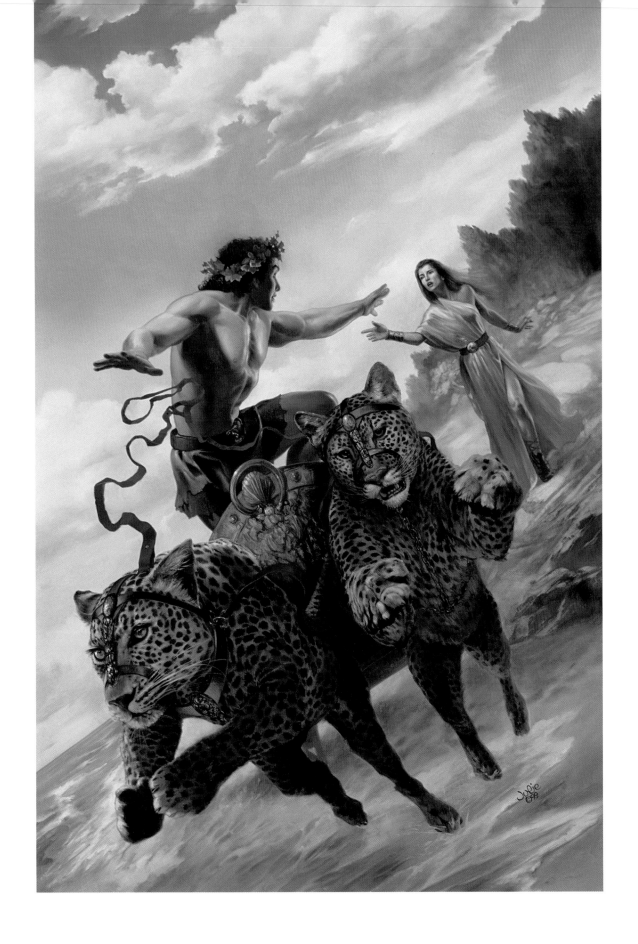

'BACCHUS AND ARIADNE' 1999 JULIE

'THE CREATOR' 1998 JULIE

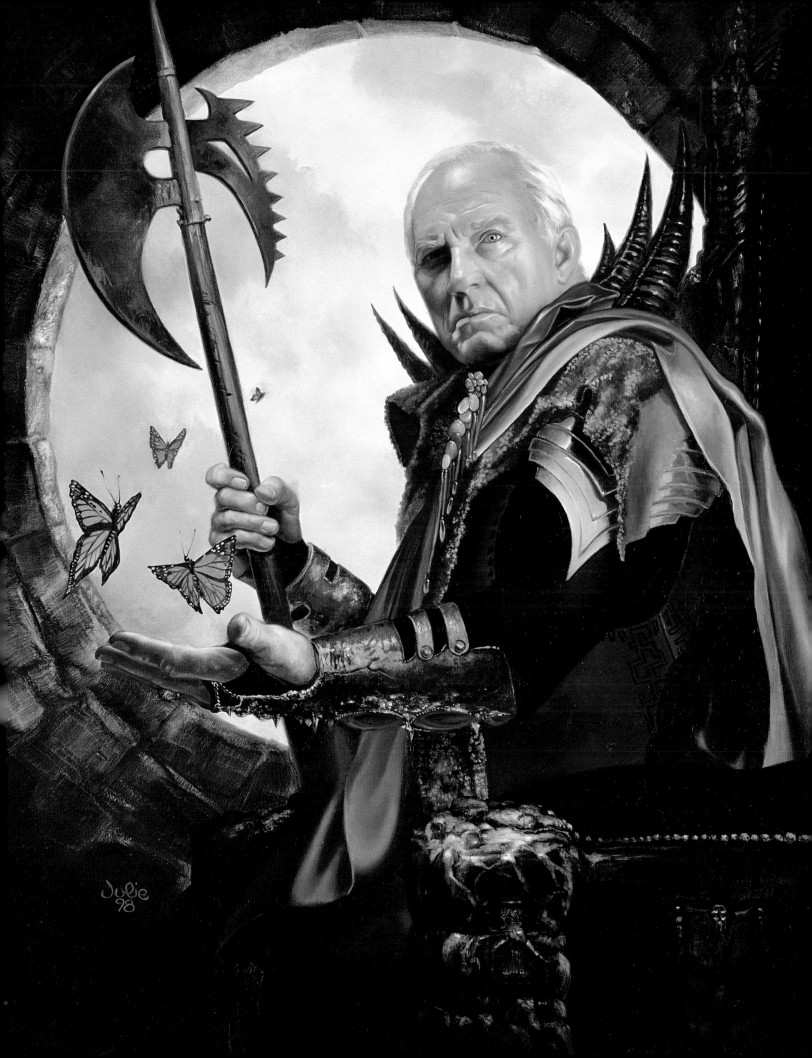

Julie
98

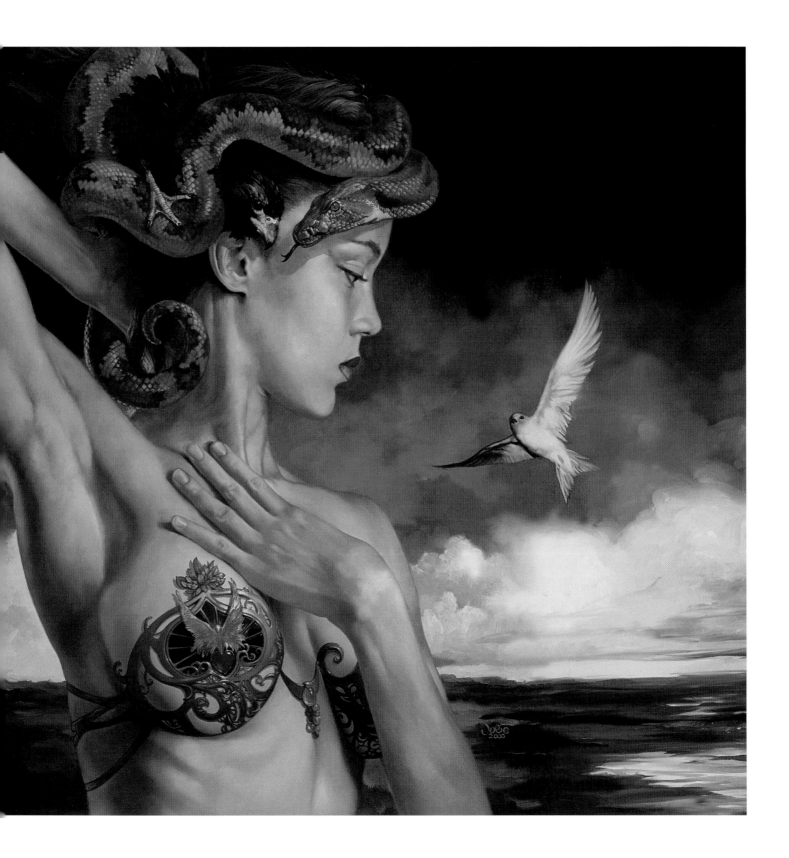

'A PRISONER OF HERSELF' 2000 JULIE

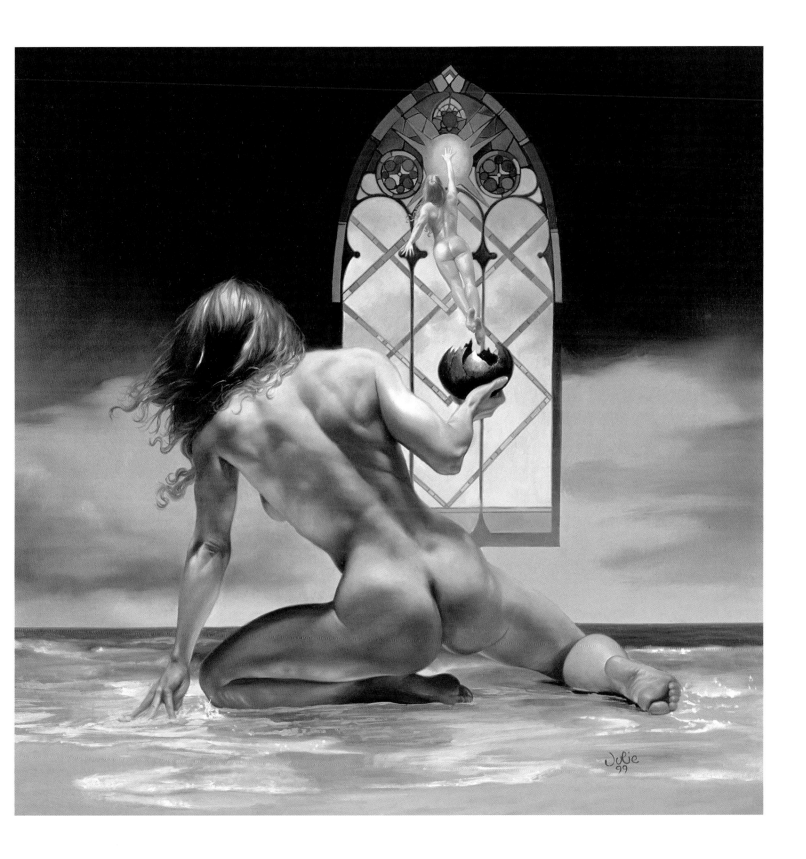

'EL VITRAL' 1999 JULIE

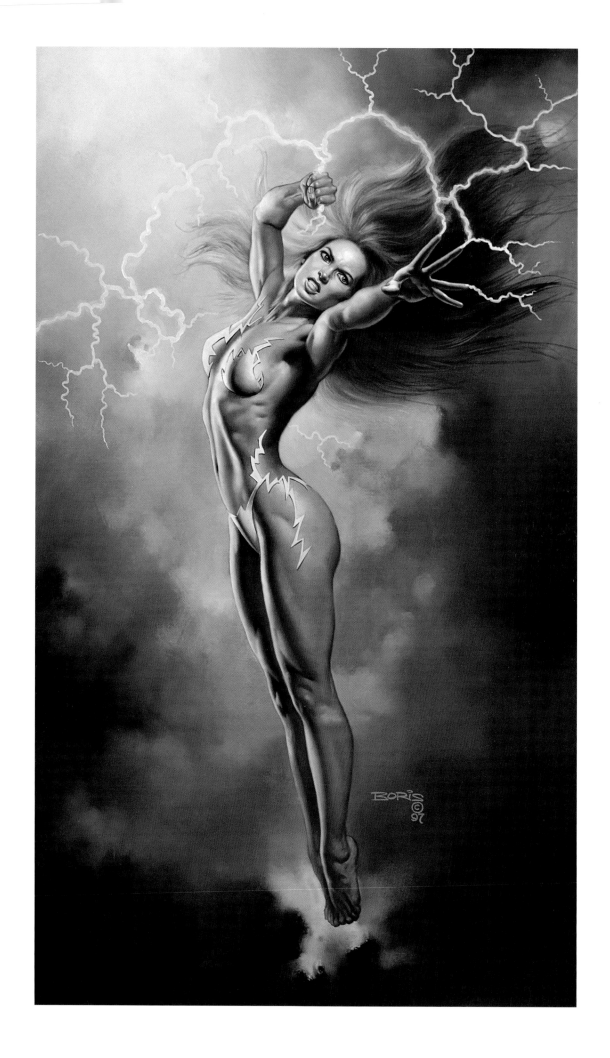

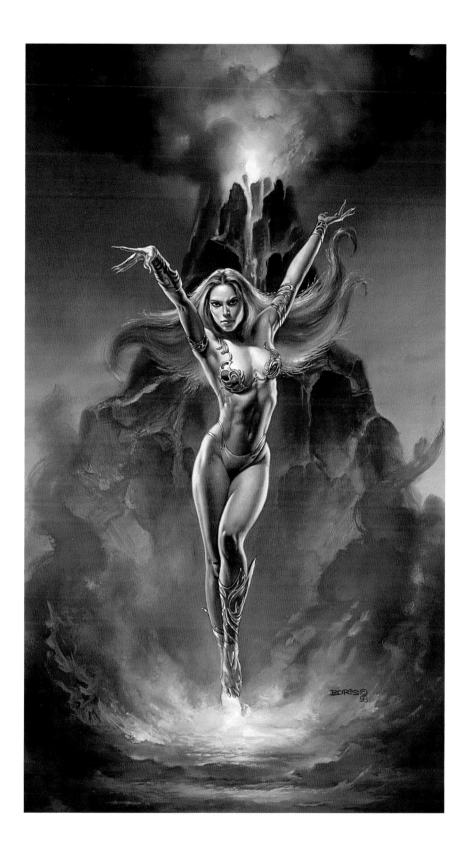

'MISTRESS OF THE STORM' 1997 BORIS 'MISTRESS OF THE VOLCANO' 1998 BORIS

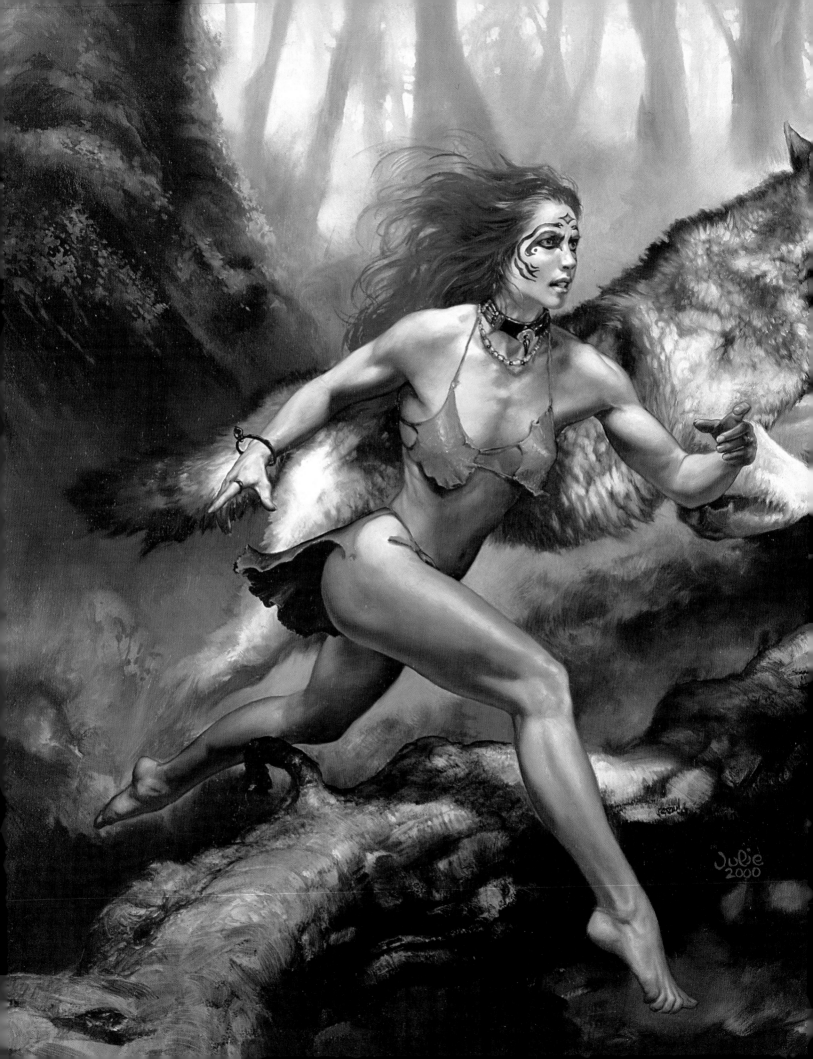

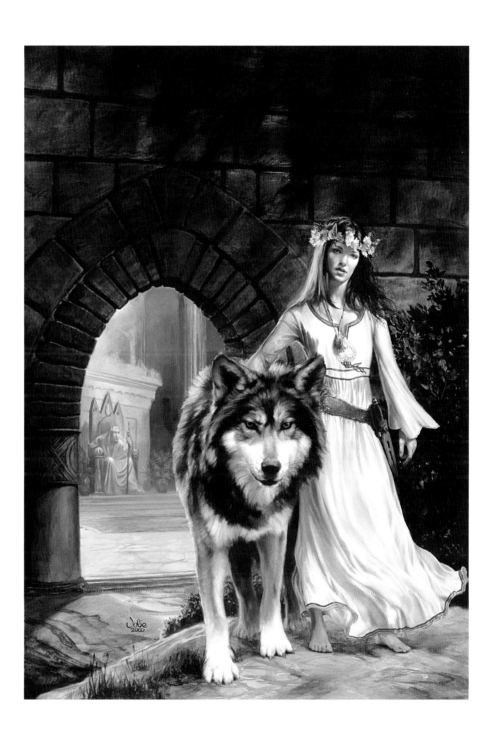

'THE COMPETITION' 2000 JULIE

'WOLF EYES' 2000 JULIE

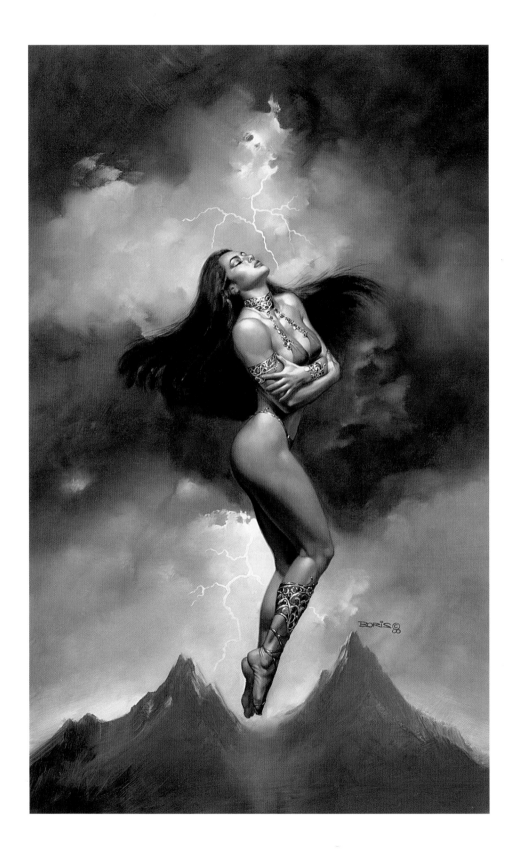

'MISTRESS OF THE THUNDER' 2000 BORIS 'A TRIO' 2000 JULIE

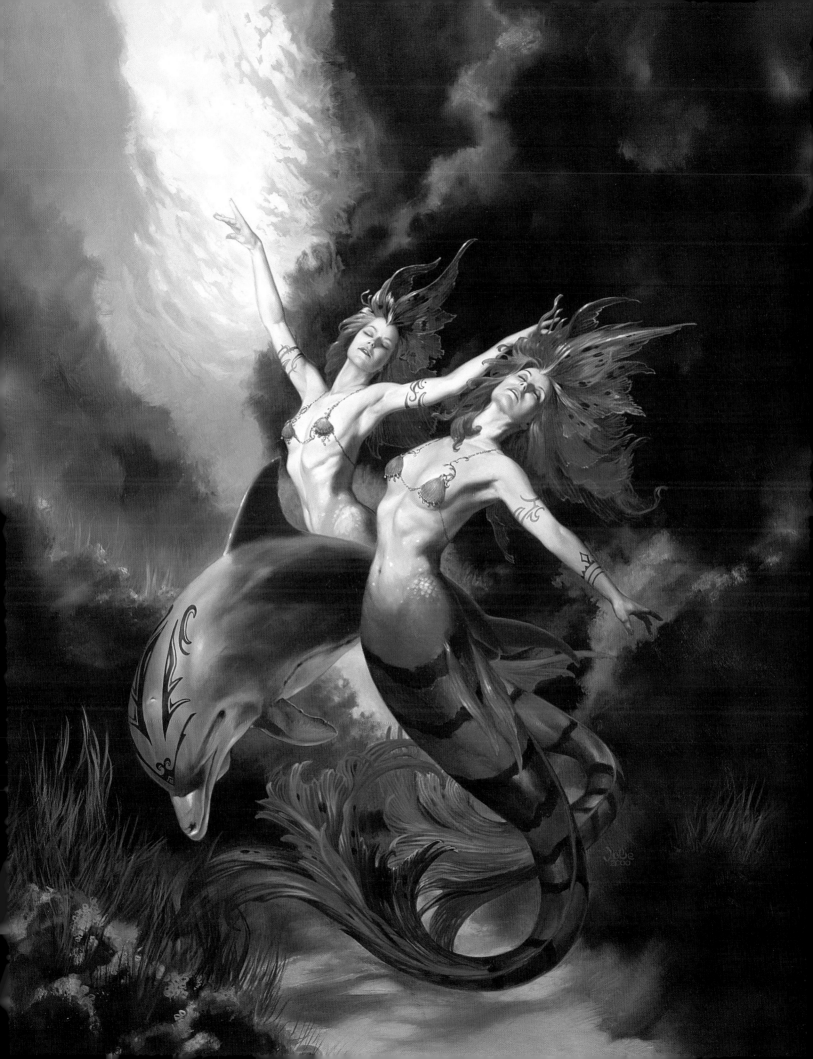

'LLANTHONY' 2000 JULIE

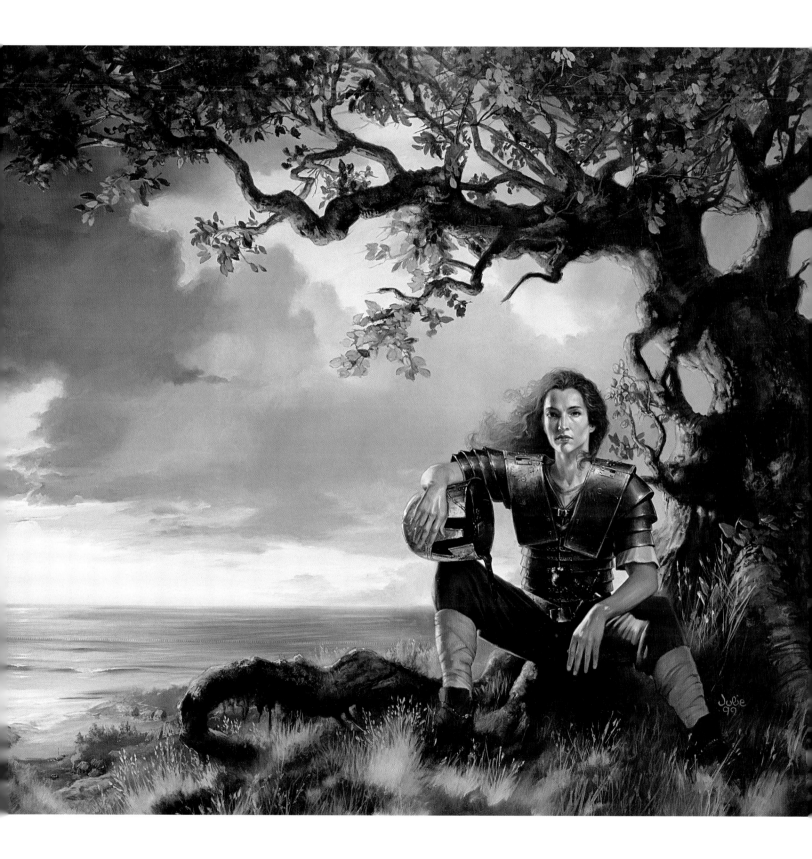

'WARRIOR GIRL' 1999 JULIE

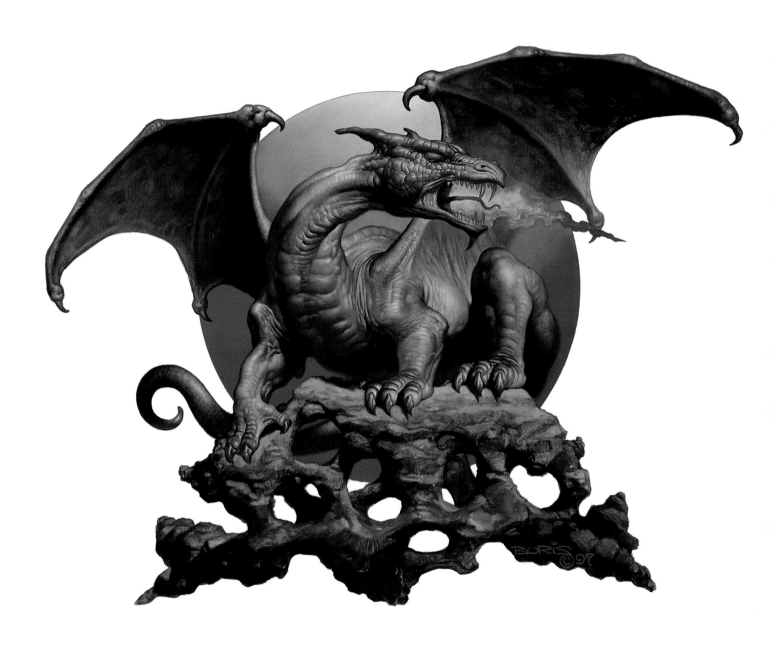

'DRAGON' 1997 BORIS

'PEDRUM' 1993 BORIS

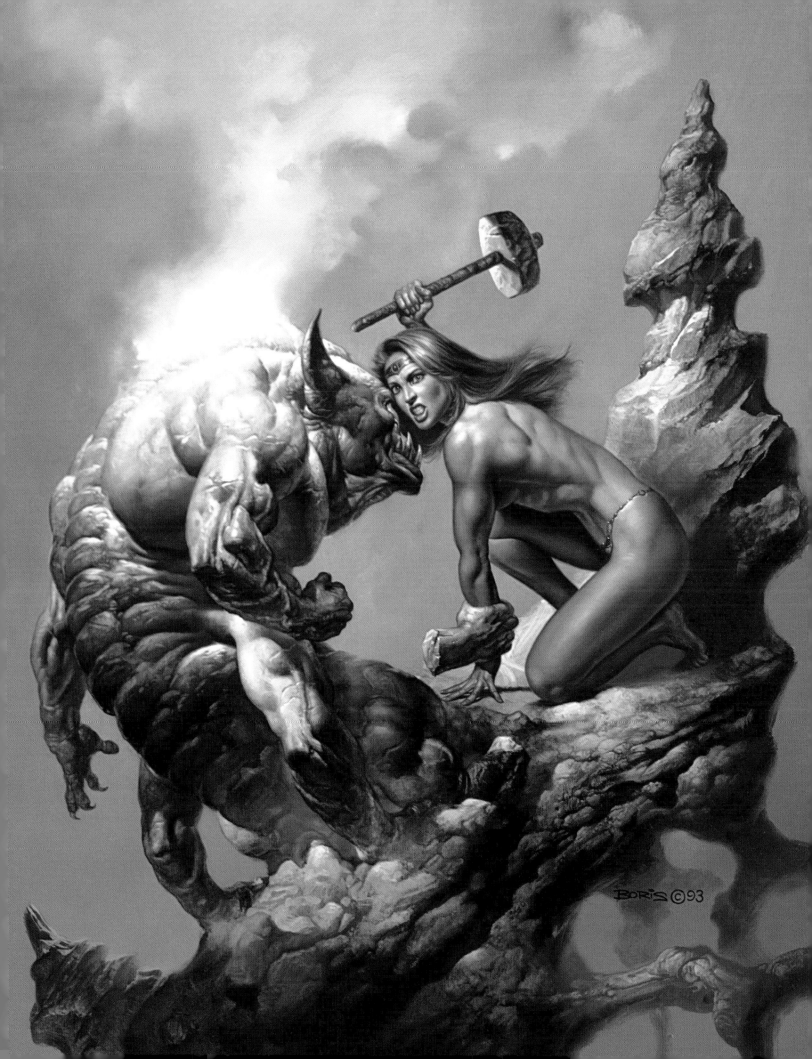

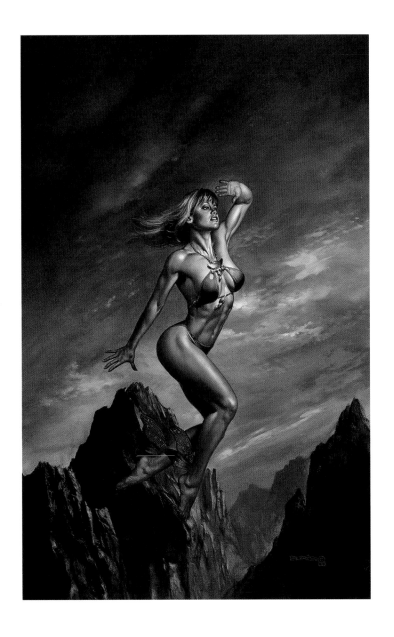

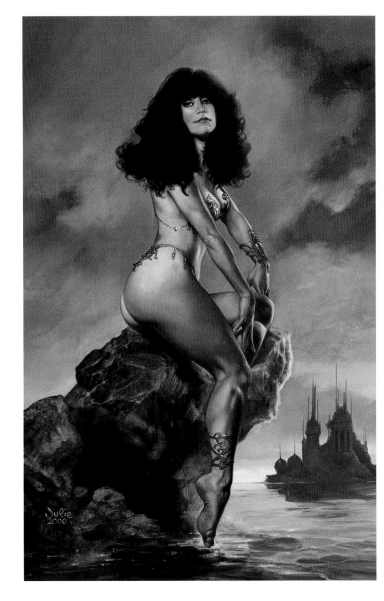

'MISTRESS OF THE DAWN' 2000 BORIS 'SUSAN' 2000 JULIE 'EGYPTIAN PRINCESS' 1998 BORIS

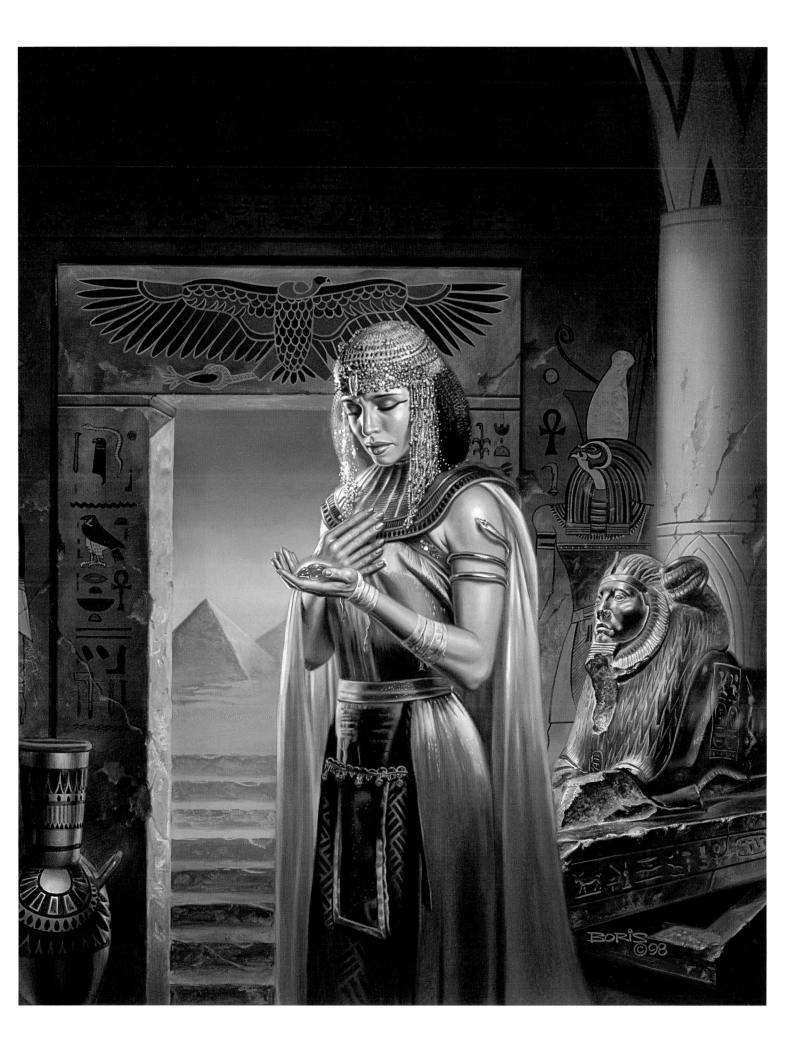

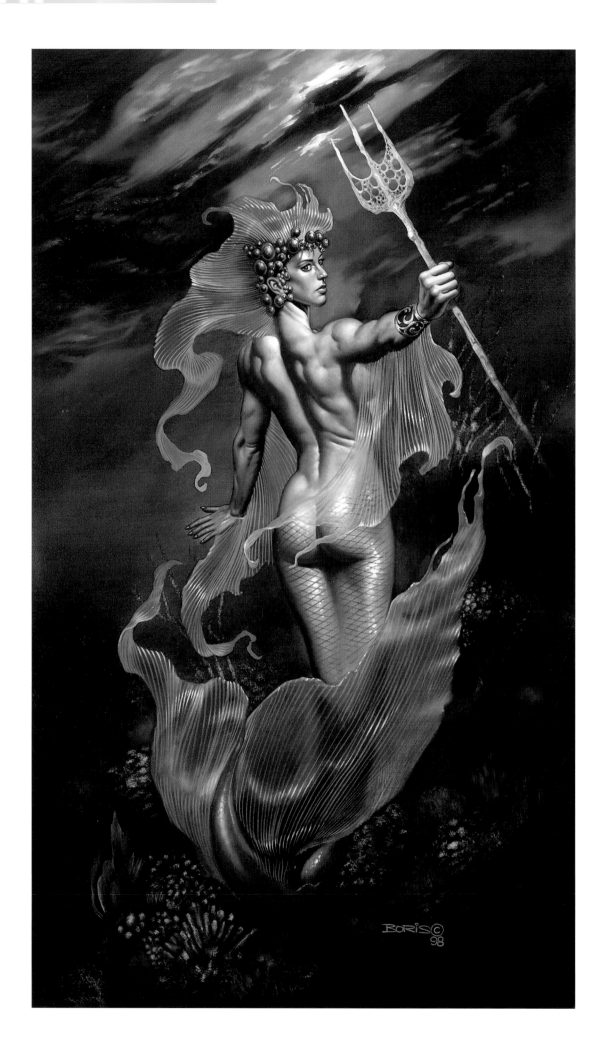

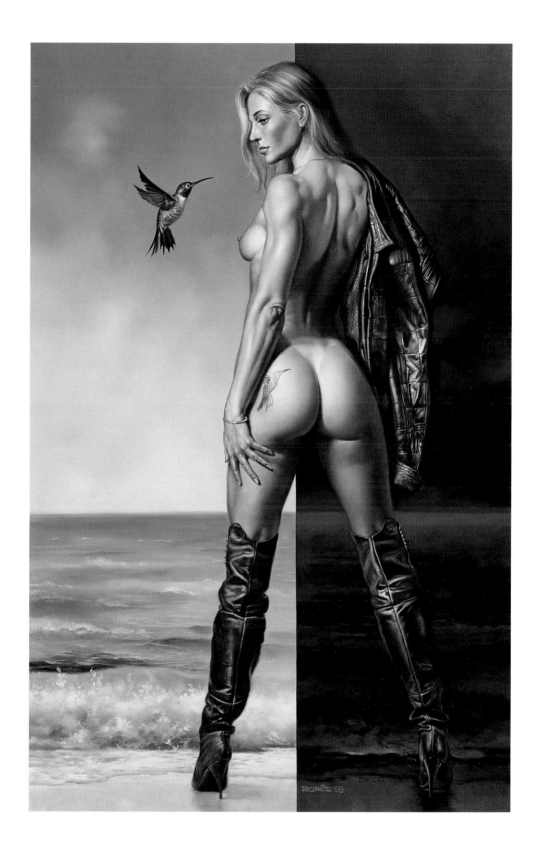

'MISTRESS OF THE OCEAN' 1998 BORIS 'MESSENGER OF HOPE' 1998 BORIS

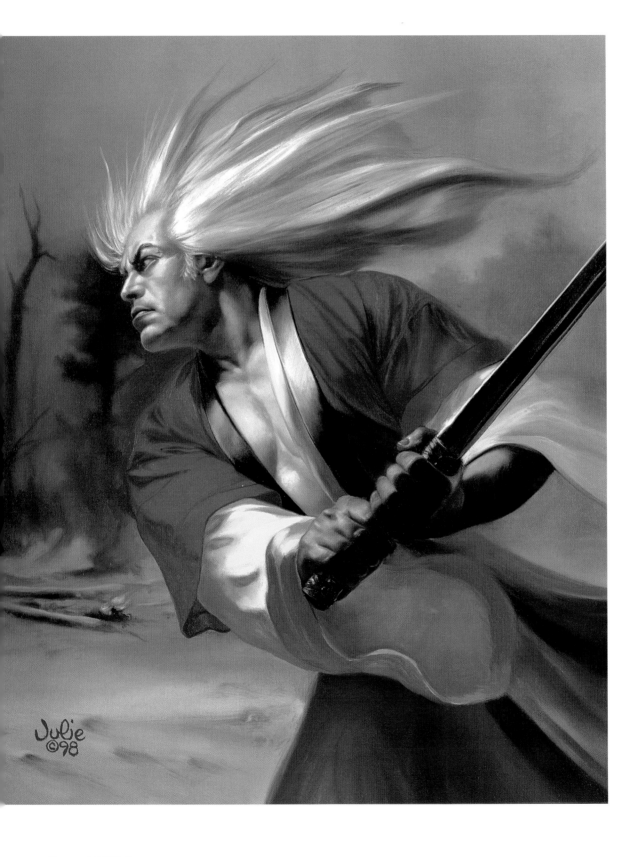

'SAMURAI' 1998 JULIE

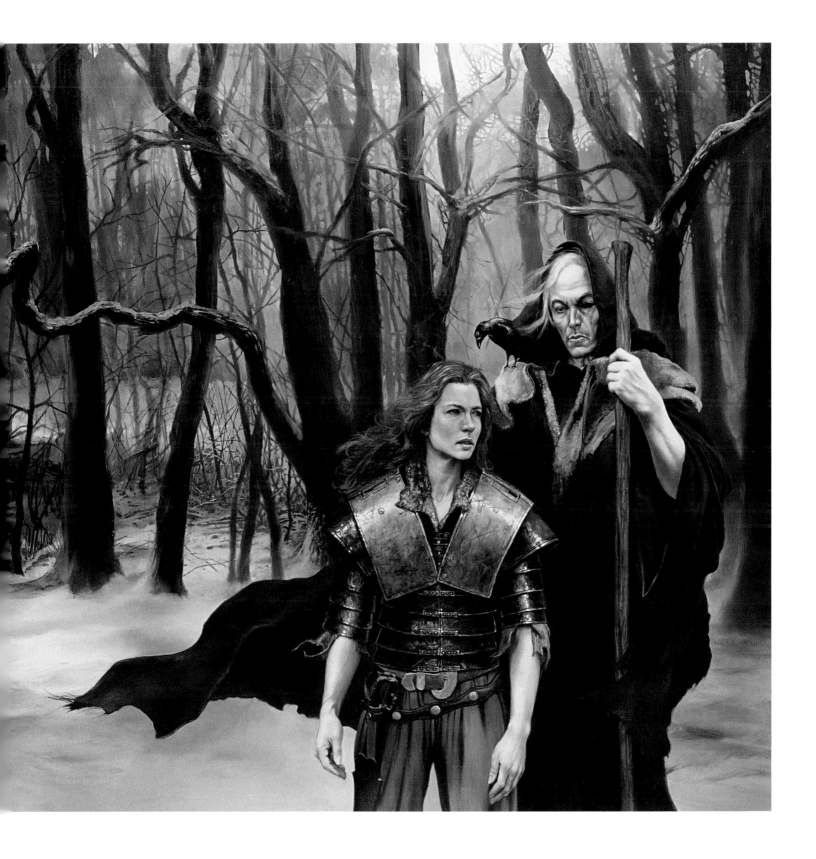

'AT BATTLE'S END' 1999 JULIE

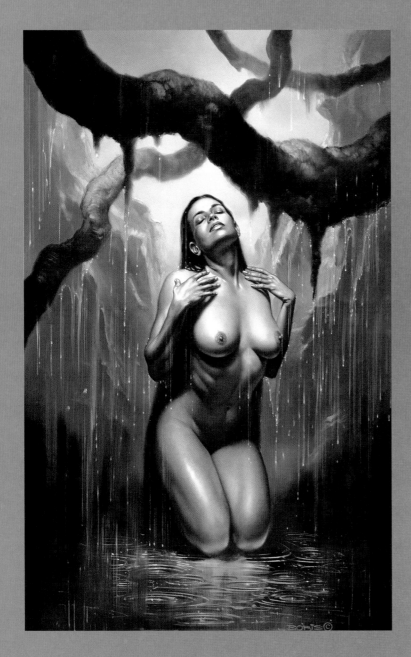

"Boris and Julie are true masters of the human form in all its complexities and subtleties. The beauty, power and elegance of their paintings captivate and inspire."

Brom www.bromart.com

'MISTRESS OF THE RAIN' 1998 BORIS 'MONICA'S AXE' 1998 BORIS

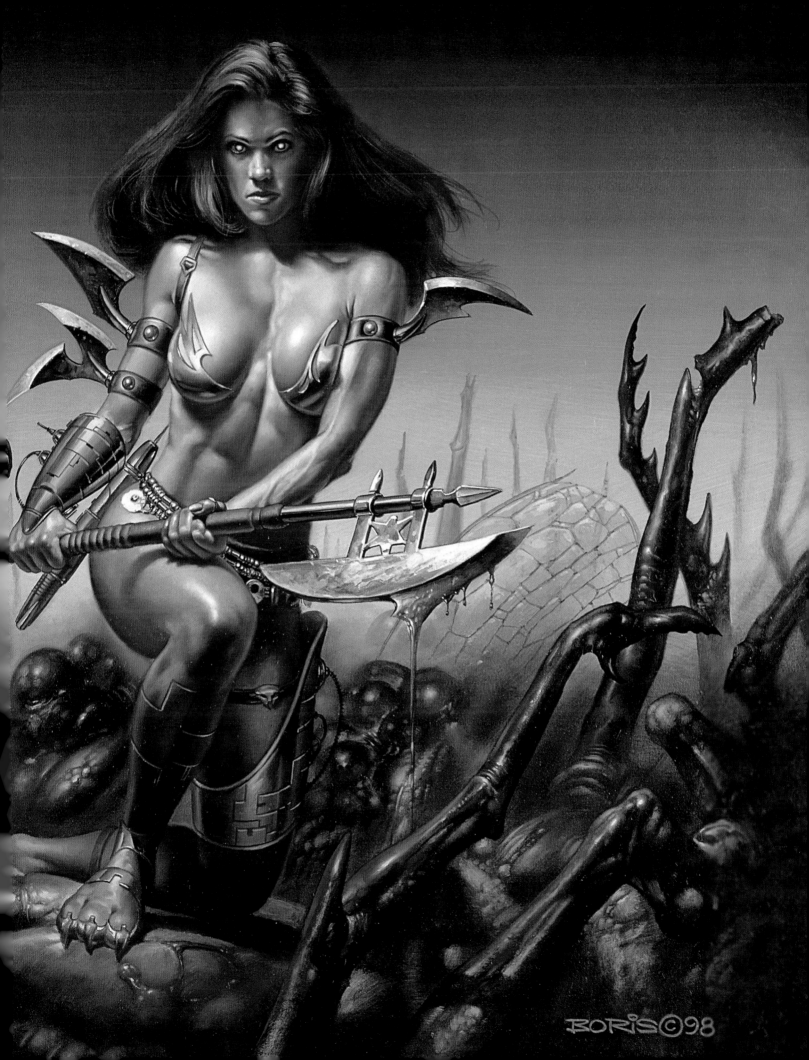

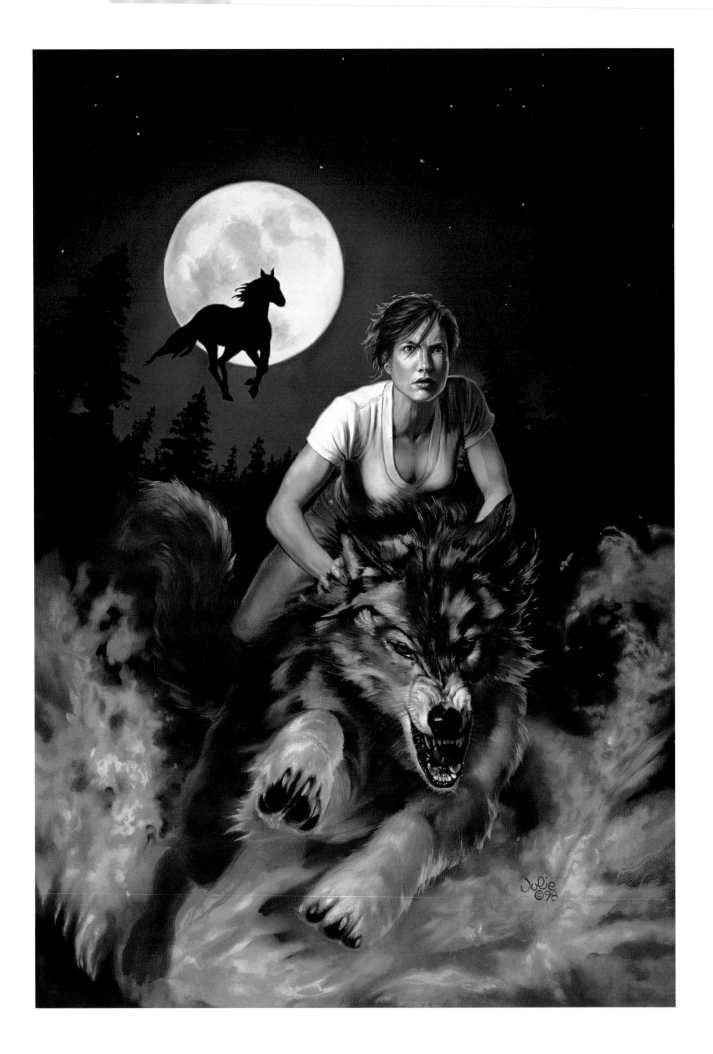

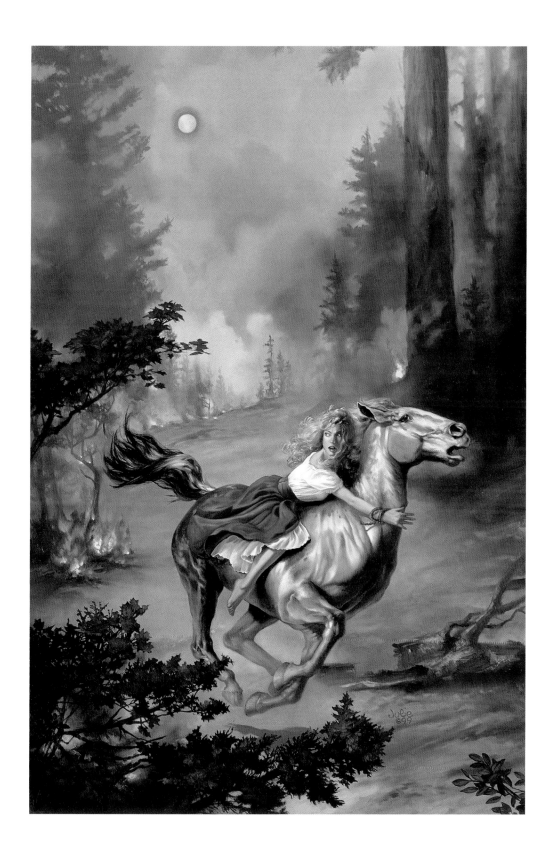

'WOLF RIDER' 1998 JULIE

'FOREST FIRE' 1999 JULIE

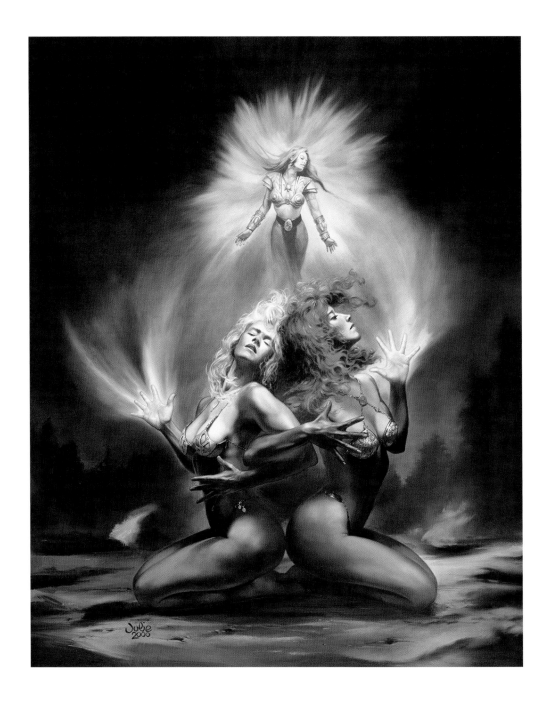

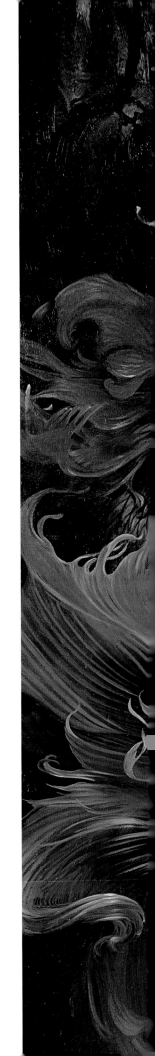

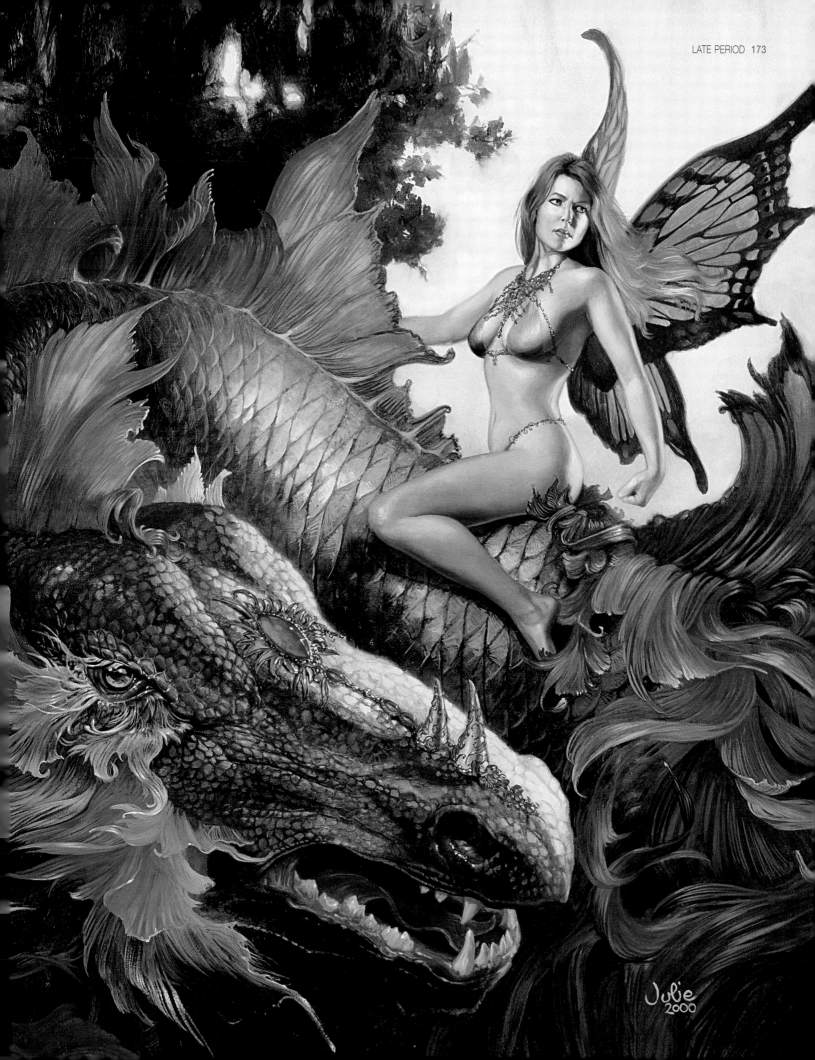

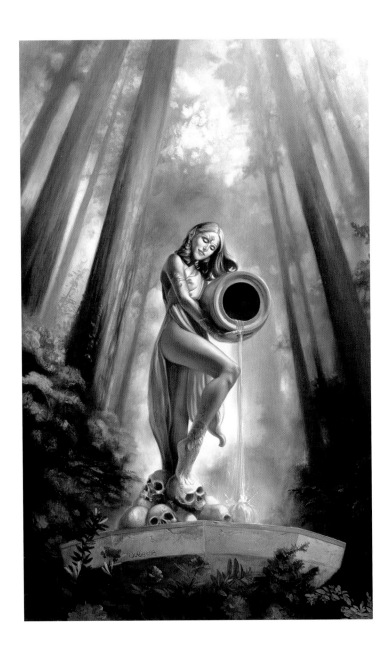

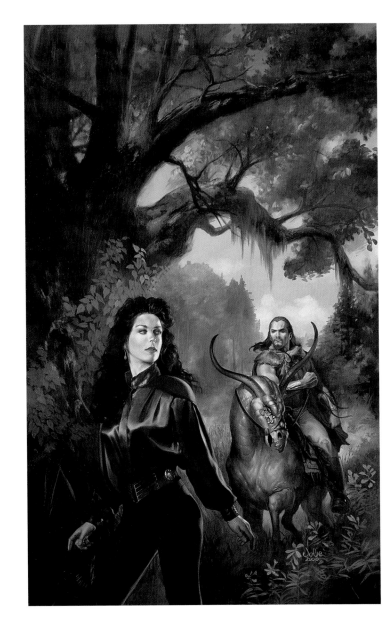

'FOUNTAIN IN THE RED WOODS' 1998 JULIE

'THE ENCOUNTER' 2000 JULIE 'GODDESS OF THE EARTH' 1997 BORIS

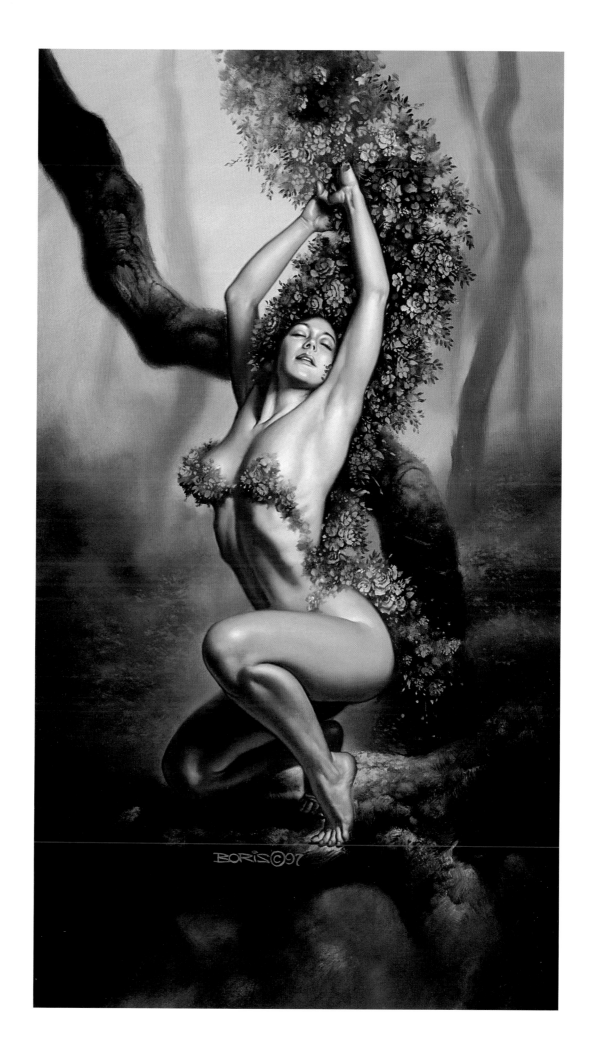

PHOTOGRAPHS
& SCULPTURES

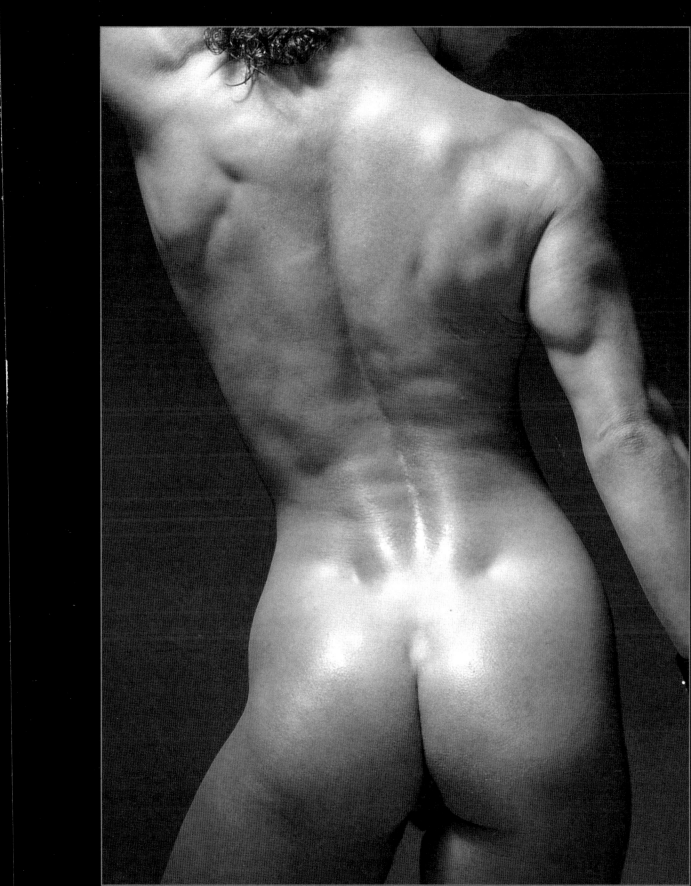

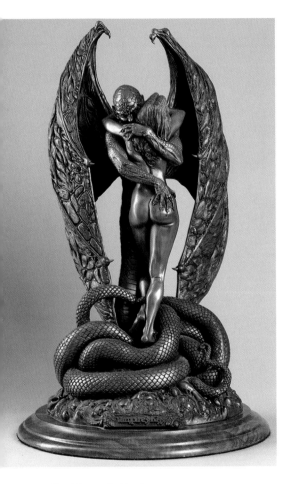

'THE VAMPIRE'S KISS' © CELLAR CAST

PREVIOUS PAGE: 'BACK'

PHOTOGRAPHS & SCULPTURES

Paintings are what Boris and Julie are famous for, but there are other dimensions to their art that we're showing a few samples of in this chapter, including photography, which is integral to their painting. Boris has published two books of photography so far – *Bodies* and *Hindsight* – which focus on both artists' favourite theme, the human body toned to perfection.

The relevance of such pictures to their art is clear, but less clear perhaps is the part that nature photography plays. But flick through the flower and insect photos in this chapter and you'll see where some dragon wings, skies and other effects in their paintings have come from. They may have nothing to do with flowers but in some curious way this doesn't matter. Being drawn from a natural source, such colour effects have more conviction than purely imaginary schemes, whatever they are applied to.

With the sculptures, Boris and Julie themselves have no direct hand in the modelling and casting, they simply supply the designs for the craftsmen (and women) to work from.

To start with they send a drawing or painting of the all-important front view or 'photo angle' – the shot that will appear in advertisements. From this the manufacturers fashion a rough model, or maquette, that the artists use to make refined drawings of the other angles. Julie says 'It's always really fun to receive a 3D model of a favourite painting, though we'd also enjoy being more involved in the process.'

Boris: The first thing to say about photography is that it is the beginning of our painting. I wouldn't say that we would not be able to paint without it,

but if we just painted from life it would look very different. You learn a number of things by shooting photos for reference that you would not see otherwise. You have to think in terms of what attitude or approach is needed to get a certain effect. Most of the time we work with figures but also we use photography a lot for other effects.

Julie: The thing about working with photos is that what you're looking at is already flattened out, which makes it easier to translate into a painting. With figures we usually paint from black and white photos because that allows us to add colours that suit the picture. But from the pictures we take of flowers and butterfly wings and things like that we learn how colours can be saturated and other effects. It's more an impressionistic thing.

Boris: Exactly, it's not scientific photography. Often we're just looking for abstract forms – colour and shape and how they flow. In extreme close-ups the flowers themselves are not always discernible because we're looking for graphic design in them. Also, when looking at a flower or insect many people can't see beyond what it is from their normal distance. If they are repelled by insects, all they might see is some crawling, disgusting thing that should be squashed; but if you go in close they become quite different.

Julie: When you get to their level insects can become like amazing pieces of jewellery.

Boris: Iridescent colours, armour, intricate designs . . .

Julie: Boris was really brave once, shooting some wasps guarding their nest. Close up they looked like storm troopers straight out of *Star Wars* with great big eyes – warriors whose only purpose is to kill you.

Boris: I was shooting the wasps at the entrance to their hive and, using a macro lens, had to get close. However, as I was doing this I didn't notice at first that they were communicating with each other, touching each other with their antennae. There were six or eight of them standing outside the nest, then all but one of them disappeared inside and the one that was left

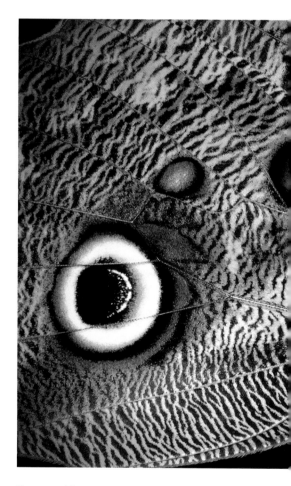

BUTTERFLY WING

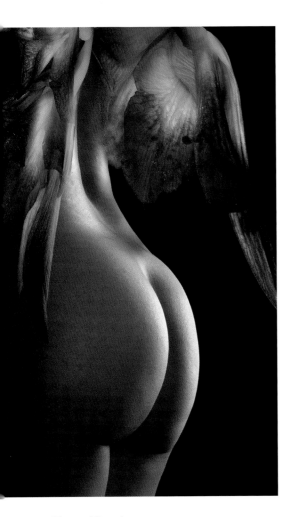

'FLORAL WINGS'

just stared fearlessly straight into the lens with the intense look of
a warrior.

Julie: They didn't attack, just sat and watched while Boris shot the pictures.
Then we called the exterminator and got rid of them! That's no way to
treat a model. But for every warrior that's around, I guess there's a bigger
warrior somewhere. We not only get inspired by the look of such situations
but the storyline. You enter a different dimension where SF is going on
under your nose.

Boris: Once we watched a Jumping Spider stalking ants just the way a human
hunter would stalk prey. It's not that it's copying us in any way of course,
but a reminder that we're animals too. Small creatures do the same things
but on a smaller scale.

Julie: A lot of what we show in our art is just what goes on in life but on a
different scale and different emphasis.

Boris: Keep in mind that our interest in this kind of photography comes
straight from our artistic background. We sent some pictures once to a
professional macro photographer to hear what she had to say, and she felt
that our artistic training totally shone through. It's something so natural in
art to look at everything as a painting. So our art feeds into our
photography, and that feeds back into our painting.

People often don't see the relationship between the photographs we
take and the paintings we do. Sometimes the connection is recognizable but
more often not.

Julie: With flowers, they are not usually what the photo is about. We look at
the flowers as textures and fields of colour that can be used to represent

something completely different and give it a natural, believable look that you would not otherwise get. If you take one natural thing and imagine it to be something completely different, you can create a whole new possibility for a painting. For instance, it's interesting to look at a cloudy sky and imagine it to be a vast planet surface just over your head. Immediately the clouds become something else, but with a natural texture that has a ring of truth about it. The same thing happens with flowers, insects and so on – you can take elements and put them into a whole different context. It works better than pure imagination because it's based on something real, just taken out of context.

Boris: Also, I do think the idea of doing macro photography is to see things the way the naked eye can never hope to.

Julie: As we said, it's like going into a completely different dimension where you find amazing warriors with jewel-like armour. The insect world becomes something you can honour.

Boris: You have to remember that painting is an illusion. You are creating a 2D image with the illusion of depth so you have to learn to look on objects as a combination of light, shadow and form. Often when studying art we are told that we should not look at them as a person – at their chin, nose eye, etc – because you can get too hung up on what the nose looks like, for example. You look for light, shadow and form and then the person will follow naturally.

That is what we do in our photography. We can spend hours shooting one flower and find dozens of different statements – all kinds of angles from which the flower becomes a different story or pattern.

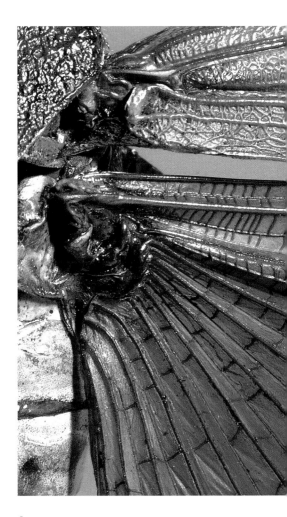

GRASSHOPPER

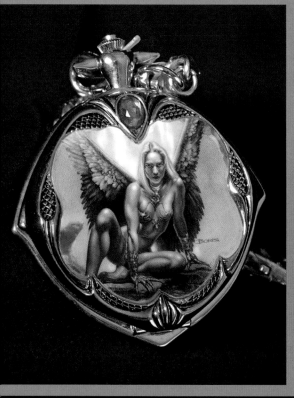

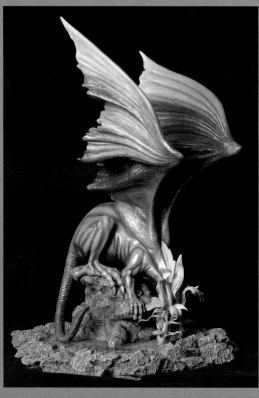

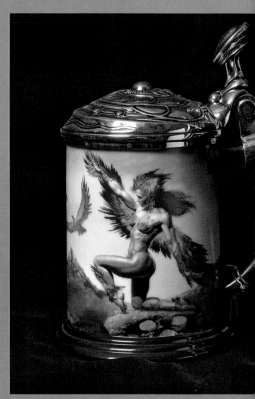

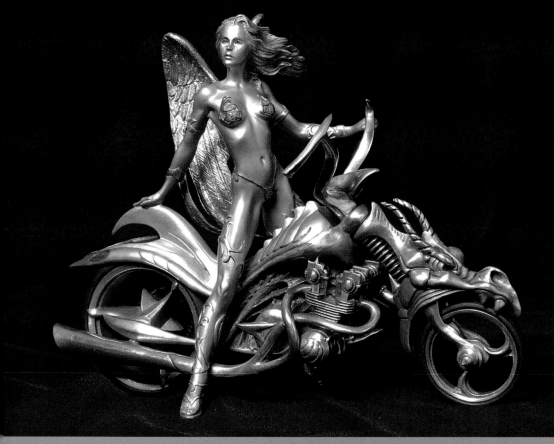

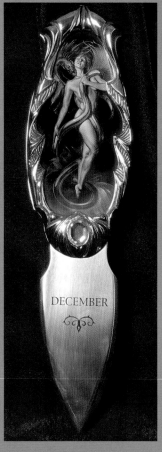

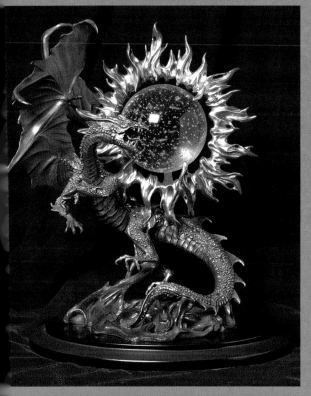

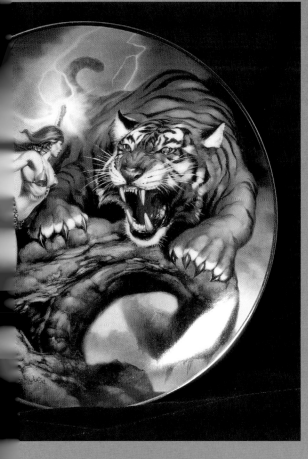

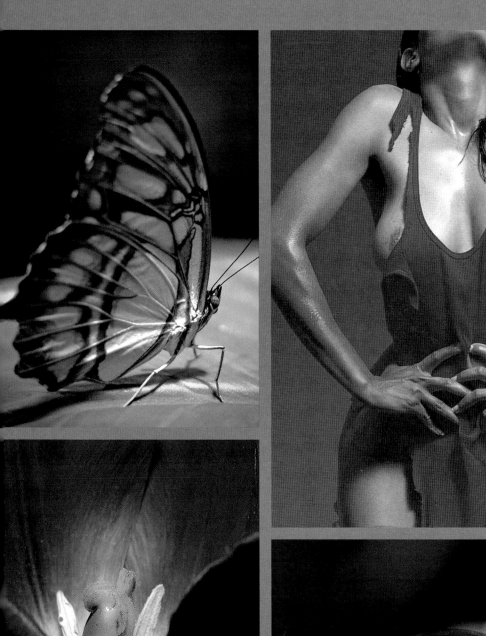
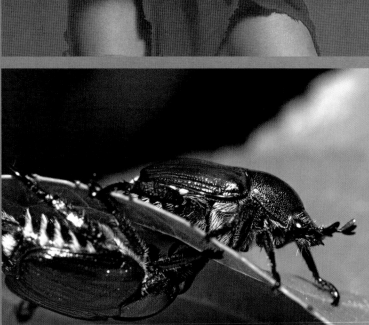
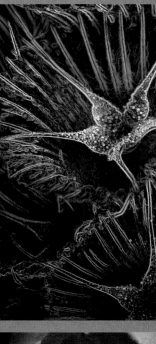
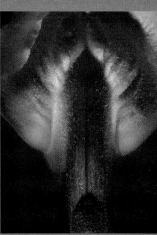
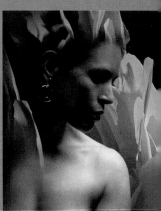

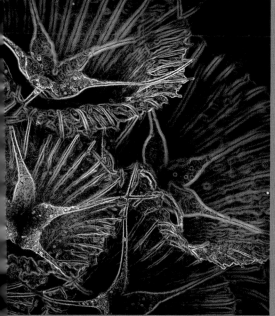
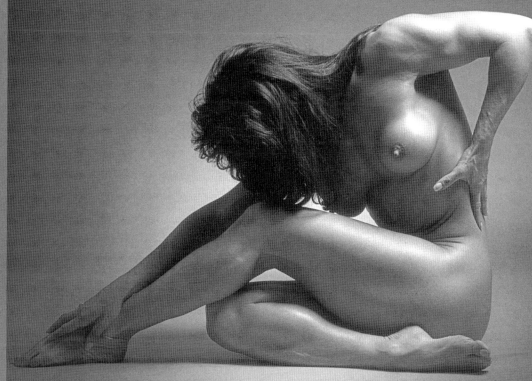
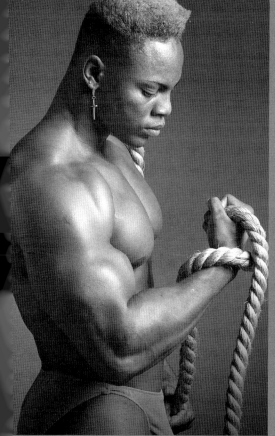

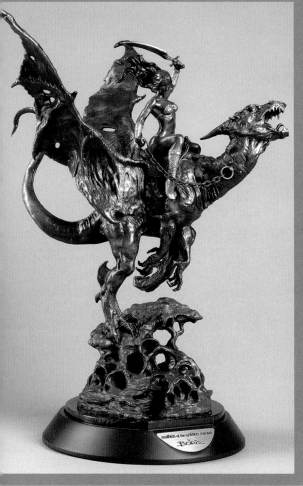

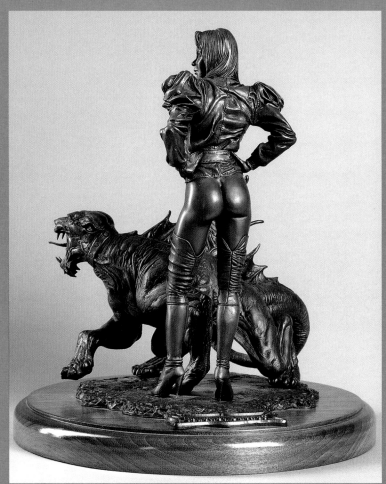

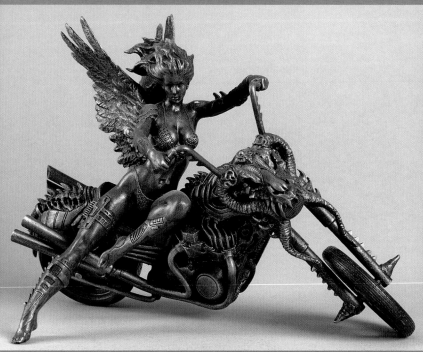

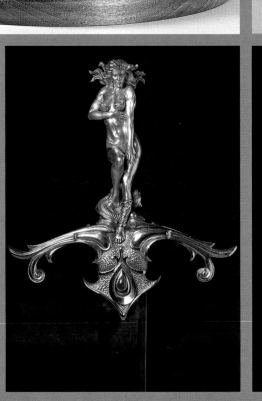

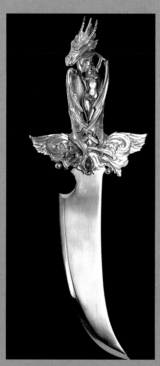

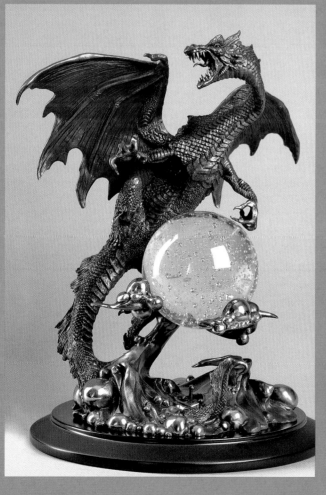

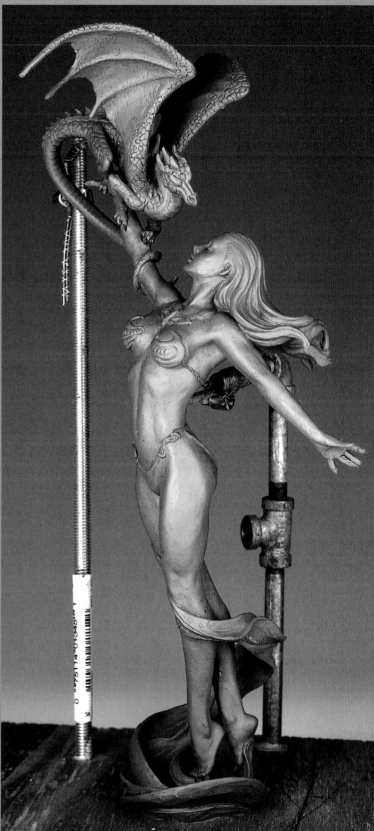

PUBLICATIONS

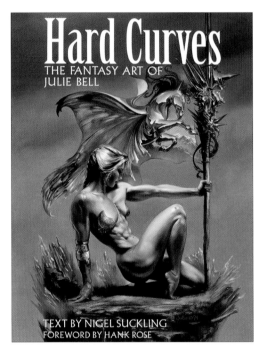

HARD CURVES: THE FANTASY ART OF JULIE BELL 1995

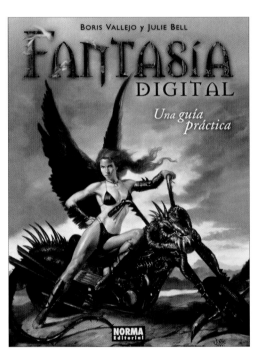

FANTASIA 2003

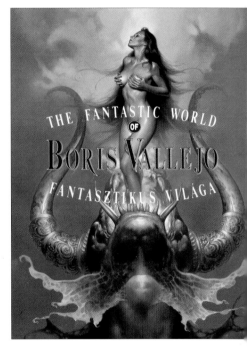

THE FANTASTIC WORLD OF BORIS VALLEJO 1989

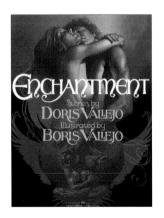

ENCHANTMENT 1985

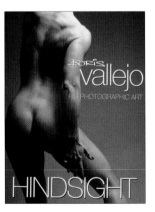

BORIS VALLEJO PHOTOGRAPHIC ART: HINDSIGHT 1998

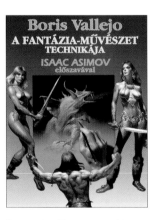

FANTASY ART TECHNIQUES 1985

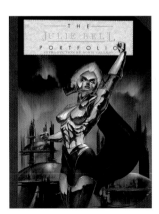

THE JULIE BELL PORTFOLIO 1994

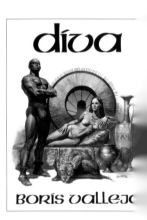

DIVA 1979

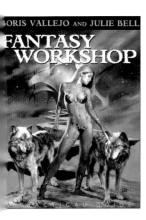

ntasy Workshop: A Practical
uide 2003

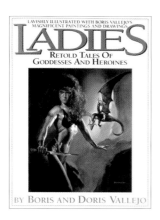

Ladies 1992

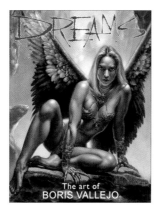

Dreams: The Art of Boris
Vallejo 1999

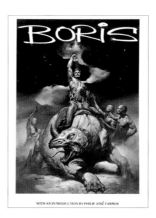

Boris 1978

Twin Visions: Boris Vallejo and
Julie Bell 2002

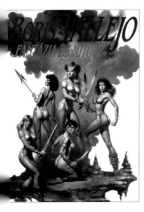

tasy And Myth 1991

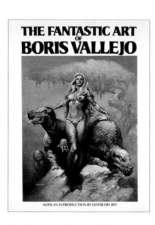

The Fantastic Art of Boris
Vallejo 1978

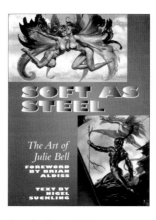

Soft As Steel 1999

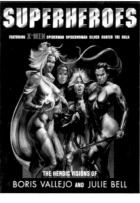

Superheroes 2000

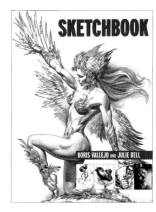

Sketchbook 2001

is Vallejo 1994

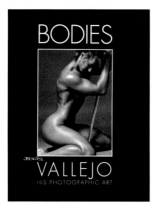

Bodies: Boris Vallejo – His
Photographic Art 1996

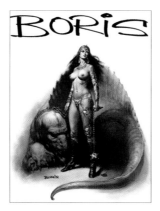

Boris 1978

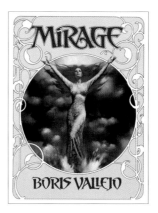

Mirage: Boris Vallejo 1982

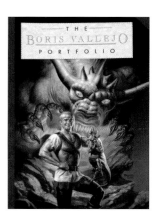

The Boris Vallejo Portfolio
1994

INDEX OF PAINTINGS

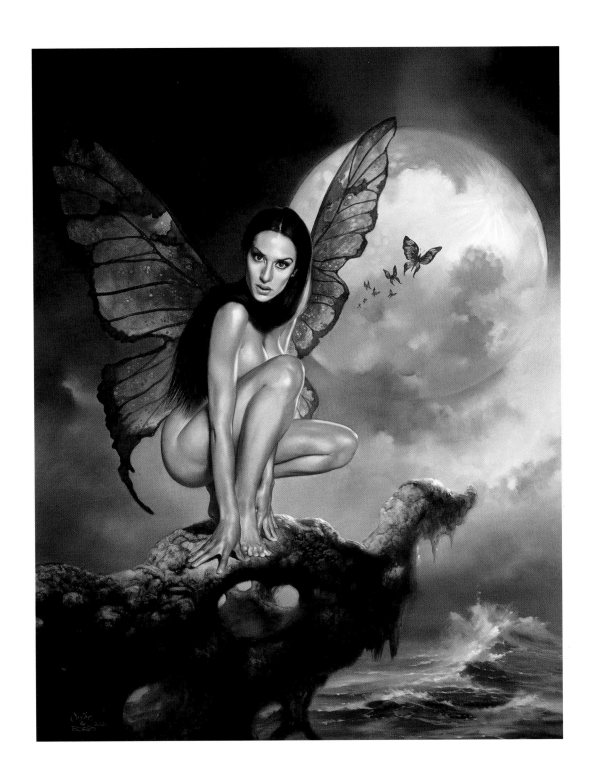

'MONICA' 2000 BORIS & JULIE (Used with kind permission of Monica Naranjo)